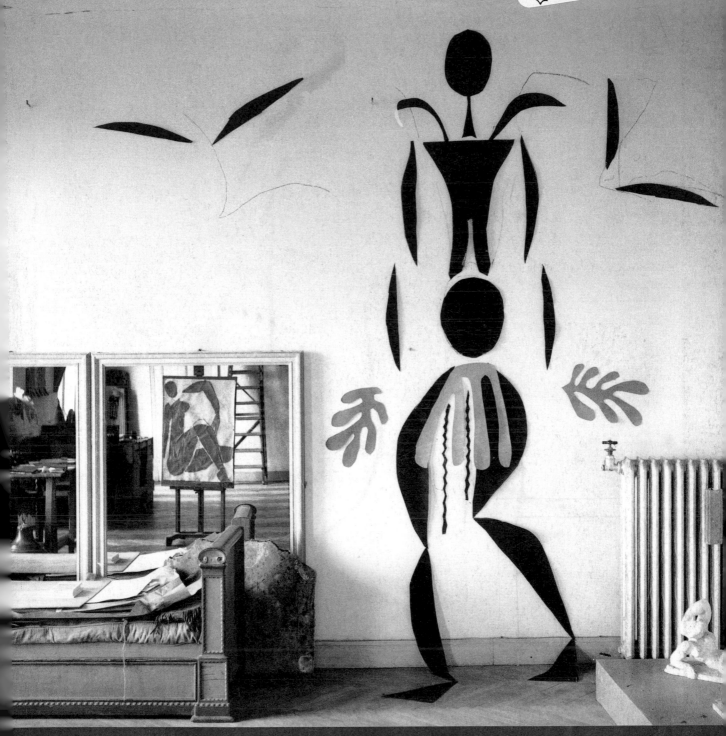

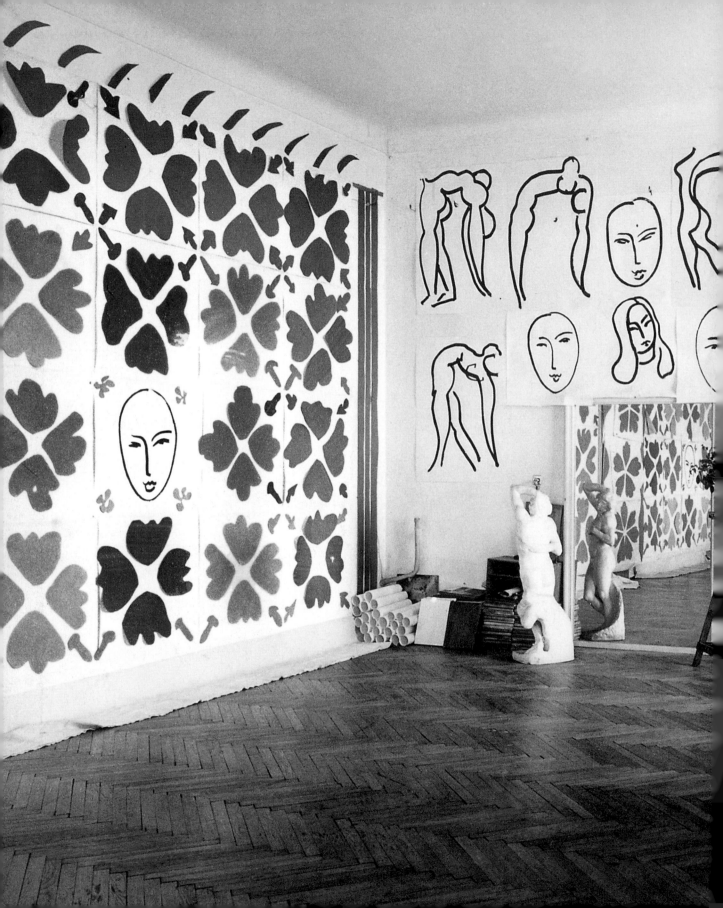

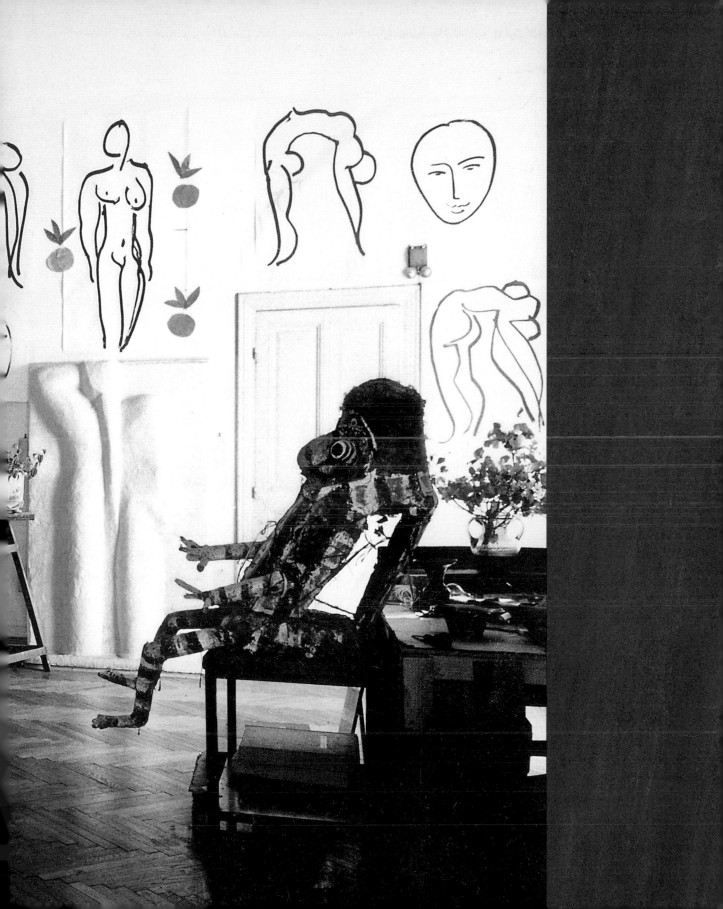

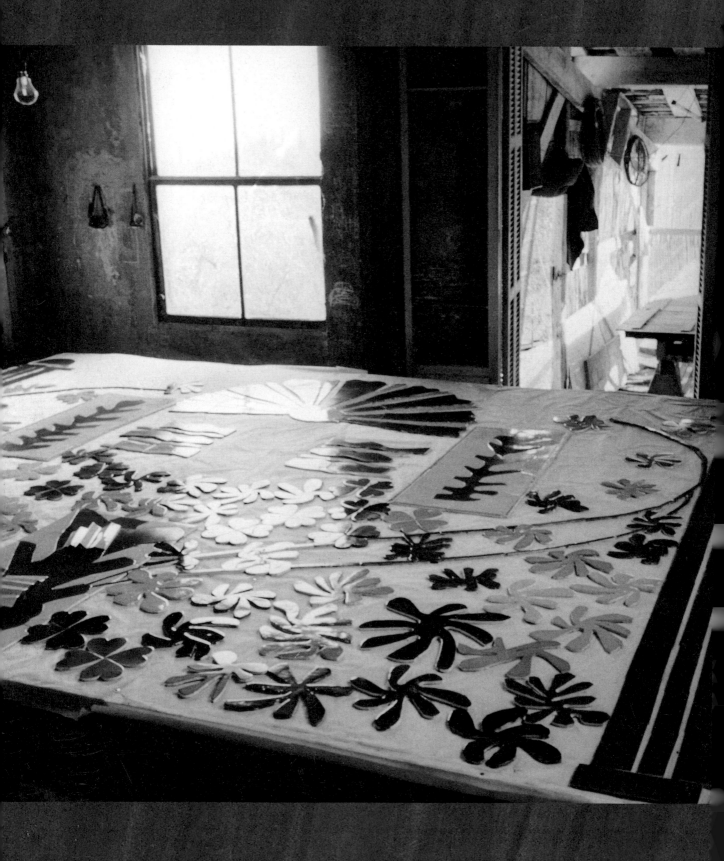

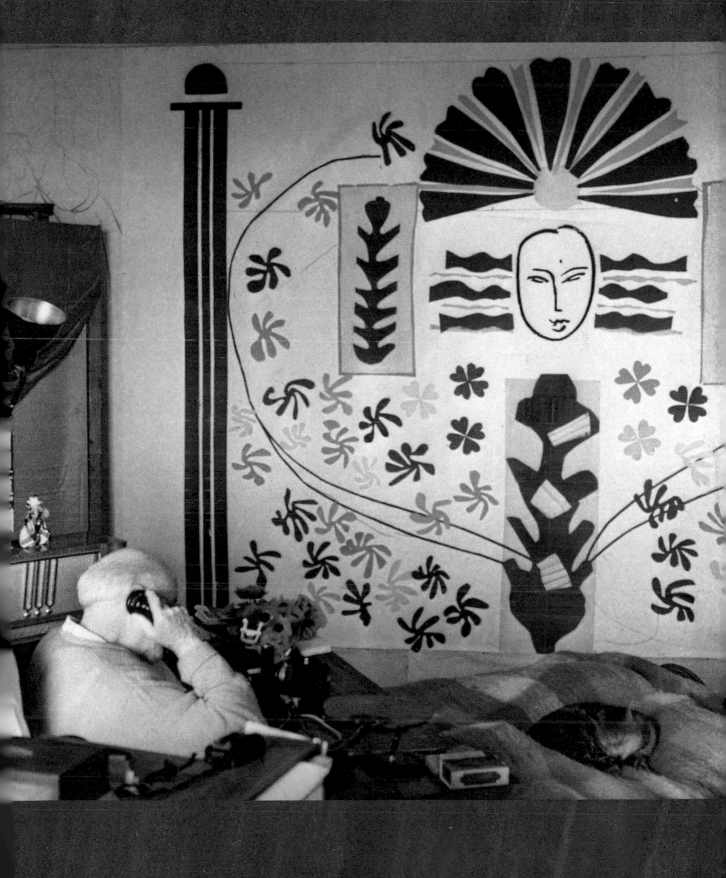

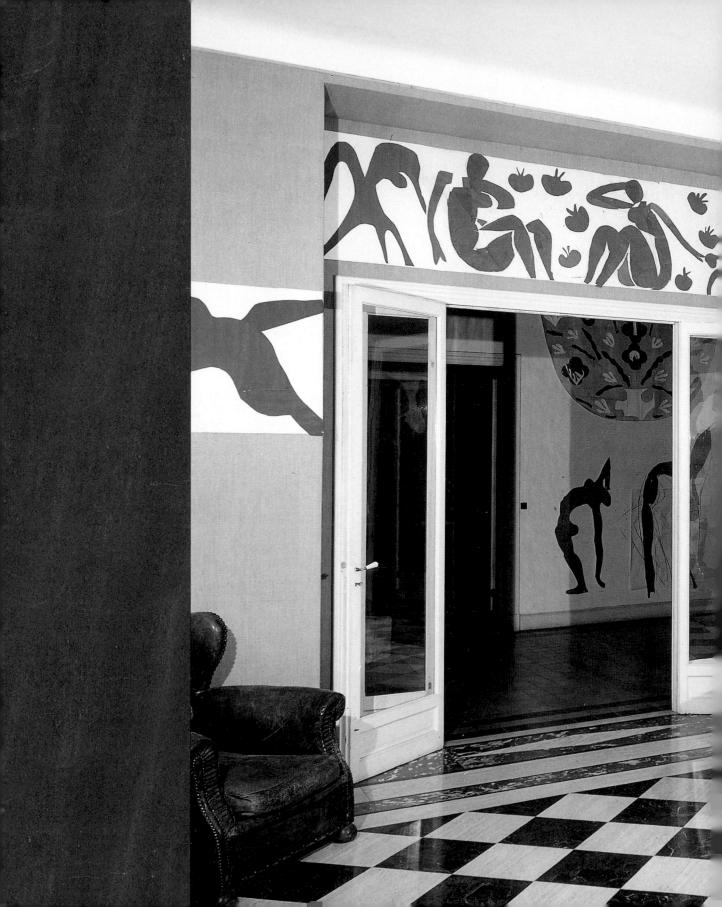

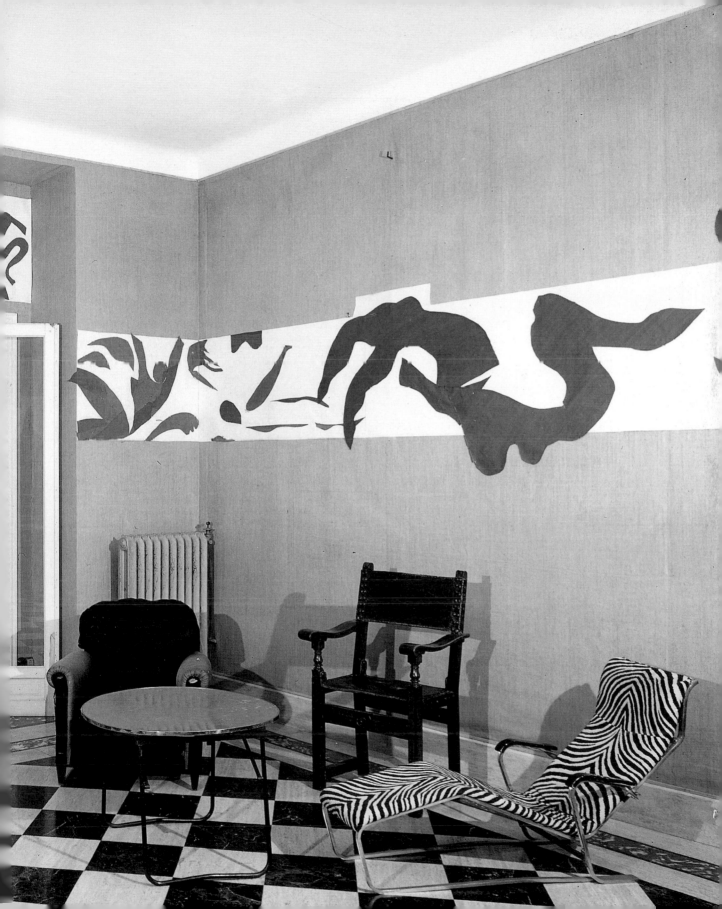

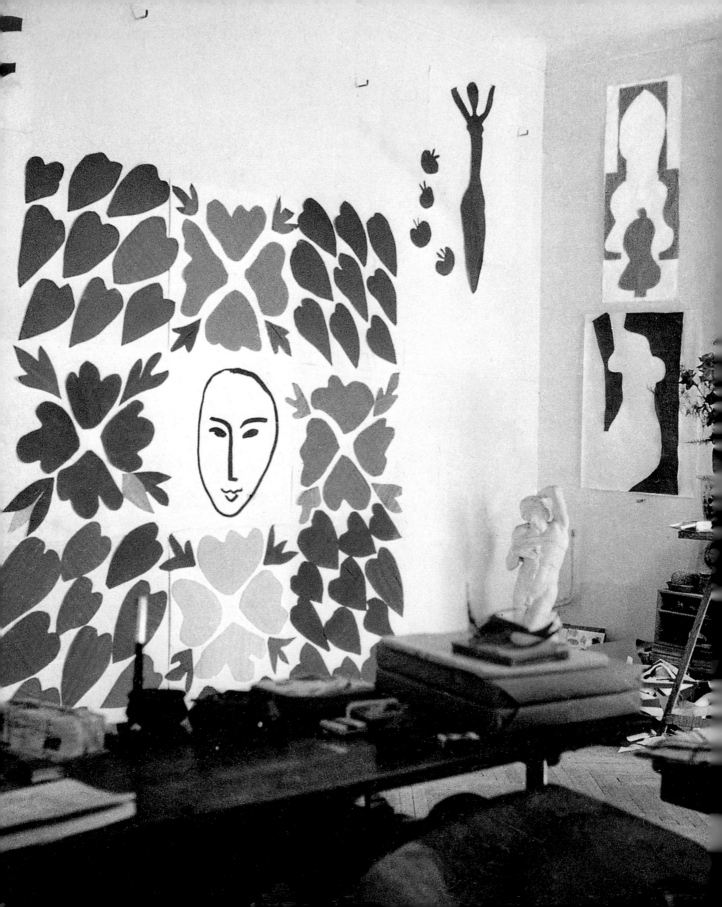

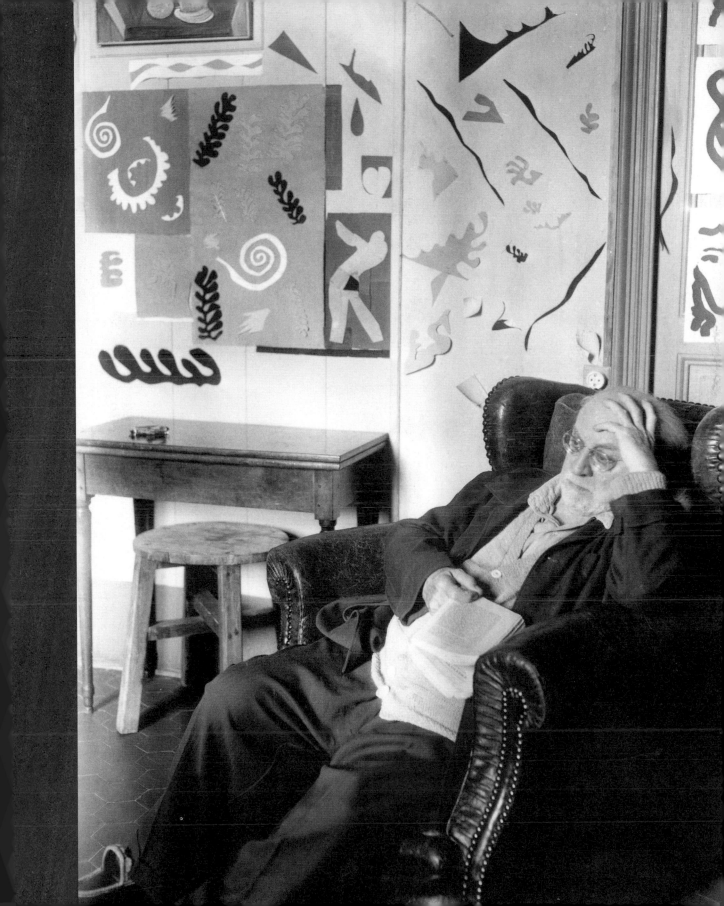

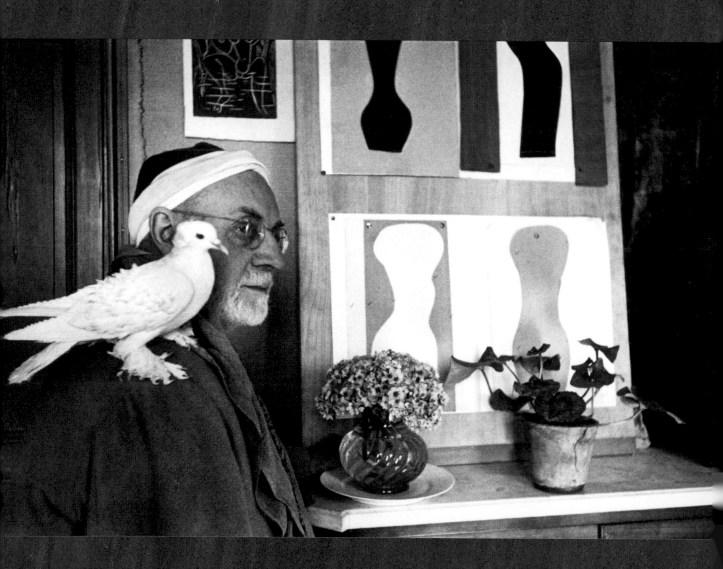

Henri Matisse

Drawing with Scissors ·
Masterpieces from the Late Years

Edited by Olivier Berggruen and Max Hollein

With contributions by Michel Anthonioz, Olivier Berggruen,
Hannes Böhringer, Rémi Labrusse, Gunda Luyken, Ingrid Pfeiffer
and Margret Stuffmann

Prestel

Munich · Berlin · London · New York

Dedicated to the memory of Maria Gaetana Matisse

Contents

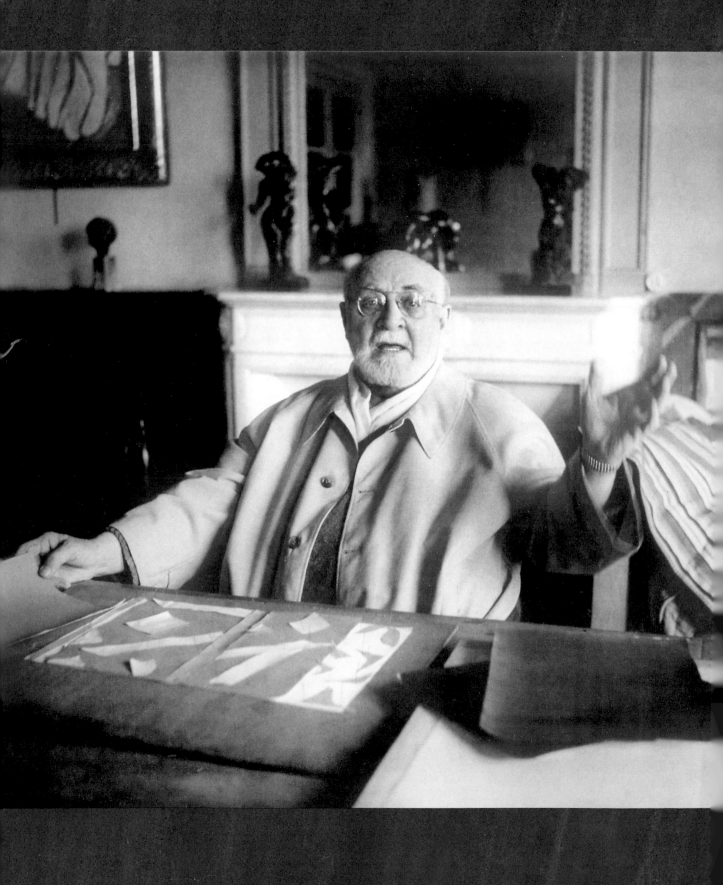

Foreword

This publication first appeared in conjunction with an exhibition of Matisse's cut-outs and represented the fulfilment of a long-cherished dream. The first talks about the basic idea, format and importance of a compilation of this sort took place several years ago in New York. We were at one in our enthusiasm for these unique works and about the need for a thorough and comprehensive exhibition covering all phases of this late œuvre. We were in total agreement as to the great vigour and topicality of the works. However, during our lengthy discussions we were well aware that this would be an extremely difficult project to organise. Despite the utter seriousness with which we tackled this task, it was thus not ignorance but rather a touch of youthful exuberance that—for all our frequent doubts and the scepticism of others—successfully carried us through.

The *papiers découpés* or cut-outs that Matisse was intensively preoccupied with from the 1940s until his death in 1954 can also be seen as the essence of his artistic ambition—the synthesis of line and colour. The now world-famous works document his memories of a journey to Tahiti in 1930, an intense experience of a paradise of Oceanic flora and fauna that ignited his creative zest and which he later condensed into symbols in numerous series featuring algae, leaves and stylised natural shapes. Contemporary history—the experience of World War II and the political persecution of his family—is also reflected in coded form in many a motif of his painter's book *Jazz*.

The decorative power (in the most positive sense) of these unique compositions and the emotional effect of the colours together with their reduced, ornamental expressive forms coincide with present day artists' newly awakened interest in emphasising surface. Thus this volume reflects not just the sensuousness and synergetic vitality of these masterpieces of twentieth-century art but also their absolute topicality.

This publication boasts sixty-eight plates, including the first independent cut-out, the cover design for the *Cahiers d'Art* of 1936 from the Berggruen Collection. In addition, it presents a number of very rarely shown designs associated with *Jazz*, which as a key early work among the cut-outs is shown as a complete portfolio. All phases of the *papiers découpés* are represented, from almost abstract compositions via the great series of variegated algae and famous *Blue Nudes* to the later wall-size masterpiece *La Perruche et la sirène*.

Because of the technique involved—paper painted with gouache colours subsequently cut out by the artist and pasted onto another sheet of paper—the cut-outs as a key medium of Matisse's late œuvre are not only among the most important and impressive works of classic Modernism but also among the most valuable and susceptible.

Max Hollein Olivier Berggruen

Acknowledgments

We are greatly indebted to each and every individual for the trust they showed in us and our ambitious project. We would like to thank Doris Ammann, Thomas Ammann Fine Art Zurich, Sammlung Berggruen, SMPK Berlin, Ernst Beyeler and the Fondation Beyeler in Riehen/Basle, the estate of Gérald Cramer, Geneva, Mirjam Gelfer-Jörgensen of the Danish Museum of Decorative Art, Copenhagen, Dennis McFadden of the Davis Museum and Cultural Center, Wellesley College, Kiichiro Hayashi of the Ikeda Museum of 20th Century Art, Japan, Bernhard Mendes Bürgi of the Kunstmuseum Basel, Alessandra Carnielli of the Pierre and Maria Gaetana Matisse Foundation, New York, James T. Demetrion and Matthew Drutt of The Menil Collection in Houston, Hélène Vincent of the Musée de Grenoble, Alfred Pacquement, Isabelle Monod-Fontaine and Agnès de la Beaumelle of the Musée National d'Art Moderne at the Centre Pompidou, Paris, Glenn Lowry, John Elderfield and Gary Garrels at The Museum of Modern Art, New York, Earl Powell III and Jeffrey Weiss of The National Gallery of Art, Washington DC, Herbert Beck, Alfred Mauritz and the Städelscher Museums-Verein, Frankfurt, Rudi Fuchs and W.S. van Heusden of the Stedelijk Museum, Amsterdam, Francesco Buranelli and The Vatican Museum in Vatican City, Kazuhito Yoshii and the Yoshii Gallery in New York and all those who did not wish to be mentioned by name.

We acknowledge our deepest gratitude to the Matisse family and estate, but most especially Georges Matisse and Wanda de Guébriant and of course above all Claude and Barbara Duthuit in Paris, who supported us and advised us in many matters relating to loans and research. Their always good-natured and generous cooperation in correcting the illustrations for this publication contributed substantially to the success of the project.

We would like to thank the following for their help and for their advice: Esperanza Sobrino of Acquavella Galleries, New York, Yve-Alain Bois, Cambridge/Massachusetts, Camilla Cazalet, London, Federico Forquet, Rome, William T. Hillman, New York, David Lachenmann, Munich, Daniella Luxembourg and Simon de Pury, Geneva, Pierre Schneider, Paris, Eugene V. Thaw, Santa Fe, Patty Tang, Alice Tériade, Paris, E.V. Thaw & Co., New York, Barbara Verocchi, New York and Nancy Whyte, Nancy Whyte Fine Arts, New York.

Our warmest thanks to Michel Anthonioz, Hannes Böhringer, Rémi Labrusse, Gunda Luyken, Ingrid Pfeiffer and Margret Stuffmann for their contributions to the publication. Marget Stuffmann and Markus Brüderlin participated in the Schirn Forum001 in preparation for the exhibition.

Our particular thanks to Prestel Publishing of Munich, notably Jürgen Tesch, Victoria Salley and Meike Weber, for their unflagging professional work in preparing this publication.

Above all, we must thank the team at the Schirn Kunsthalle, Frankfurt, for their great commitment at all

stages of the project. Ingrid Pfeiffer, as a curator at the Schirn, steered the project to fruition and probably made the most substantial contribution to its realisation. We gratefully acknowledge her very professional work, extraordinary dedication and great enthusiasm, and thank Sybille Schmidt, who valiantly helped Ingrid Pfeiffer with the preparation of the publication.

Without the enthusiastic support of the Sammlung Berggruen in Berlin and especially Heinz Berggruen personally, the exhibition and this publication would not have been possible. His legendary exhibition of 1953 undoubtedly paved the way for this one.

Jazz: Rhythm and Meaning[1]

Margret Stuffmann

Neither the form nor the content of *Jazz* fit in with the normal pattern of illustrated books.[2] The large format and intensity of colours initially emphasise the autonomy of the visual representations. As we know, they were originally conceived without text, and even the order of presentation was only decided later. The pages might therefore suggest no coherent overall treatment, with at best occasionally overlapping chains of thought and associations. To some extent, they relate to biographical data of the artist, but more especially they concern thoughts of general importance. The main group deals with the subject of the circus, with the corresponding cast of clowns, acrobats, trick riders and sword-swallowers, but at the same time this is linked with a modern interpretation of mythology—Icarus (VIII) for example is the personification of the artist. In this material, Matisse draws on an old tradition where the clown and the acrobat are metaphors for the artist's life. Matisse had vivid memories of Watteau's *Gilles* and Daumier's *Saltimbanques*, indicating how—particularly in France—tradition and modernity can overlap.

The great themes of life in *Jazz* derive from biographical elements such as the recollection of a journey to the South Seas in the *Lagoons* (XVII–XIX). They include love (V, VI), death (X), fate (XVI), the dramatic relationship of man and woman (XIV, XV) or even the elements, such as fire (IV), water (XII) and air (XI).

The text, a sequence of pages written in a flowing hand with a quill and Indian ink, does not bear any discernible connection with the pictures, and the outsize lines do not make it easier to read. Yet the free linear flow of the writing has a powerful, visual effect. It constitutes a connection between the pages, and tempers the effects of proximity, the conflict between aggressive, sometimes wholly incompatible colours. The text consists of passages of rambling reflections. Though the presentation is apparently simple and casual, the subjects are serious, and the thoughts wide-ranging and detached. They concern life, the perception of heaven and earth, travelling, creating art from the conscious or unconscious mind, youth and age, folk tales and finally the question of belief in

1 Henri Matisse: "Jazz est un rhythme et une signification," conversation with André Verdet, in: *Henri Matisse. Écrits et propos sur art*, ed. by Dominique Fourcade, 1977/1992, p. 250

2 In accordance with the art-historical importance and intellectual complexity of *Jazz*, the literature on the subject is so vast, varied and excellent that it was quite impossible to discuss it completely or in detail here. For this reason, and with particular regard to the context of this exhibition, we preferred to focus on the preparatory and precipitating role of the series for Matisse's late work. The most important overall surveys of *Jazz*, with further reading: *The Paper Cut-Outs of Henri Matisse*, exhib. cat., National Gallery of Art, Washington, Detroit, St. Louis 1977/78. Riva Castleman: Introduction. In *Jazz. Henri Matisse*, New York 1983. pp. 7–12. Gottlieb Leinz: "Jazz von Henri Matisse," in: *Pantheon*, Series 44, 1986, p. 141ff. Andreas Stolzenburg: "Das Buch Jazz und der Beginn der Gouaches Découpées," in exhib. cat. Staatsgalerie, Stuttgart 1993. p. 227ff. Beatrice Lavarini: *Henri Matisse. Jazz. Ein Malerbuch als Selbstbekenntnis*. Munich 2000. Most important of all were the works containing the artist's own words: *Henri Matisse. Écrits et propos sur l'art*. Dominique Fourcade (ed.), Paris 1972/92. *Henri Matisse. On Art*, ed. Jack D. Flam, 1973/82

God. In its apparently obvious simplicity, *Jazz* is so reminiscent of children's books of the 1930s that we may wonder whether Matisse intended the similarity.[3] Supporting this view is the artist's comment shortly before his death in 1953 that one should see life and the world with the eyes of a child.

As far as the title is concerned, the first idea was *Cirque*, and the notion of *Jazz* came up only as work progressed. Familiar as Matisse was with America, and much as he appreciated the clear light, crystalline look of the architecture and vitality of the country, *Jazz* is unlikely to refer just to individual experience, and is as unlikely to be meant solely as a visual equivalent of the American music that became equally fashionable in Paris from the 1920s. The term more probably refers to a more nebulous complex of ideas, from the rhythm of modern life to a specific existential feeling, both vital and free as well as aggressive and dangerous, constantly alternating between risk and success, mischance and luck.[4]

When *Jazz* was first presented to the public in December 1947 at Pierre Bérès' bookshop in Paris, it met with great approval.[5] Its unique mix of great seriousness and vitality bordering on aggression, with its abrupt changes from major to minor, must have been very much in tune with the post-war situation, with its traumatic memories of the past and hopes of a new start. *Jazz* therefore became one of the great art books of the twentieth century—especially for the America of the 1950s and 1960s—and an established component of the popular images of our time.

From an art-historical point of view, *Jazz* seems today a concentration of design energy, affecting both the form and the concept of the sequence in equal measure. Like taking a deep breath before a performance, it appears to have been an essential prelude to the artist's late work. *Jazz* launched the last decade of his long life, the preoccupations of which were his paper cut-outs and the Chapelle du Rosaire project in Vence, as a completion of a great work and at the same time a new start pointing to the future.

When in 1943 Matisse began the preliminary studies that would lead to *Jazz*, using cut-outs for artistic purposes was no novelty to him, but till then he had used the technique solely for subordinate aspects of his artistic work, not to implement an intellectually comprehensive concept. One occasion for using cut-outs had been his works for Diaghilev and Massine's Ballets Russes in 1918/19 (Stravinsky's *Chant du Rossignol*) and 1938/39 (*Rouge et noir*, or *L'Étrange Farandole* by Shostakovich). Possibly it was the special circumstances of the theatre and the need for rapid improvisations and variations that prompted Matisse to apply the principle of bits of paper or card cut-out and

3 This applies especially to the *Babar the Elephant* children's books by Jean de Brunhoff (1899–1937), which are still popular in France and elsewhere. His *Vacances de Zéphir* for example (1936) has a comparable arrangement to *Jazz* with pages in large handwriting opposite illustrations in strong colours. Moreover, Brunhoff's name appears repeatedly in connection with the programmes of the Ballets Russes, for whom Matisse also worked. For Matisse's remarks in 1953, see: Dominique Fourcade 1992, op. cit., p. 321, and Flam 1982, op. cit., p. 261 ff
4 Matisse on New York: D. Fourcade, op. cit. 1992, pp. 107–10. Matisse on jazz as music: Flam 1982, op. cit., p. 305
5 Matisse-Rouveyre: "Correspondence établie, presentée, annotée par Hanne Finsen," Paris 2001, nos. 857–60, 863, 873

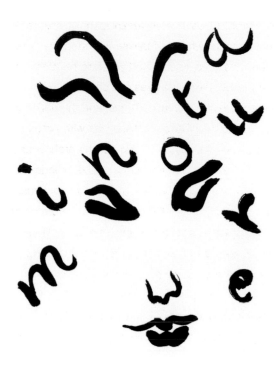

Henri Matisse, cover for
Minotaure 9, October 1936

stuck together for figures, curtains and other decorations.[6] Another occasion was the monumental wall decorations he did for Dr. A.C. Barnes's building in Merion (Pennsylvania, 1931–33), during which Matisse began to work with paper templates in order to achieve the balance he wanted in a large-scale composition in its relationship to the wall and the area around. In panel painting as well, particularly the preparatory studies for the *Nu rosé* (Baltimore), Matisse likewise resorted to the template procedure when he was endeavouring to achieve a mutual integration of body and surface.[7]

Not least, it was the world of Parisian magazines and 1930s book art that came up with the most important stimuli for *Jazz* in terms of both form and content. It would seem that the paper cut-out technique—simple, bold and typographically intelligent as it was—matched the taste of the time, as can be seen in Christian Zervos's *Cahiers d'Art*, Skira and Tériade's *Minotaure* and especially Tériade's publication *Verve*. Tériade himself would be the publisher of *Jazz*.[8] These magazines are still fascinating for the sheer variety of their articles, ranging from ethnology, art history and psychology to poetry, painting or photography. Their coverage of the contemporary intellectual and cultural world, which included a particular awareness of and debate about Surrealism, is exemplary. Their influence on Matisse was considerable.[9]

6 *Ballets Russes de Diaghilev 1909–1929*, exhib. cat. Musée des Arts Décoratifs, Paris 1939. More information on the works for the Ballets Russes in Lydia Delectorskaya: *Henri Matisse. L'apparente facilité. Peintures de 1935–1939*, Paris 1986. Matisse at the Ballet: *Le Chant du Rossignol*, exhib. cat., Israel Museum, Jerusalem 1991

7 "Henri Matisse. Entretien avec Dorothy Dudley" in D. Fourcade 1992, op. cit., p. 139ff, exhib. cat., Stuttgart 1993, op. cit., pp. 112–13

8 *Minotaure*, reprinted by Albert Skira, New York 1968. Michel Anthonioz: *L'Album Verve*, Paris 1987 and *Matisse et Tériade*, exhib. cat., Le Cateau-Cambrésis, Florence 1996/97

9 An early discussion of this subject, Kenneth Bendiner: "Matisse and Surrealism" in: *Pantheon*, vol. 50, Munich 1992. p. 134ff

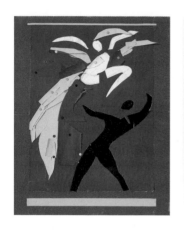

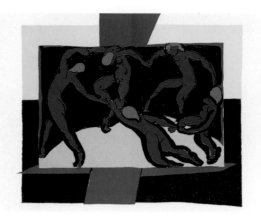

Henri Matisse,
Two Dancers 'Rouge et Noir'
(Deux Danseurs 'Rouge et Noir'),
1937/38, cut-out on paper,
graphite, drawing pins,
80.5 x 64.5 cm, MNAM/CCI
Centre Pompidou Paris

Henri Matisse, *The Dance*
(La Danse), in *Verve* 4,
November 1938, pp. 52–53

From 1935, the artist was involved in the production of individual issues. In 1936, he designed a cover for *Minotaur* in the Chinese manner (see p. 25), a fluid shorthand-style drawing done in ink, which he later used for the frontispiece and contents page of *Jazz*.

Though the cover of the first number of *Verve* 1937 was done as lithography, in its combination of pure colour surfaces, letters and cut-out strips it should be considered a directly preliminary to *Clown* and *Cirque*, the first two sheets of *Jazz*. Issue no. 4 of *Verve* (December 1938) documents a decisive moment in treating paper cut-outs as a logical development on the road to abstraction. Though it contains a colour reproduction of Matisse's famous painting *Dance* (1909/10, St Petersburg, see p. 110), in its unconventional framing with underlaid, irregularly displaced colour surfaces it anticipates the way he would handle the pages of *Jazz*. This new 'composition' is flanked by two linocuts, whose white figures look at first glance like ornaments. But their titles, *Lancé* and *Retenu*, indicate positions from ice-skating or ballet, and the gestures directly recall the sweeping shapes of paper cut-outs dancing figures that Matisse produced in 1937/38 in connection with *Rouge et noir*. Here the step from an object-based pictorial idea to a *signe*, as Matisse understood it, becomes quite clear.[10]

In a different creative direction but still looking forward to *Jazz* is the double-page cover for *Verve* conceived in August 1939 but only published in summer 1940. Matisse himself called it a *Symphonie chromatique*.[11] Just as, in his paintings of this time, he conferred particular importance on the colour black as an intensification of colours, here he worked with brightly coloured shapes on a black background, Lavishly printed with 26 successive printing plates, the

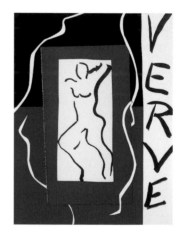

Henri Matisse, cover for *Verve* 1,
December 1937

10 D. Fourcade 1992, op. cit.,
pp. 171, 204, 361
11 Letter from Matisse to Tériade,
February 1940, in *Matisse et Tériade*,
1996/97, p. 62

Henri Matisse, *La Lancé*,
in *Verve* 4, November 1938

cover achieves an extraordinary effect, with letters and heart-shapes flying, floating and whirling in an a dark, undefined space. In the movement of colour, the cut-out colour shading suggests the effect of light.

Verve no. 13, published in April 1945, is worth mentioning because from a design point of view its double-page cover and frontispiece are closely linked with the *Tobogan*, *Cirque* (Circus) and *Icarus* pictures in *Jazz*. The same applies to the content called *De la Couleur*. Most pages place linear colour schemes in black and white opposite one of the paintings with strong coloration. A similar, even more systematic confrontation of colour and line occurs in *Verve* no. 11–22 of autumn 1948, containing a review of Matisse's work since 1944. Astonishingly, in both issues the same balance that would characterise the successful combination of written pages and pictures in *Jazz* shortly after is generated by the contrasts here, mainly because of the subtlety of layout and proportion.

Clear though the connection is between the activities of Matisse intended for the public and the origination of *Jazz*, his artistic work in private is just as informative. The precarious state of his health after a life-threatening operation in January 1941 with its lengthy aftermath, but also the effects of World War II with the partial occupation of France by the Germans and the family problems caused thereby, explain why Matisse spent these years almost entirely in Nice and Vence. Although he painted whenever his health allowed, his main interest at the time was working on and with paper, and his thoughts were more focused than ever on the mutual relationship between drawing and painting. His serial

Henri Matisse, *Chromatic Symphony*
(Symphonie chromatique), in *Verve* 8,
June 1940, p. 8

Cover of *Verve* 13, November 1945

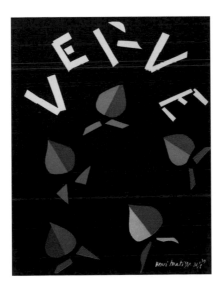
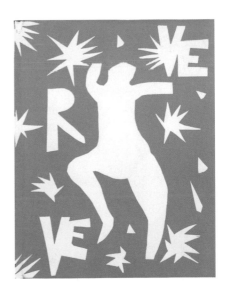

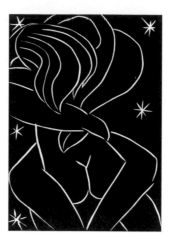

drawings of a very few subjects, particularly nudes and still lifes, which he published in 1943 as an album called *Thèmes et variations* with a text by Louis Aragon, are an important result of this period.[12] Despite the diversity of external appearance, these drawings are also of particular importance as preliminaries to *Jazz*. Their systematic restriction to pure line and the consequent neutralisation of materiality or flattening out of physical depth is part of a process of abstraction. But at the same time Matisse, who spent his sleepless nights reading and drawing, was also thinking about the possibility of illustrated books and folders of the kind that were popular in Paris around 1900, particularly following the initiative of Ambroise Vollard.

In connection with *Jazz*, it should be remembered that the focus of Matisse's interest was never in illustration in the traditional sense nor in working up complex narrative material. What interested him chiefly was poetry and the possibility of correspondences in design. With his light-filled outline etchings for poems by Stéphane Mallarmé, he had done all the preparatory work for the forthcoming major seamless transition from ornamentation to three-dimensional form and vice versa back in 1932.[13] Between 1941 and 1944, i.e. shortly before and contemporarily with *Jazz*, he produced illustrations for Henri de Montherlant's *Chants de Minos*. *Pasiphaé* (appeared 1944) and *Florilège des amours* by Pierre de Ronsard (1524–85), which was not published until 1948.[14] Of direct interest for the principle of cut-outs is the former, a rare and consequently less-known book of high artistic quality. Its subject matter—the fierce passion of Minoan princess Pasiphae for a white bull and the subsequent birth of the Minotaur—demanded a nocturnal scene. Instead of the customary etching or

Henri Matisse, illustration in Pierre de Ronsard, *Florilège des amours*, Paris 1948

12 Flam: "Matisse. Dessins: Thèmes et Variations. Ein Buch und eine Methode," in cat. Stuttgart 1993, p. 103ff. Flam 1982, op. cit. p. 171ff
13 Claude Duthuit et al.: *Henri Matisse. Les ouvrages illustrés*, Paris 1988, no. 5: Stéphane Mallarmé: *Poésie avec des eaux-fortes*, Lausanne 1932
14 Claude Duthuit 1988, op. cit., no. 10: Henry de Montherlant: "Pasiphaé, Chants de Minos. Avec des gravures originales de Henri Matisse," Paris 1944, no. 25: Ronsard: *Florilège des Amours*, Paris 1948

lithograph, Matisse therefore opted for the technique of linocut, which he had been working at since 1938. In this way, he reversed the traditional relationship of black lines on a dark ground, achieving a kind of moonshine effect. In contrast to lithography and etching, which permit smooth drawing and light hatching, Matisse developed a rather rough linear idiom, controlling the resistance of the material with the gouge. It combines the arabesque character of his drawing with the effect of physical volume, producing pictures of individual poetry and vitality. In my view, this concept of cutting as gesture, the calculation of reliefs it involved and the mastery of light values prove Matisse to be a graphic artist, sculptor and painter in equal measure. His use of the gouging technique here—around the same time as the paper cut-outs of *Jazz*—along with the black and white coloration plus just a touch of red in the typography and the plain blue cover with a figurative title, suggest *Pasiphaé* was the beginning of a development that would eventually lead to the late blue nudes of 1952 (cat. 62) We get the impression that Matisse integrated the above described 'linear idiom', with its relationship with the coloured surface, directly into the technique of cutting coloured surfaces.

Florilège des amours is wholly different from *Pasiphaé* even though it dates from around the same time, manifesting an undisguised sensuality engendered by a bold but flowing line on a light background. It can thus been seen as a counterfoil to *Jazz*. The two books may seem to demonstrate inconsistency of concept, but nonetheless they both display an artistic balance between the drama of colour and the linearity of a fluent hand. This is what Matisse took to perfection in *Jazz*. He himself drew attention to the importance of the synthesis for his later work at the Chapelle du Rosaire in Vence, where black and white walls contrast with coloured glass windows.[15]

These different routes to *Jazz*, which appear more ramified than they really are, reveal Matisse's unusual capacity to work conceptually on a large as well as a small scale. He could employ a wide variety of media to make use of both harmonious and stark forms in rapid alternation, time and again drawing on his own previous experiences and achievements as he did so. The process of cutting into paper, surfaces, colours and spaces enabled him to enter the three dimensional, as is appropriate to a sculptor.[16] These qualities are revealed in exemplary fashion in the paper cut-outs for *Jazz*. In the intelligence of the design, their detail is eloquent of an exciting sense of an unerring artistic purpose as well as the risks of the process—notably in the use of coloured paper overlays and underlays to achieve both positive and negative effects, along with delicacy

15 Henri Matisse, Marie Alain Couturier, L. B. Rayssiguier: *La Chapelle de Vence. Journal d'une création*, Paris 1993. p. 14

16 Fourcade, op. cit. 1992, pp. 250–51. Flam 1982, op. cit., pp. 259–260. Fourcade 1992, op. cit., p. 237: "Découper à vif dans la couleur me rappelle la taille directe des sculpteurs. Le livre a été connu dans cet esprit."

of shape. It is both an expression of compositional imagination and the result of out-of-the-ordinary manual dexterity, combined with a marked feeling for different materials. But Matisse also reveals himself here as one of a generation of artists in which the received notion of the genesis of paintings was amended by the *papiers collés* of Cubism and the collages of Dada and Surrealism to a concept of layers of pure colour and material structures. In this context, his own technique should be seen as a kind of purposeful montage.

How greatly the process of creating a work of art and the technique concerned were seen as conscious acts and part of the interpretation thereof is also evident from the photos that Tériade printed in *Minotaure* illustrating the virtual metamorphosis that some of Matisse's paintings underwent.[17] Matisse himself presented his assistant Lydia Delectorskaya with an album containing various series of this kind.

Though Matisse's work is to a high degree to be interpreted on its own terms, there were external influences in the case of *Jazz* that obviously contributed to its formal structure. For example, a glance at the pages of *Minotaure* or *Verve* indicates that photography was a vital constituent of the wide range of artistic subjects they covered, and should be investigated for what it can add to understanding the work of Matisse. Chiefly this means the photos of Brassaï (1899–1984), which reveal more parallels with formal features of *Jazz* than can be due to coincidence. Matisse and Brassaï had become personally acquainted by 1935 at the latest, and the celebrated portraits of the painter came from the Hungarian's camera. Brassaï is particularly notable for his photos of nocturnal scenes and artificial light, and for his keen eye for unusual or mysterious aspects of everyday life.[18] His *Pilier de métro parisien* and *L'Homme qui perd son ombre* of 1938, both reproduced in *Minotaure*, show amazing silhouettes that immediately recall pages from *Jazz* such as *Monsieur Loyal* (III) and *Le Destin* (XIV). Brassaï's *Ciel postiche*, a landscape created by two horizontally prone female nudes seen from the front and rear, and Matisse's *Formes* (IX) appear to be comparable, though in a more complex way. The relationship is evident in the rhythm of the parallel silhouettes and the transformation of materiality by using positive-negative effects—a technique of ambivalence mentioned earlier in connection with contemporary nude drawings by Matisse. Another aspect of Brassaï's photographic style is the interaction of space, light and movement, as for example in the photos of the Cirque Medrano taken in 1932, which Matisse also went to. In these, our eye is steered towards the long view, the net or patterned carpet in the distant arena, comparably with *The Codomas* (XI), the picture of

17 E. Tériade: "Constance du Fauvisme," pp. 1–9, in: *Minotaure* 1936, no. 9
18 Brassaï retrospective, exhib. cat. Centre Pompidou, Paris 2000. Figs. pp. 102, 103, 104, 106, 162. *L'Homme qui perd son ombre*, in *Minotaure*, May 1938, p. 64

 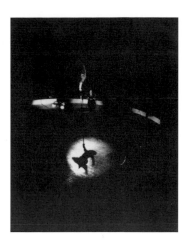

Brassaï, *Pillar in the Paris Under-ground* (Pilier de métro parisien), in *Minotaure* no. 7, June 1935

Brassaï, *Shadow ombre* (L'Homme qui perd son ombre), in *Minotaure* no. 11, spring 1939

Brassaï, *Artificial Sky* (Ciel postiche), in *Minotaure* no. 6, winter 1936

Brassaï, *Tightrope Walker at the Circus Médrano* (Équilibriste Cirque Médrano), 1932

the trapeze artist in *Jazz*. And the shadow of the artiste with the stocky shape and rope against the beam of light corresponds directly to *The Cowboy* in plate XIV. The motif of the lights in the background of *Monsieur Loyal* (III) like-wise recurs, though the alternation of two tones of yellow suggests not just the multiple perception of gold buttons on uniforms but also the effect of flashing lights. But this is not a matter of simply borrowing various details. What is involved is a remarkable but understandable affinity of vision—related takes on the visible world. It appears plausible—and an accepted feature of the long tradition of cut-outs—that an artist who is the process of exploring the principle of cut-outs should understand silhouettes as a mirror world, present as a shape but not physically, and take them as subject matter.

In the sequence of individual pictures in *Jazz*, one increasingly notices re-current cut-out, free-floating shapes—wavy lines, zigzags, leaves, rhomboids, dots. Initially they allow associations with specific objects such as curtains, lamps, flowers, trees and stars, but they soon take on an autonomous character and become independent design features dependent on their colour, proportion and position within the picture. They synchronise depth and surface values, rhythmicise and intensify actions or represent the given subject itself. A compar-able development occurs in the Ronsard book *Florilège des amours*, begun in 1941. Here too individual shapes and fragments become independent, acquire ornamental character and gain an ambivalence that admits new associations and analogies. Right from the first, Matisse had displayed a particular feeling for ornament and included it in his deliberations when designing pictures. The constant recurrence of the vocabulary of arabesques as a freely extensible

 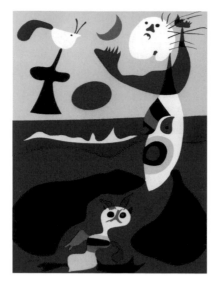

abstract form that can also carry meaning provides the key here. It opens the way to a new understanding of the ambivalence in the drawings of Matisse, and in this context his term *signe* is charged with subjective experience and emotion, even though it relates to visual matter. In *Jazz* this idea of the *signe* freezes narrative as dynamic action, arrests time in the sense of passing time and reinterprets physical movement as gesture. In their place come an impression of timelessness and individual imagery. *Rhythme et signification* are the striking terms with which Matisse described his sequence. An approach of this kind, which looks on ambivalence as an extension of the capacity of perception, opens the way to new possibilities of ornamentation and arabesques. In *Jazz*, this applies in particular to the three sheets of the *Lagoons* (XVII–XIX), which stand for the chosen subject (the South Seas) as pure forms.

Despite his unique power of imagination, Matisse always started from the experience of reality, and was unable to work up enthusiasm for the objectives of contemporary Surrealism, clearly distancing himself from it. Nonetheless, through friends and acquaintances such as Tériade, Aragon, Masson or Breton, and of course also through periodicals such as *Minotaure* and *Verve* as the theatre of current debate, he must at least have been fully aware of what was going on in Surrealism and the chief works it was producing.

A further look at the pages of the two magazines reveals—and moreover in close proximity to Brassaï's photos and works by Matisse—*inter alia* reproductions of works by by Arp, Miró and Kandinsky where shapes are clearly bio-

Hans Arp, *Papier décloré et interprété*, *Minotaure* no. 11, spring 1938

Joan Miró, *Summer*, lithograph, in *Verve* 3, summer 1938

Wassily Kandinsky, *Stars*, lithograph, in *Verve* 2, spring 1938

morphous in character. Even though this may at first be just a matter of external appearance, the enhanced status of ornamentation or arabesques within *Jazz* involved a related process and was an important starting point for the process of abstraction that produced the paper cut-outs. It looks as if Surrealism exercised a kind of catalyst effect on Matisse at this date.

In Miró it was the brightly coloured, uninterrupted colours that look almost naïve in combination with the quasi-cutout shapes that must have struck a chord. In Arp, it was the calculated introduction of happenstance into the combination of torn paper and forms. In Kandinsky, the open-ended, undulating margin zones with their subtle positive-negative effects and particularly their turquoise and white coloration, are echoed in two great works Matisse did in 1946, viz. *Polynésie, le ciel* and *Polynésie, la mer*.

Thus the revaluation of ornamentation or arabesques particularly within *Jazz* appears to have been a vital preliminary to the subsequent paper cut-outs. Notably their compression of shape, absolute colour and liberated three-dimensionality make them metaphors of the view of nature—sensory and spiritual in equal parts—that made up Matisse's late work.

JAZZ was published by the Greek-born publisher Tériade in book form in 1947, with some unbound copies.
Format: fol. in quarto; 42.2 x 32.5 cm/16.6" x 12.8"
Scope: 146 pp, with following table of contents.
Of these, 15 double-page spreads and five half-pages were in colour, with texts opposite. 68 pages of text overall.
The colour pages were printed as stencils (*pochoirs*) based on the cut-outs (*gouaches découpées*) provided by Matisse. For these, the same colours were used as Matisse employed to coat his sheets of paper before he cut them up. The *gouaches découpées* for *Jazz* are now at the Département des Arts Graphiques at the Musée National d'Art Moderne, Centre Georges Pompidou, Paris.
The titles of the individual sheets, together with supplementary explanations by Lydia Delectorskaya, in English translation are:[19]
The Clown (I); The Circus (II); Monsieur Loyal (III, a well-known Parisian circus director in the nineteenth century). His profile suggests that this was an allusion to General de Gaulle, i.e. contemporary history; The Nightmare of the White Elephant (IV); The Horse, Rider and Clown (V); The Wolf (VI, i.e. the wolf from *Red Riding Hood*, the fairy tale by Charles Perrault. It is also an allusion to Hitler, i.e. contemporary history.); The Heart (VII); Icarus (VIII); Forms (IX); Pierrot's Funeral (X); The Codomas (XI, two famous trapeze artists); The Swimmer in the Tank (XII, a memory of a performance Matisse saw in the aquarium of the Folies-Bergère); The Sword Swallower (XIII); The Cowboy (XIV); The Knife Thrower (XV); Destiny (XVI); Lagoons (XVII–XIX); Toboggan (XX, Slide)

My colleagues Ulrike Goeschen and Jutta Schütt were of particular help in the preparation of this article with their critical and helpful comments. My sincere thanks to them both.

19 Stolzenburg, op. cit., note 29

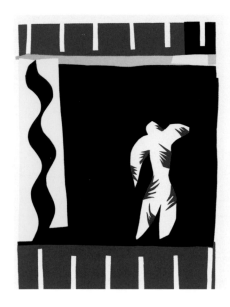

Henri Matisse

Jazz

Tériade éditeur

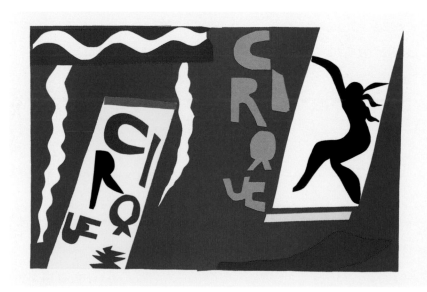

1 **The Clown (I)** Le Clown (I) 1943
2 **The Circus (II)** Le Cirque (II) 1943

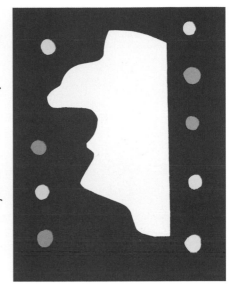

Ces pages ne
servent donc
que d'accompa-
gnement à
mes couleurs,
Comme des
asters aident
dans la compo-
sition d'un
bouquet de

18

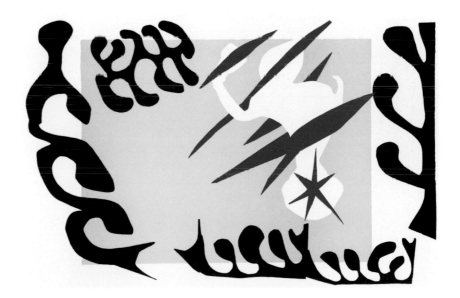

3 Monsieur Loyal (III) 1943
4 The Nightmare of the White Elephant (IV)
 Le Chauchemar de l'éléphant blanc (IV) 1943

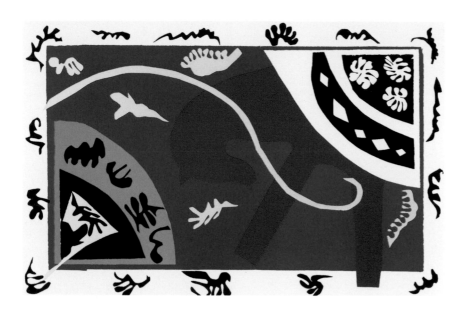

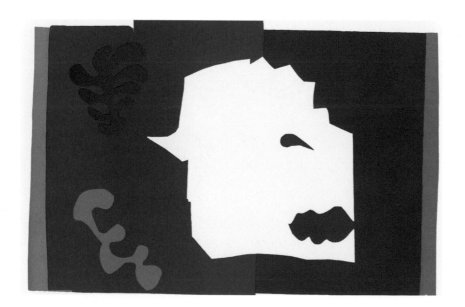

5 **The Horse, Rider and Clown (V)** Le Cheval, l'écuyère et le clown (V) 1943
6 **The Wolf (VI)** Le Loup (VI) 1944

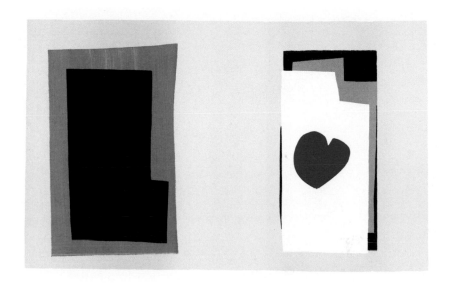

un moment
d'libres.
Ne devrait-on
pas faire ac.
complir un
grand voyage
en avion aux
jeunes gens
ayant terminé
leurs études.

54

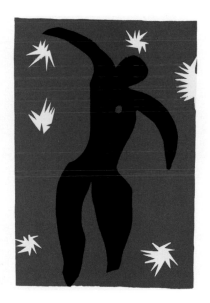

7 **The Heart (VII)** Le Coeur (VII) 1943/44
8 **Icarus (VIII)** Icare (VIII) 1943

9 **Forms (IX)** Formes (IX) 1943/44
10 **Pierrot's Funeral (X)** L'Enterrement de Pierrot (X) 1943

11 **The Codomas (XI)** Les Codomas (XI) 1944
12 **The Swimmer in the Tank (XII)** La Nageuse dans l'aquarium (XII) 1944

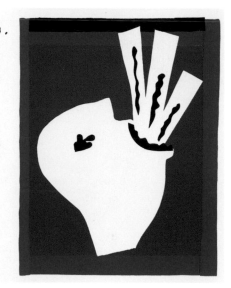

l'esprit humain.
l'artiste doit
apporter toute
son énergie,
sa sincérité
et la modestie
la plus grande
pour écarter
pendant son
travail les
vieux clichés

90

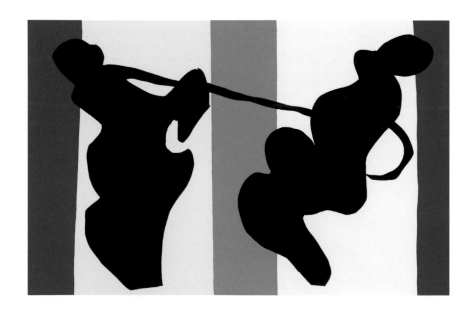

13 **The Sword Swallower (XIII)** L'Avaleur de sabres (XIII) 1943/44
14 **The Cowboy (XIV)** Le Cow-Boy (XIV) 1943/44

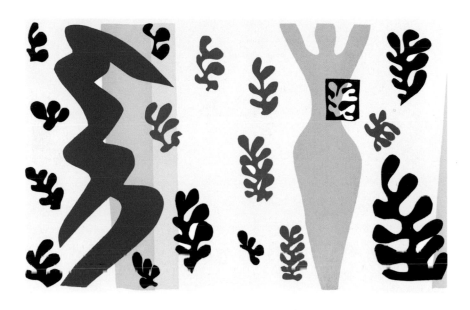

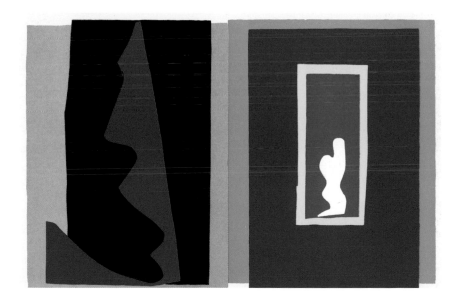

15 **The Knife Thrower (XV)** Le Lanceur de couteaux (XV) 1943/44
16 **Destiny (XIV)** Le Destin (XIV) 1943/44

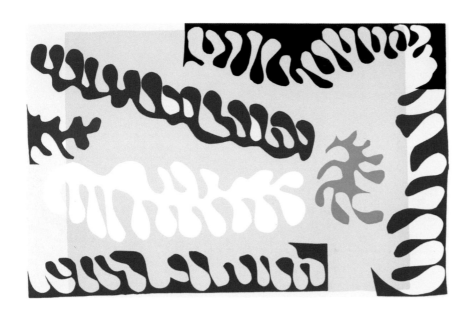

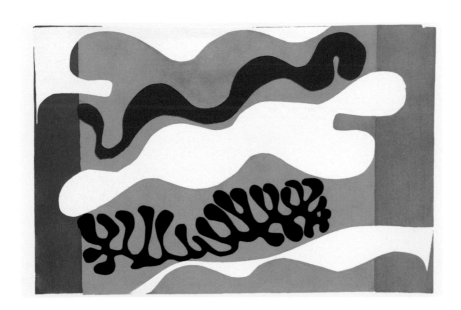

17 **Lagoons (XVII)** Le Lagon (XVII) 1944
18 **Lagoons (XVIII)** Le Lagon (XVIII) 1944

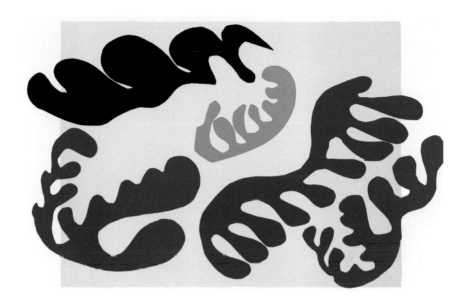

de contes
populaires
ou de voyage,
J'ai fait ces
pages d'écri-
tures pour
apaiser les
réactions,
simultanées

142

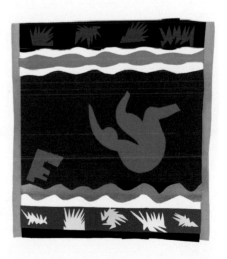

19 **Lagoons (XIX)** Le Lagon (XIX) 1944
20 **Toboggan (XX)** Le Tobogan (XX) 1943

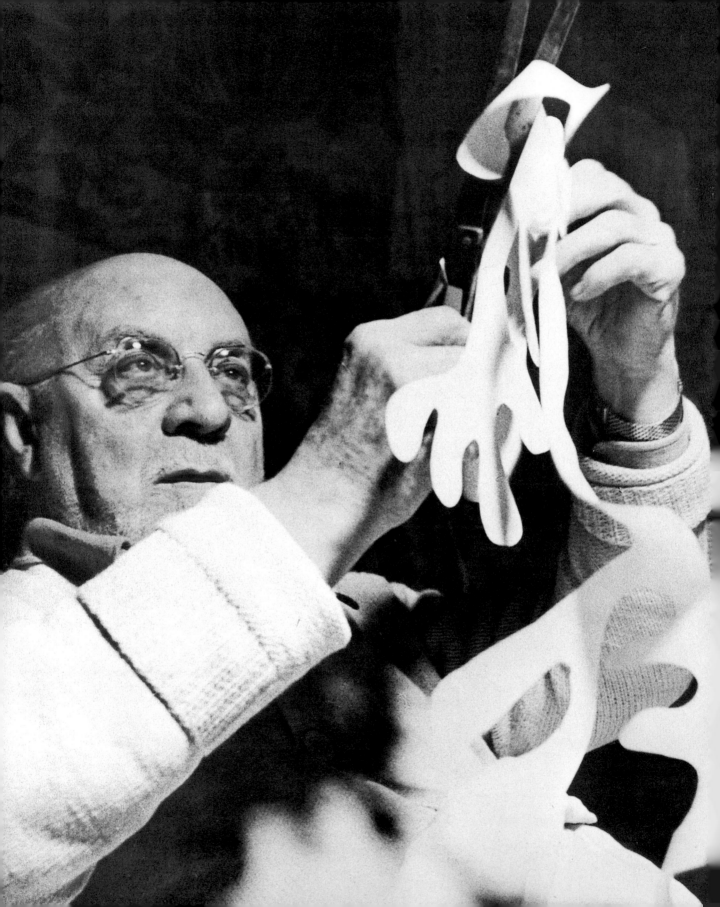

Painting with Scissors:
Jazz and *Verve*

Michel Anthonioz

Painting with scissors, drawing with paint.

Henri Matisse's invention of gouache cut-outs undoubtedly gave rise to three of his masterpieces from an art-historical viewpoint—his work on the Barnes building in Merion (Pa.), the *Jazz* album created at the prompting of his Parisian publisher Tériade and the Dominican Rosary Chapel in Vence.

Matisse first used the technique of cutting painted papers, his 'threepenny toys' as he called them, in 1920 for his costume designs for Diaghilev's ballet 'Le Chant du Rossignol'. But it was not until 1930 that he realised that his cut-outs could bridge the gap between his paintings and drawings, between colour and line. Particularly while he was working on *Jazz*, he became aware that he could use the technique to further develop the great interest of his life and work—light.

It is not irrelevant that the art of cut-outs developed in two key traditional fields of French painting—wall decoration and book illustration. With his cut-outs made of painted paper Matisse thus discovered the essence of the beginnings of French painting—Tériade never tired of saying that the latter developed in close harmony with man himself. There was the immediate environment to paint—walls to beautify in a house, church or chateau—and then there were the books: books of hours, prayer books.

The collective and the private. Togetherness and solitude. Though bedridden, Matisse nonetheless succeeded in furthering his massive œuvre in both areas, thanks to his willpower and genius.

In my consideration of Matisse, I should like to look closely at the subject I am most familiar with—Matisse's collaboration with Tériade, the result of which would be *Jazz* and several works for *Verve*, the periodical founded and published by Tériade and Angèle Lamotte.

The collaboration between Matisse and Tériade went back a long way, to a book of Mallarmé poetry illustrated by Matisse and published in 1932 by Albert Skira.

It seems to me important to note that Tériade included a cut-out by Matisse in the very first issue of *Verve*. The masterly cover of this first issue appeared in December 1937. Made from gouache-coated cut-outs, it was preceded by detailed correspondence between the two men, which merits a separate publication of its own one day. Apart from the correspondence, numerous conversations between Matisse and Tériade are documented.

In April 1972 I had the good fortune to be able to speak to Tériade in person at the Villa Natache. During the conversation, I jotted down some of his statements and reflections, most of which I have since published in *Album Verve*.[1]

Tériade wanted to commission an illustrated book from Matisse on the subject of circuses back in 1938. Why this subject? In fact it was a very productive seam for him, because he had already published circus-related works by Chagall, Léger, Rouault, Miró and others. On 14 December, 1938, Tériade turned down Matisse's offer of his *Pasiphaé* for publication. He wrote to Matisse: "I must apologise for not replying to you sooner in connection with the publication of *Pasiphaé*. Unfortunately it will scarcely be possible for me to find time for this book…, dealing with *Verve* is keeping me too busy to start anything else … I should like to discuss several projects with you."

The 'projects' concerned were *Verve* itself and the circus idea, which Tériade would stubbornly persist with.

During the war years, both of them constantly returned to the subject.

On 10 June, 1941, Tériade wrote to Matisse from Souillac:

"Now there is nothing to stop me devoting myself to my 'hobby-horse'— *your* book about colour. The cover, comprising twenty-six plates[2] is coming along so well that one can easily imagine the result of this process in even colour tones with no shading. What a demonstration! My old idea of a modern 'illuminated manuscript' still keeps me awake at nights. It has never been done yet. It's just the sort of thing we can do now. And it would be wonderful, because just now, when everything is becoming harder, it seems to me to be the right time to do the most difficult things. Paper is scarcely to be had and is of poor quality. There's only the best Arche paper.[3] A year ago, when we thought that we could only save what we could carry, I took the booklet with me with the samples of the La Flèche inks from which you had personally cut pages. And I now think less reverently you can find lovely colours. The Colour of Henri Matisse, the Book of Colour by Henri Matisse, what a wonderful special edition for *Verve*! Double-page or single-page collages of every colour in the world… This would

1 Apart from these conversations, I should also like to acknowledge testimony from Pierre Schneider, Jean Leymarie, Jack Flamm, Pierre Courthion, Dominique Fourcade and others. In addition, I was able to draw on the published correspondence and unpublished letters in the Matisse archives that I was able to see thanks to the kind offices of Claude Duthuit and Wanda de Guébriant. In this connection I should like to thank Alice Tériade for her generosity in consulting me when she was looking through her father's work.
2 *Verve* no. 8, 'Symphonie chromatique', original cover by Henri Matisse, 1940
3 Matisse preferred to use white hand-made paper with watermarks from the Arche company.

in no way exclude the publication of your most recent drawings. I haven't forgotten the *Conversations* by Gide, which could likewise be included in the edition. In short, I'm dreaming of a *livre fleur.*

Initially Matisse rejected Tériade's request on the grounds of age and lack of time. Despite this, Tériade's idea was soon to be realised.

On 11 July, Matisse wrote to Tériade: "I have decided to write a letter to you about the plates made from collages with printer's ink; I need coloured sheets."

However, it would take until 27 October, 1943 before Matisse finally wrote: "I have completed one plate—the rider and the clown. But the cut is so tricky that it probably can't be carried out. Certainly you can do finer work with a woodcut."

On 4 July, 1944, amidst endless explanations of his lack of time and the sufferings of his family, Matisse asked Tériade for paper, and the work 'jazz' cropped up. Matisse asked: "How do you spell 'jazz'?" And it is clear from the second 'z' that he hesitated while writing.

On 13 April, 1946, he finally returned to the vital subject of the Linel colours[4] he had used to paint the sheets that he 'cut out of colour': "What you did with Linel. No dirty primary colours. It's absolutely imperative you look for whatever it takes for the grey-violet. Without it there won't be any *Jazz.*"

For his part, Tériade sought to encourage him, and proved just as stubborn. Even if it is not possible to match letters and replies in every case, Tériade's enthusiasm for *Jazz* shines out from this correspondence. One of those wonderful bonds developed between painter and publisher that account for so many a masterpiece. Having had the good fortune to get to know Tériade more closely, I would even venture to claim that that his contribution to *Jazz* was that of a creator. Though Matisse was incontestably the originator as painter, calligrapher and writer, one can nevertheless say that Tériade acted as a kind of co-author in this masterpiece.

Tériade's letters from 1941–43 prove this. Below I should like to quote some excerpts from them dating from the time when Tériade was preparing issue 13 of *Verve*, published in April 1945 and called *On Colour.* Two cover designs for this issue are known, one multi-coloured, the other (the one Matisse finally opted for) in green. This special issue contains the first publication of the *Fall of Icarus*, the peculiar bird-man who plunged from the sky after going too close to the sun and whose vermilion-coloured heart seems to positively explode. With the death of Angèle Lamotte, Tériade's life took a tragic turn, but he

4 Matisse exclusively used gouache paints made by the Linel company, preferring to apply them as pure, unmixed colours.

nonetheless went on working indefatigably even in the war years, meantime helping out his artist friends both intellectually and practically, which included providing food parcels.

He wrote from Souillac, his refuge in the unoccupied zone, on 22 June, 1941: "These colour reproductions in even colour tones with no shading have opened up new horizons for me. In four-colour printing you can only control everything at a distance. Every correction means changing the whole thing, and because of all the compromises the result is always just a relative one. In the case of even colour tones with no shading you can do the corrections directly on the machine by changing the amount of ink or adding a touch of colour. It's comparable to a certain extent with colour lithography, except that the possibilities are greater in respect of intensity and openness.

"The visual representations you can reproduce in this way would come very close to the original. Knowing full well that it is easy simply to imagine this, I have variations of a main colour in mind, and so that the demonstration should not be too abstract, I have particularly large visual representations in mind that can bring out the relationships between the drawing and the colour (you recently spoke to me about this in connection with your picture *La Musique*).

The Dancer, which seemed to me an example, was a 'collage' for your Monte-Carlo ballet that you showed me in your Paris studio (a blue surface with a small black figure, I believe)."

And on 14 July, 1941, Tériade wrote again: "This 'number book' by you about colour is an idea that I can't get out of my mind, and I'm sure that doing it will be such a wonderful success that I can't give it up, which is why I'd like you to go on with these experiments.

But as waiting throws me into a panic and I'm afraid you might start work on other projects, can I implore you to use *all the tempera colours* you can imagine that Madame Lydia can make for you. I guarantee you that when we print it, we shall get *exactly your* colour.

If we print in even tones with no shading, we have nothing to be afraid of, we shall succeed in finding the perfect tone, as each colour is printed separately. So you do not need to worry. If Madame Lydia would do us the favour of making you the coloured papers you want, then you can be sure that they will differ less in printing than the sample on Flèche special paper compared with printing on the actual production paper."

Two years later Tériade went to Paris to have a close look at the first printing pulls. *Jazz* was on its way.

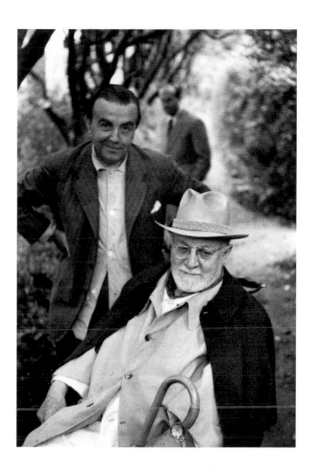

Henri Matisse and
the publisher Tériade
(standing)

"I had to go to Paris to meet the printers about *Jazz*. I wanted to deliver two plates to them personally and explain what you wanted. They are aware of the importance of the book, and I believe they will do everything humanly possible to make it perfect. They are starting with proofs of engravings. But since printers' inks are greasy, they cannot get the exact quality of gouaches. My printers are looking for ways to render the original colours exactly, and have even considered printing with inks specially made by Linel. If this should work out, everything will be perfect. Though it may be quite difficult, I think we shall get there."

Unfortunately Matisse was disappointed with the quality of reproduction. What came back did not seem to be the colours he had selected. It was touch and go with the project. What was then known as 'Cirque' and was later published as *Jazz* was in danger of never becoming reality due to Matisse's very high expectations of reproduction quality.

On 29 December, 1943, Matisse wrote to Tériade from Vence—the latter was still in Souillac at the time. The letter is a great importance because Matisse

put his doubts on paper for one last time before the two men agreed on a stencil plate approach, which allowed the original Linel colours to be used.

"I have just received the folder from Chêne with sixteen reproductions of my pictures. It has not changed my opinion about this method of reproduction, which you are well aware of. I will say it again. Four or three-colour printing can only given an approximate idea of things, in the way photography also does to a certain extent. The colours very often lack intensity, and the brightness of many of the original colours is lost. Because of the need to make something accessible to a public that has only a vague and superficial notion of artists, particularly in the face of something new, where admiration is thus basically a matter of snobbery and therewith incomprehension, retouchers think it is absolutely essential to emphasise colours that don't reproduce well so they are as bright as in the original. The reproduction is then nothing to do with the original. The artist who made the picture comes away with the impression that his picture has been destroyed, and he loses every hope of it being understood by means of this approximate reproduction.

Someone said to me: 'Obviously it isn't that, it's something else.' So what is it? A different combination of colours? No, it's nothing to do with that. I've chosen a combination of colours such as you get in countless number if you shake a kaleidoscope for a few minutes—completely random colour combinations that amaze for a few seconds but then soon disappear again because the eye has seen enough of them and they leave the mind completely unaffected. Accordingly, it involves something that has nothing whatsoever to do with the picture one wants to reproduce.

These are the rather depressing thoughts that go through my mind during all this.

I'm thinking of our book, about the 'Circus', and remember how many times I poured cold water on your enthusiasm and finally agreed only for the sake of peace and quiet. I didn't think the thing through.

I very much fear we shall not come to any really satisfactory outcome —not with regard to various trivialities, but in respect of the more profound meaning of things that confers inner necessity on creative work. Obviously things always come out more or less differently from what I imagine and they therefore turn into lies that ought not to find their way into the public's consciousness. I lose the originals and what do I get in the end? Books you make money with, money you could make just as easily on the black market or with weapons.

To show you exactly what I mean and prove that I am not trying to split hairs, I should like to ask you to remember that, despite its inadequacies, I don't feel as betrayed by three-colour printing, because even if it does not render visible what I did, it nonetheless expresses my mind and shows what I want to say. The outstanding quality of an orator is not lost if his speech is reproduced in a deep voice, because even if the ear would prefer to hear the baritone of his metallic voice, the mind loses nothing by the inadequate reproduction."

Matisse's cut-outs might well have remained originals if Tériade had not persisted with the book. Three weeks later he wrote in answer to Matisse's letter: "I'm very worried about the Matisse number, which ought to be just the tribute for you I imagined. There is no comparison between what will appear and our proofs, which consist of five to nine new colours and which the *patron* makes himself. He has been working exclusively on this since this summer and is not responsible for the proofs of the other book. Taking your comments into account, we shall get a good result. You'll remember that at first you attached importance to the freshness and value of your tube colours, so that we concentrated mainly on this aspect in our work. I can appreciate your present thinking on the emphasised and interpreted colours. With our colours we have a different problem, because we must try to rid them of their black outline. In this case, this means cleaning all the colours evenly and automatically at the same time without adding any emphasis so that the relationship between the colours remains the same as those in photography. You are against the whole process, and you know better than I do that there will always be a huge difference between reproductions and pictures. As far as anyone can judge, there's nothing we can do about that. We can only ask the technicians to do a decent job and get as close as possible without interpreting it in any way. So on the one hand there is the process, which can do what it can do, and on the other hand there is the intervention of the craftsman, who in our case does quite excellent work but who is constrained by the process itself. If you are of the view that reproductions of your pictures which are of necessity always only relatively accurate harm your work *excessively*, then you know very well that, despite the 200,000 francs I have already invested in the work, I shan't in any event press you to go against your feelings. I can only promise you that I shall do everything to ensure the work is carried out as conscientiously and as well as possible and there is no-one who could do it better."

Matisse went at it. From now on, plates had names: *Mimi Cassecou, Joseph Cassetout, Receveuse de Couteaux*, etc.

As Tériade wished, Matisse created a real circus with his scissors.

On 21 October, 1947, Matisse finally wrote to Tériade from Vence: "Dear friend Tériade, have you received the cover for the *Jazz* album?" And a little further down in the same letter he notes: "If you bring or send me the pages for *Jazz* to sign, could you bring a complete copy of *Jazz* in the portfolio at the same time or send it to me. *I must see what I am signing*."

There followed preparation for the exhibition poster for Paris and Rio, on which Matisse worked with the greatest of care.

The publication of *Jazz* was a huge overnight success. Théo Schmied's templates were very convincing. The brightness of the colours was impeccable because Matisse created his coloured cut-outs directly from painted colour paper. The intensity of the pictures in the book comes very close to the originals in the cut-outs. With Pierre Linel's assistance, the challenge had been successfully overcome.

In a letter to his friend and long-standing confidant André Rouveyre, Matisse wrote: "The colours of the reproductions are the same as those in the originals, and their relationships display the same energy and harmony. The relationships are new, and the drawing also recurs in it. Anyone who has not seen the originals will get an impression of the essentials from the book!"[5]

This revelation, which goes back to the collaboration with Tériade and which Matisse owed to Tériade, would not be without consequence. It also formed the basis for Matisse's last great work—the Rosary Chapel in Vence. "I cut out sheets of paper which I got a nun to colour. And the reproductions were made with exactly the same tempera colours by Linel. There is even a certain dark pink among them that Linel made before the war with colours from Germany."

In this way, the celebration that is *Jazz* (after all, 'jazzing it up' is celebrating) is transformed into a prayer. Matisse also explored facets of colour, which *Jazz* came to grips with in such spectacular fashion, in the Rosary Chapel and other church windows, and in two major interior projects—*La Piscine* and the *Nus bleus* of 1952.

In 1930 Matisse had discovered to his regret that "my paintings and my drawings are going separate ways", thereby formulating a basic problem every painter encounters. However, the cut-outs and the difficulties of reproducing them we have described here enabled him to overcome the problem. The cut-

5 Letter to Rouveyre dated
22 February, 1948

outs meant he could go back to the essentials, in fact in an extreme, even radical way. With their help, Matisse bridged the gap between painting and drawing.

With the cut-outs, he mastered not only line and colour but also the third dimension—space.

One could say that a cut-out by Matisse is a drawing, painting and sculpture all in one. The French word for scissors is *ciseaux*, while *ciseau* is a sculptor's chisel. The only difference between the two tools is that the word for the former is plural because the tool has two blades while *ciseau* is singular because it has only one blade. Both tailors cutting cloth to make clothes and sculptors hewing wood or stone work directly on the material. The abstract dimension of painting—the *cosa mentale*, as Leonardo put it—contrasts with the work of the artist who creates colour as substance.

In a letter to Pierre Bonnard[6], Matisse wrote: "Instead of drawing and then applying colour, I draw direct with the colour."

With regard to the wonderful pages of *Jazz*, he wrote: "These pictures with their strong, lively tones developed from crystallisations of memories at the circus, folk tales or travelling."

I can still remember just how uncomfortable I felt when I was writing my text for the *Hommage à Tériade* catalogue in 1972[7]. To put my anxieties to rest, Tériade told me: "Don't worry, what you are doing is creating grey tones so the pictures stand out."

And in *Jazz*, Matisse wrote: "These pages thus only act as an adjunct to my colours, just as the Michaelmas daisies lighten a bouquet of more precious flowers."

May these lines serve as grey tones or Michaelmas daisies and bring out the prophetic icons that Matisse created thanks to the marvellous, selfless relationship he had with Tériade.

I would like to express my deepest gratitude in particular to Alice Tériade, Wanda de Guébriant from the Succession Matisse, Claude Duthuit and Olivier Berggruen.

6 Dominique Fourcade, *Henri Matisse. Écrits et pages sur l'art*, Dominique Fourcade (ed.), Paris 1972/1992
7 *Hommage à Tériade*, exhib. cat., Grand Palais, Paris 1973

For further reading on this subject, please refer to the following works: Henri Matisse, *Jazz. Tériade pour les éditions Verve*, Paris 1947; *Henri Matisse, Jazz*, Munich 2001; *Henri Matisse. Paper Cut-Outs*, exhib. cat., The St Louis Art Museum and The Detroit Institut of Arts 1977; Pierre Schneider, *Matisse*, Paris 1987; *Matisse et Tériade*, Musée Matisse, Cateau-Cambresis 1996; *Hommage à Tériade*, Grand Palais, Centre National d'Art Contemporain 1973; Michel Anthonioz, *L'Album Verve*, Paris 1987

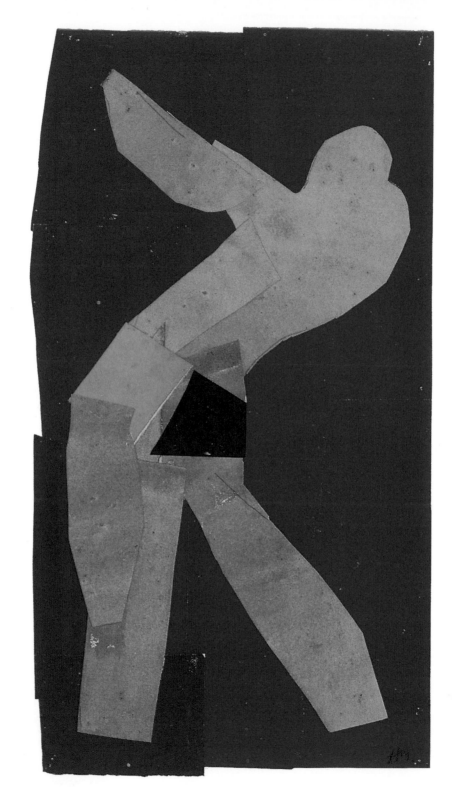

21 **Small Dancer on Red Ground** Petit Danseur sur fond rouge 1937/38

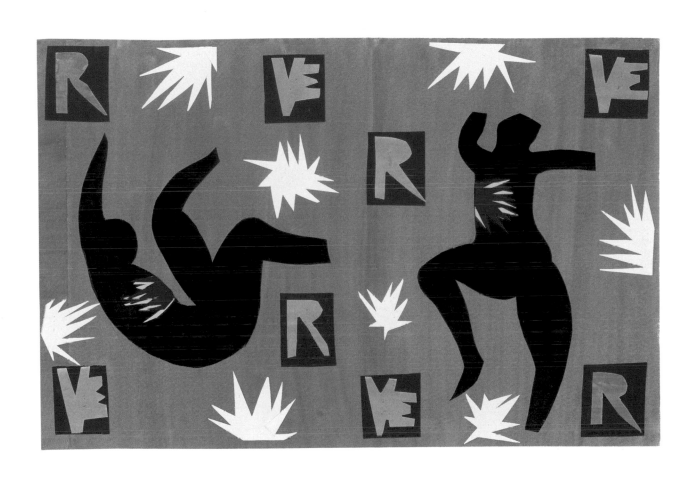

22 **Verve IV (cover design)** Verve IV (maquette de couverture) 1943

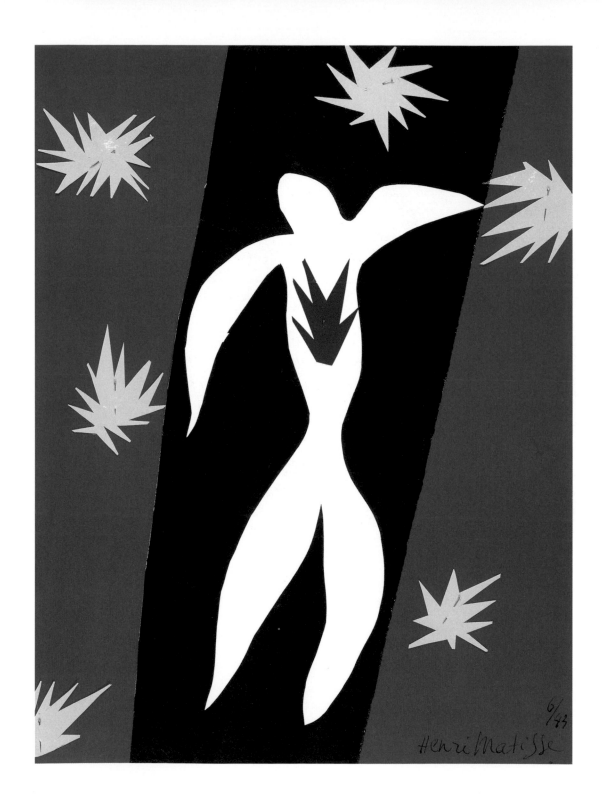

23 **The Fall of Icarus** La Chute d'Icare 1943

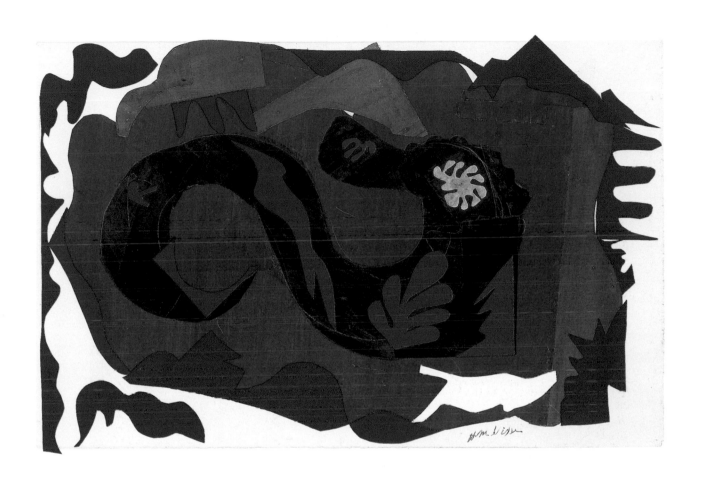

24 **The Dragon** Le Dragon 1943/44

Drafts for Publications
and Maquettes

Ingrid Pfeiffer

The drawing of 1936 for the cover of *Cahier's d'Art* nos. 3–5 published by Tériade can be regarded as the first independent cut-out in Matisse's œuvre. One year later, Matisse designed the first issue of *Verve*, the periodical also published by Tériade.[1] As in later commercial graphic work, the use of a largely abstract and in fact strongly geometrical formal idiom is noticeable, though it is otherwise un-usual for Matisse's work and even for the cut-outs as a group. Purely abstract or geometrical (non-object-based) works are very rare in Matisse's œuvre overall, and are found only within the group of cut-outs.

Matisse in his house 'La Rêve'
in Nice, *c.*1944

A photo of his studio at his house in Vence dating from around 1944 shows a large, very unusual cut-out by Matisse, now lost or possibly something he later reworked. It likewise consists of basic geometrical forms. Considerably larger than the above drawings for catalogues or periodicals, its lines and flat shapes (unfortunately the colours are not known) give it a decidedly architectural look, particularly compared with Matisse's normal preference for figurative or floral subject matter. This large cut-out appears to have been an experiment that Matisse did not follow up, or not at any rate in this form.

In later maquettes for cover drawings such as *Les Fauves* of 1949 and *Matisse, His Art and His Public* of 1951, the famous monograph published by Alfred H. Barr, or even in the drawing for the catalogue cover for the *Exhibition H Matisse* at the Museum of Modern Art in New York in the same year, colour zones consisting mainly of clear, unmixed primary colours are juxtaposed and combined according to specific rules. Dynamic diagonals, spatial designs and linear structures manipulate the viewer's gaze. This strategy and the selection of basic shapes used—red squares, for example—recall the typographical experi-ments of Russian Constructivism and the Bauhaus.[2]

Not only the *Les Fauves* sketch but also other cut-outs have been com-pared with designs by Sonia Delaunay[3], who did a lot of collages for book covers from the 1920s and whose work was strongly influential among Parisian artists. Art Deco should be especially mentioned in this context. Following the

1 Cf. Stuffmann, p. 26
2 Some of the Russian Constructivists such as Natalia Gontcharova and Olga Rosanova were using basic geometric shapes for book cover collages as early as 1912–15. Henri Matisse. *Paper Cut-Outs*, St Louis 1977, p. 160
3 Ibid., p. 122

celebrated *Exposition des Arts Décoratifs* in Paris in 1925, many Art Deco book artists adopted the geometrical style (notably that of De Stijl and the Bauhaus), combining it with a specifically French decorative tradition.

In Matisse's maquettes, we frequently observe his typical method of resorting to the same subjects and motifs time and again or re-using them in modified form. In *Exhibition H Matisse* he places part of a stylised face in the top left-hand corner, a motif from his series of broad-brush ink portraits around 1950. Figurative insertions of this kind come as no surprise, because in all phases of his work Matisse attached great importance to never straying across the frontier into abstraction, despite all the stylisation and simplification into symbols. He always considered the objects of the real world his basis.[4]

Recycled images and parallels of a formal nature also recur in a drawing of 1952 called *Livres illustrés estampes sculptures*: the motif of a sitting parrot from a wall-sized cut-out of the same year *La Perruche et la sirène* crops up again here, abstracted and stylised as a mirror image, likewise the algae. Nonetheless, the phenomenon of narration outweighs the symbolic quality—this cannot be described as a process only typically found in the maquettes.

Henri Matisse: Gravures récentes is the cut-out drawing for the lithographic cover of the Galerie Berggruen catalogue bearing this name in Paris in 1952. It shows a biomorphous green shape—reminiscent of the fruits in various other cut-outs (e.g. *Les Coquelicots*)—over a geometric blue zone. The contrast of shape and colour adds visual interest. Matisse also cut into the edges slightly so that, despite the small format, the cover gains a certain monumentality. The striking two-dimensionality and light background are features of the way the large cut-outs developed from 1952, the cut-out shapes now being almost always placed directly on a white undercoat or wall surface.

We may say that in maquettes for publications Matisse used basic geometrical forms far more frequently than cut-outs intended for other purposes, for example as patterns for materials, windows or ceramics. As might be expected, the cut-outs often reflect the current phase of the major works and contain motifs and references to the artist's interest at that particular time. The sense of balance and quality of the maquettes and drawings used for printed graphics in Matisse's œuvre are indicative of his general attitude that these were not minor works but were equal in value to other works within the cut-out group.[5]

4 "But Matisse always took care not to cross the boundaries of abstraction; he worked rooted in reality." Dominique Fourcade, 'Something Else', in ibid., p. 53

5 "He nevertheless considered his maquettes as independent works in their own right; indeed, he apparently made no distinction between them and his other cut-outs." John Hallmark Neff, *Matisse: His Cut-Outs*, in ibid., p. 29

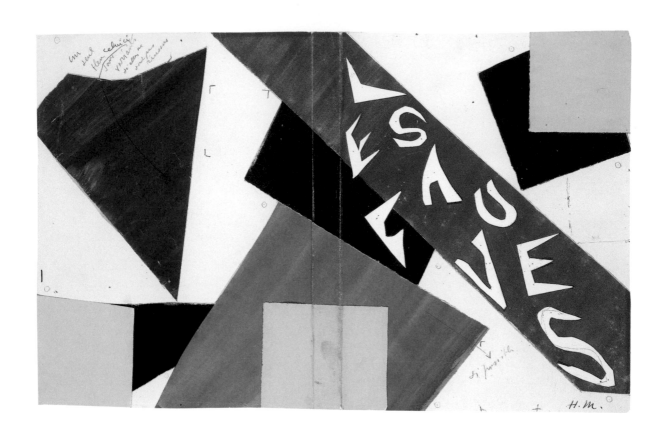

25　**The Fauves (book-cover design)**
Les Fauves (maquette de couverture) 1949

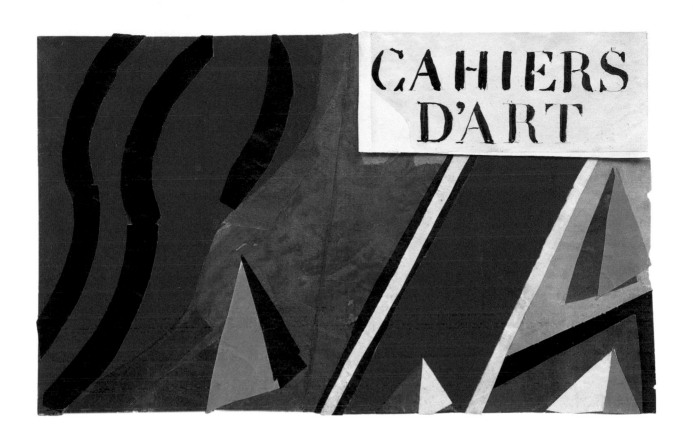

26 **Cahiers d'Art 3–5 (cover design)**
Cahiers d'Art 3–5 (maquette de couverture) 1936

27 **Matisse. His Art and His Public (book-cover design)**
Matisse. His Art and His Public (maquette de couverture) 1951

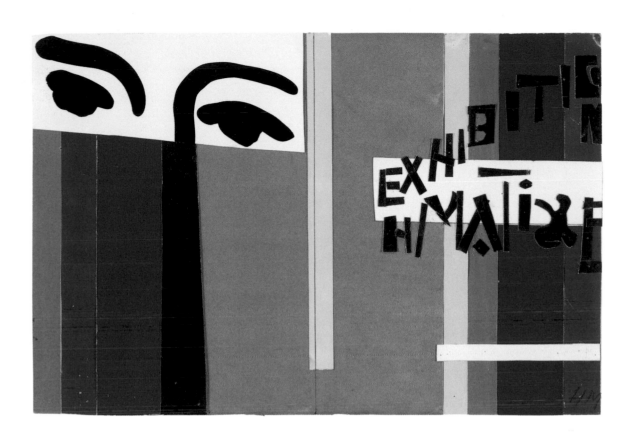

28 **Exhibition H Matisse (book-cover design)**
Exhibition H Matisse (maquette de couverture) 1951

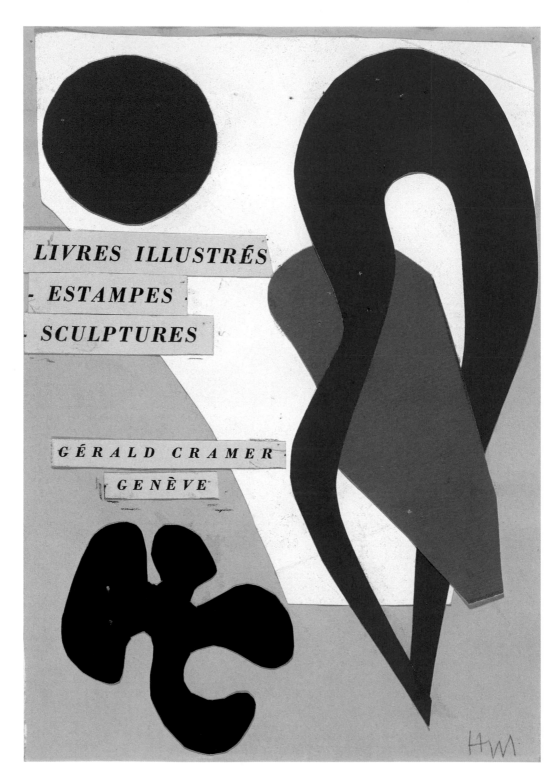

29 Livres Illustrés Estampes Sculptures (book-cover design)
Livres Illustrés Estampes Sculpture (maquette de couverture) 1952

30 Gravures récentes (book-cover design)
Gravures récentes (maquette de couverture) 1952

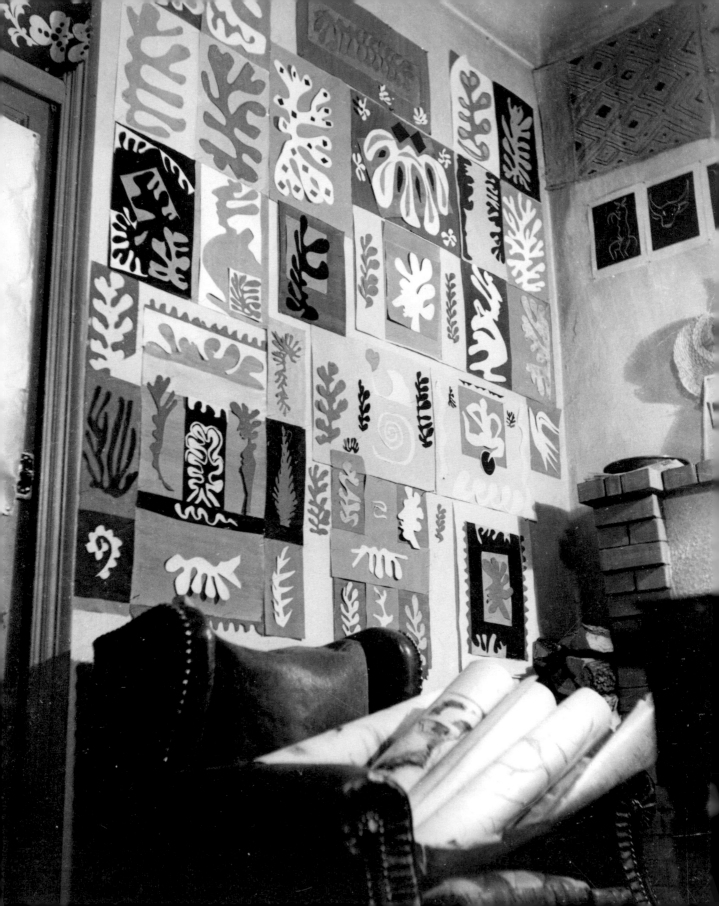

Decoration beyond Decoration

Rémi Labrusse

At the bottom lies a paradox. In his final years, Matisse simultaneously emphasised the continuity between his cut-outs and the rest of his work, and the radical shift that this new technique involved. After World War II, when he was not only experimenting but systematically developing the technique of cut-outs and theorising about them, it is a striking fact that he frequently alludes to his Fauvist period: "From the *Bonheur de vivre*, I was thirty-five then; to this cut-out, I am now eighty-two, I have remained the same… because all this time I have been searching for the same things, which I have perhaps realised by different means."[1] At the very moment when he was almost exclusively absorbed into the creation of a 'spiritual space'[2] in the Vence chapel, combining stained-glass windows and line drawings painted on ceramics (see p. 129 ff.), he also wrote to his daughter an astonishing definition of what he "had been searching for" since those memorable days of 1905: "A Fauvist painting is a luminous block made up of the consonance of several colours. They form a possible space for the spirit (as a musical chord does, I believe). The created space might be empty, like an empty room in a flat, but the space is still created. Am I clear? I think so."[3]

1 'Témoignage', 1951, in Jack D. Flam ed., *Matisse on art*, Berkeley and Los Angeles, 1995, p. 207 *["De la Joie de vivre - j'avais trente-cinq ans - à ce découpage - j'en ai quatre-vingt-deux - je suis resté le même [...] parce que, tout ce temps, j'ai cherché les mêmes choses, que j'ai peut-être réalisées avec des moyens différents."]*
2 Matisse as quoted by Father Couturier in his diary, 8 September, 1951, in Marcel Billot ed., *La Chapelle de Vence. Journal d'une création*, Paris, 1993, p. 363 *["J'ai voulu créer un espace spirituel dans un local réduit."]*
3 Letter to Marguerite Duthuit, around 1950, quoted in Rémi Labrusse, *Matisse. La condition de l'image*, Paris, 1999, p. 196 *["Un tableau fauve est un bloc lumineux formé par l'accord de plusieurs couleurs, formant un espace possible pour l'esprit (dans le genre, à mon sens, de celui d'un accord musical). L'espace créé peut être vide comme une pièce d'appartement mais l'espace est tout de même créé. Suis-je clair? Je le crois."]*

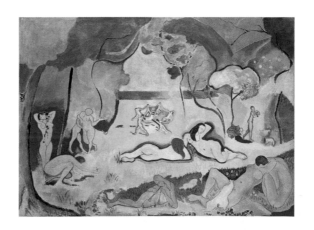

Henri Matisse, *Joy of Life* (Bonheur de vivre), 1905/6, oil on canvas, 175 x 241 cm, Barnes Foundation, Merion Station, Pennsylvania

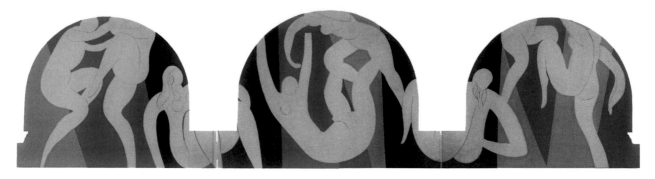

Henri Matisse, *The Dance* (La Danse), 1932–33, oil on canvas, three parts:
339.7 x 441 cm; 355.9 x 503 cm; 338.8 x 439.4 cm, Barnes Foundation,
Merion Station, Pennsylvania

This reference to Fauvism as the decisive birthdate of his aesthetics is not
particularly surprising: Matisse referred back to it each time he felt challenged in
his own development. The same thing happened at the turn of the Twenties and
the Thirties, when he was feeling trapped in his Odalisque paintings and inter-
minable Nice still-lives, and decided to make a clean break. This new start, in-
augurated by the etchings for the Mallarmé poems and by the Barnes commis-
sion for *La Danse*, was also rooted in his Fauvist experiments: *La Danse*
evolved directly from the central motif of *Bonheur de vivre* of 1906, while the
choice of Mallarmé (which Matisse preferred to the initial commission of an illus-
tration for La Fontaine's *Fables*) reflected the neo-symbolist intellectual atmos-
phere to which he had been drawn at the beginning of the century. Fauvism for
Matisse had always been a way of touching base, when he felt ready to break
through, to leap again into the future.

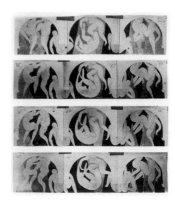

Henri Matisse, *The Dance*, prepara-
tory stage paper cut-outs, 1931

The reference to Fauvist aesthetics did not imply any formal repetition.
They were not thought of as a fixed source, but rather as a pool from which to
draw. Here is the paradox: while he is referring to his Fauvist period to clarify,
both for himself and his public, the meaning of his cut-outs, Matisse fervently in-
sists on the 'new freshness',[4] even more, on the complete renewal of his prac-
tice through these means: "By renewing myself completely, I think that I have
found in them one of the main visual perspectives and constructs of our time. By
creating these cut-out and coloured papers, I believe that I gladly embrace what
is to come. I don't think that I have ever achieved such a perfect equilibrium as I
have now, with these cut-outs. But I know that only later will people realise how
forward-looking my current work is."[5] In other words, this continuity, over almost
exactly fifty years, meant nothing but the lasting constraints and paradoxical

4 Interview with André Verdet, around
1952, quoted in Flam, 1995, p. 292
[*"Je tente de redécouvrir, avec des
moyens techniques inhabituels, les
belles saisons de la ligne et des
couleurs, à en tirer des timbres et des
accords d'une fraîcheur nouvelle."*]

Henri Matisse, *Mourner's Costume* (Costume de Pleureur), 1919, after a design by Henri Matisse for the ballet *Le Chant du Rossignol*, 1919, felt and velvet, 160 x 160 cm, Musée d'Art et d'Histoire, Geneva

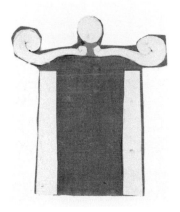

Le Chant du Rossignol, study for book wall, 1919, pencil and gouache on paper, cut out and pasted, 16.3 x 13 cm, private collection

5 Interview with André Verdet, around 1952, quoted in *Henri Matisse, Écrits et propos sur l'art*, Dominique Fourcade ed., Paris, 1972, p. 251 *["En me renouvelant entièrement, je crois avoir trouvé là un des points principaux d'aspiration et de fixation plastiques de notre époque. En créant ces papiers découpés et colorés, il me semble que je vais avec bonheur au-devant de ce qui s'annonce. Jamais, je crois, je n'ai eu autant d'équilibre qu'en créant ces papiers découpés. Mais je sais que c'est bien plus tard qu'on se rendra compte combien ce que je fais aujourd'hui était en accord avec le futur."]*

metamorphosis of a single position. Are his final years an ending or a new beginning? Or should we say that the very idea of completion could only be envisaged by Matisse as an occasion for renewal?

To begin with, let us make it clear, what the cut-outs are not. When the technique was systematically developed by Matisse, in the early forties, it was by no means new to him. Its first historical emergence dates from the end of 1919, when Matisse, commissioned by Diaghilev, designed the décor and costumes for the ballet *Le Chant du Rossignol* in London. The painter then conceived a scale model of the stage in order to work out his colour scheme, and, to do this, he resorted to cut-out and pasted papers. What remains of this small construction is strikingly evocative of the cut-outs he was to make twenty years later , as is the set of magnificent costumes for the mourners in the ballet. More than a decade later, the technique was of crucial importance during the elaboration of the *Danse* panels for Barnes, in 1932 and then again for the décor and cos-

Henri Matisse, *Still-life with Mussels* (Nature morte au coquillage), 1941, study, pencil, chalk and gouache colours on paper cut-outs on canvas, 60 x 82 cm, private collection

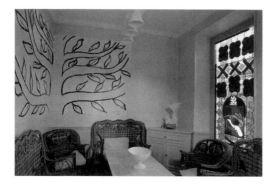

Dining-room in Tériade's villa in Saint-Jean-Cap-Ferrat

tumes for the ballet *Rouge et noir* in 1937–39. It was also used by Matisse during the thirties almost every time he came up against a problem in his painting; *La Branche de magnolia* of 1934, *Nu rose* of 1935, and, most noticeably, *Nature morte au coquillage*, of 1940, demonstrate this unequivocally.[6] And if, in all these instances, he only resorted to paper cut-outs in the preparatory phase, is this not the case with many of the late cut-outs? The designs for *Jazz* (cat. 1–20) and for *Océanie, le ciel* and *Océanie, la mer* (cat. 37, 38) were made into prints; the one for the Vence chapel, for *Lierre en fleurs*, for *Poissons chinois*, for *La Vigne*, were made into stained-glass windows; *Apollon, La Piscine* (cat. 64), *Les Acanthes, Grande Décoration aux masques* (see p.72), etc., were originally conceived as ceramic murals; not to mention the book covers, the scarves (for the Ascher commission), the tapestries, the chasubles, etc.

Is it necessary to add that in the course of Western art, the technique itself was not Matisse's invention? Innumerable examples, ranging from Philip Otto Runge's silhouettes at the beginning of the nineteenth century to some particularly striking Russian experiments in the wake of the Soviet revolution, are adequate proof of this. Even if they were not known to Matisse (with the notable exception of the early Cubist collages[7]), they should discourage us from

6 Matisse's strategic use of the technique is striking in *La Branche de magnolia*. On 28 March 1934, he wrote to his son Pierre: "First I covered the bottom, the red floor, with a piece of painted paper left over from my decoration. Then I found that the green branch was very dynamic and that the red hindered its movement; being complementary, the red paralysed it. So, I put in a piece of grey paper.[…] I kept this result for a fortnight, noticing that, though my picture was well organised and the colour effect was right—the action of the colour—the result, however, was rather poor.[…] And I took the grey paper off. I was delighted to get my red back, and, though my picture was less spacious, I had a different kind of satisfaction; I couldmake a painting more substantial. Then Bussy came to visit me and he found the painting very rich with its red floor. While he was talking to your mother, I put the grey papers back on and I called him. He was extremely surprised, looked at it for a long while before and after lunch, and told me: it's better, leave it like that. As a matter of fact, I get a greater sensation of space." (Pierre Matisse Archives, Pierpont Morgan Library, New York) *["Après avoir couvert le bas, le parquet rouge, avec du papier peint qui me restait de ma décoration, j'ai jugé que ma branche verte avait tout son élan et que le rouge dérangeait le mouvement de la branche verte, le rouge complémentaire l'immobilisait. Donc j'ai mis le papier gris. […] J'ai gardé ce résultat une quinzaine, en remarquant cependant que mon tableau était ordonné et juste au point de vue de l'action des couleurs, de l'emploi des couleurs, mais que le résultat était assez pauvre [...]. Et j'ai enlevé mes papiers gris. Alors, j'ai retrouvé avec plaisir mon rouge et quoi [que] mon tableau devenait moins spacieux, j'avais tout [de] même une autre satisfaction et me permettais de faire désormais une peinture plus substantielle [sic]. Puis Bussy est venu me voir et a jugé mon tableau très riche avec son parquet rouge. Pendant qu'il était à causer avec ta mère, j'ai remis mes papiers gris et l'ai appelé. Il a été tout à fait surpris et après l'avoir considéré avant le déjeuner et après, pendant assez de temps, il m'a dit : c'est mieux, ainsi, laisse la comme cela. J'ai en effet une plus grande sensation d'espace."]*

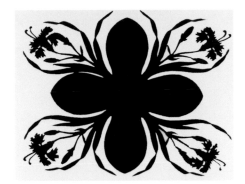

Philip Otto Runge, *Carnation*, c.1800, paper cut-out, 22 x 28.3 cm, private collection

7 See, among other examples, Tristan Tzara's remarkable article, 'Le papier collé ou le proverbe en peinture', in *Cahiers d'art*, 1931, n° 2. The reproductions (not only of Braque and Picasso from 1912–13, but also of Arp and Miro from 1930) are as illuminating as the text itself: "The papier collé in its many guises marks the most poetic and most revolutionary moment in the history of painting, the most touching flight towards more viable hypotheses, a greater intimacy with everyday verities, the invincible affirmation of transience and of short-lived and perishable materials, the sovereignty of ideas." (p. 64, conclusion of the article) *["Le papier collé, sous tant de différents aspects, marque dans l'évolution de la peinture, le moment le plus poétique, le plus révolutionnaire, le plus touchant essor vers des hypothèses plus viables, une plus grande intimité avec les vérités quotidiennes, l'affirmation invincible du provisoire et des matières temporelles et périssables, la souveraineté de l'idée."]*

8 Letter to Paul Rosenberg, 2 June, 1946, quoted in Labrusse, 1999, p. 182 *["Je suis bien gêné pour vous écrire que je ne puis accepter votre offre de contrat, aussi tentante soit-elle. Je suis forcé de prendre en considération que je vais lâcher – jusque …? – la peinture pour des travaux décoratifs tels que tapisseries, fresques, etc… Je ne ferai avant longtemps de tableaux qu'exceptionnellement."]*

9 Letter to Paul Rosenberg, 2 March, 1948, Pierpont Morgan Library, New York *["Je suis en train de faire de la peinture, toujours avec autant de curiosité que par le passé."]*

10 Interview with André Verdet, quoted in Flam, 1995, p. 293 *["Les papiers découpés représentent pour moi une création parallèle à la peinture à l'huile. Il ne faut pas y chercher une mise en accusation de cette dernière."]*

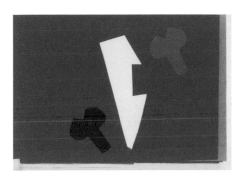

Alesksei Kruchenykh, *Futurist's Battle with the Ocean*, paper collage, 22.7 x 32.5 cm, 1916, The Museum of Modern Art, New York

focussing too much attention on the novelty of the technique if we wish to approach the true significance of Matisse's cut-outs.

Nor should we rashly claim that the cut-outs replaced 'traditional' painting, at least before the very end of Matisse's life. It remains true that he had at times viewed the medium as a radical alternative, especially at the beginning, when he was exploring all its possibilities. In June 1946, for instance, after some hesitation, he eventually turned down Paul Rosenberg's offer of a new contract, because, he said, he would be abandoning painting for the foreseeable future: "I am very sorry to have to tell you that I cannot accept your offer, tempting though it is. I need to bear in mind that I am going to drop painting in favour of decorative works such as tapestries, frescoes, etc., until…? It will be quite some time before I paint canvases again, except occasionally."[8] However, he was quick to remark that painting did stay the course, since he stated as much two years later to the same correspondent: "I am now making paintings with as much keenness as ever,"[9] an assertion that he reiterated in his conversations with André Verdet: "For me the paper cut-outs represent a creation parallel to oil painting. They must not be seen in any way as an indictment of painting."[10] As a matter of fact, Matisse carried on painting until the end of 1948, and then painted his two last canvases in 1951.

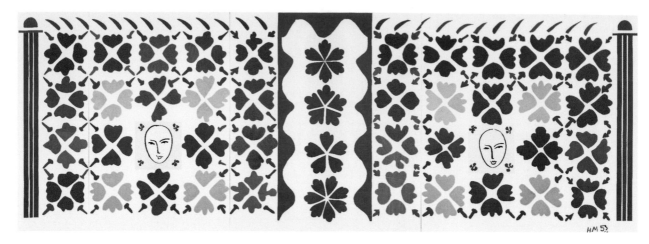

Henri Matisse, *Large Decoration with Masks* (Grande Décoration aux masques), study for a ceramic wall, 1953, paper cut-out, ink, 353.7 x 997 cm, The National Gallery of Art, Washington DC

Are the cut-outs a resolution of the traditional conflict between colour and drawing? It has become a cliché to assert this in praise of the cut-outs. The first step was taken by Matisse himself who, in *Jazz*, drew a parallel between his "cutting directly into vivid colour" and "the direct carving of sculptors."[11] The traditional dialogue between sculpture and drawing was thus transferred to the cut-outs and allowed Matisse to declare repeatedly, even more so than in the past, that, for him, "to paint and to draw are one."[12] However, such a view, so frequently held by his supporters, seems awkward when we turn to the works themselves. Line and colour could not be more carefully separated than in the most important cut-outs: *Jazz* (cat. 1–20), in its book form, is entirely based on such a separation, with the black-and-white handwriting on the left, and the coloured stencils on the right; the Vence chapel interior follows exactly the same principles, in the dialogue between the murals and the stained-glass; as do the installations for Tériade dining-room in Saint-Jean-Cap-Ferrat, or for the Lasker mausoleum commission, one of Matisse's last works of 1953 (with, in this case, an opposition between the stained-glass window and an ironwork gate, analogous to a drawing). In many other cases, such as *Grande Décoration aux masques*, *Souvenir d'Océanie*, *Nu aux oranges* (cat. 68), etc., line drawing is integrated into a single decorative body, but is still distinct from the coloured motifs. There are countless other occurrences of this kind. Moreover, the view that the cut-outs represent a triumph of pure colour is challenged by the fact that the two inaugural works employing this technique on a monumental scale,

Henri Matisse, *Ivy in Flower* (Lierre en fleurs), study of a window for the Albert D. Lasker mausoleum, 1953, cut-out, 284.2 x 286.1 cm, Museum of Fine Arts, Dallas

11 Henri Matisse, *Jazz*, 1947, in Flam, 1995, p. 172 *["Découper à vif dans la couleur me rappelle la taille directe des sculpteurs."]*
12 'Témoignage', 1951, in Flam, 1995, p. 208 *["Dans mon cas, peindre et dessiner ne font qu'un."]*

Henri Matisse, *Memory of Oceania* (Souvenir d'Océanie), 1952–53, paper cut-out, chalk, 284.4 x 286.4 cm, The Museum of Modern Art, New York

Henri Matisse, *The Yellow Curtain* (Le Rideau jaune), 1915, oil on canvas, 146 x 97 cm, private collection

Henri Matisse, Design for the proposed ironwork grille door for the Albert D. Lasker mausoleum, ink on paper, 273.1 x 109 cm, private collection

13 'Témoignage', 1951, in Flam, 1995, p. 209 *["Il n'y a pas de rupture entre mes anciens tableaux et mes dé-coupages, seulement, avec plus d'ab-solu, plus d'abstraction, j'ai atteint une forme décantée jusqu'à l'essentiel."]*

Océanie, le ciel and *Océanie, la mer* (cat. 37/38), are composed of pure white forms. Why, then, was Matisse so insistent that the cut-outs put an end to the traditional war between drawing and colour?

Matisse's late cut-outs are not a new technique, neither in the history of twentieth-century art nor in Matisse's own career. They do not constitute a radical departure from painting and they would appear at first to accentuate the separation between drawing and colour rather than to merge them. Let us add one more negative characterisation: they are not a step towards abstraction. Once again, Matisse himself could be misleading, when, for instance, he said to Maria Luz, in 1951: "There is no break between my early pictures and my cut-outs, except that with greater completeness and abstraction I have attained a form filtered to its essentials."[13] This form, though, is always related to an object. No cut-out is purely abstract and, if some of them, like *Rouge et or* (cat. 40), the plate entitled *Le Destin* in *Jazz* (cat.16), or, later, the large panel *Souvenir d'Océanie*, are on the verge of being non-figurative, it is easy to find similar experiments in his early paintings, particularly around 1914–15: *Porte-fenêtre à Collioure* (1914) or *Le Rideau jaune* (1915) are undoubtedly as far removed from a faithful depiction of the thing seen as the more strictly formal cut-outs. And all of them belong to the farthest reaches of his visual territory where what is taking place is a war against the tradition of mimetic representation but never an disavowal of the idea of figuration. Until the end, Matisse's art is fundamentally figurative; his first obsession is to avoid any mental pre-

elaboration of his images, which must always result from a shock, an open confrontation with the unforeseen; and for this purpose, a link between the elaboration of the image and awareness of the outside world appears inescapable to him.

So what, then, can we say that the cut-outs are? First of all, they turned the Western aesthetic hierarchy between fine and decorative arts on its head. The technique itself implies that one of the main features of painting as a 'high' art, the brushstroke, is wiped out. For centuries, it had been the mark of the artist's singularity. Heavy or light, subtle or demonstrative, scratched, dabbed or swept on, swift or slow, it always manifested that heroic and elusive being: the Painter. Matisse, himself straight away singled out by critics as a master of colour, had indeed displayed splendid technical mastery, applying thick impasto on the canvas, scraping it with the wooden tip of the brush, superimposing delicate layers of colour, etc. Such skills, consolidating his growing reputation after the World War I as one of the pillars of modern French painting, help explain his sense of panic when, in 1931, he decided to renounce them for *La Danse*. Having worked out his colour scheme using gouache painted cut-outs, he then commissioned a house painter to cover the surfaces on the canvas. "Nobody must know," he wrote in a letter to his son Pierre, underlining the words.[14] Two decades later, the single confidential house painter had been replaced by squads of assistants who, led by Lydia Delectorskaya, uniformly covered large pieces of paper with gouache colours and positioned the motifs on the walls in keeping with the artist's wishes.

This leap from the individual artistic touch to a highly impersonal technique can now be related to Matisse's claim regarding the merging of drawing and colour. What is at stake here is not an actual suppression of line drawing as a means of visual expression but, both intellectually and strategically, a blurring of the lines between the main categories of Fine Art. The classification of painters according to their gifts for drawing and colour, with its quasi mythical pairings (Raphael/Titian, Poussin/Rubens, Ingres/Delacroix, etc.), could only be considered by Matisse as a dangerous, though tempting trap, since, as a colourist, he might easily have been reduced to just one more chapter in the old story of the Western tradition. His goals were different. What he had always wanted, at least since 1905, was a complete upheaval of the traditional values which placed paintings on canvas—the supreme realm of traditional representation—at the top of the scale, and, at the bottom, the ornamental arts, left to the nameless masses of craftsmen. "No more separation between drawing and colour;"

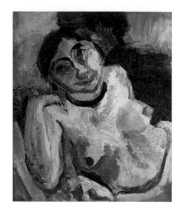

Henri Matisse, *The Gypsy* (La Gitane), 1906, oil on canvas, 55 x 46 cm, Musée de l'Annonciade, Saint-Tropez

14 Letter to Pierre Matisse, 29 November, 1931, quoted by Flam in 'Histoire et métamorphoses d'un projet', *Autour d'un chef-d'œuvre de Matisse. Les trois versions de la Danse Barnes (1930–1933)*, Suzanne Pagé ed., Paris, 1993, p. 57 *["Il ne faut pas le dire."]*

Henri Matisse, *View to Notre Dame* (Vue de Notre- Dame), 1914, oil on canvas, 147.3 x 94.3 cm. The Museum of Modern Art, New York

the main meaning of this watchword, in Matisse's last period, might well be: "No more separation between high art and ornament."

Moreover, almost all the late cut-outs from the last decade of Matisse's life clearly display their utilitarian status. They were not intended for pure contemplation in some museum gallery or other. They had to be integrated into a specific social context, where they would accompany collective or individual gestures: a religious ceremony in the Vence chapel, a silent moment in the Lasker mausoleum, a shared meal in the Tériade dining-room (see p. 70), a simple climb up or down the stairs of Pierre Matisse's house at Saint-Jean-Cap-Ferrat (with *La Vigne*, the stained-glass window commissioned by his son in 1953), etc. For Matisse, their legitimacy as visual products was primarily based on their function, and this function was to vitalise the space where everyday life is conducted.

This growing obsession with decoration emerged when he started out on the two panels *Océanie, le ciel*, and *Océanie, la mer* (cat. 37/38). Matisse set out on this venture with no particular end in view: during the summer and autumn of 1946, when he let the shapes in the future panels proliferate on the walls of his Parisian flat, he had only a vague idea of what he was getting into: "I don't yet know how all of this will turn out. Maybe panels, mural fabrics...," he said to Brassaï at the time[15]. Originally, these shapes were designed to cover up stains on the preparatory wallpaper in Matisse's flat, which was about to be refurbished. The cut-out motifs were vaguely evocative of his Tahitian trip of 1930, but without any biographical or identifiable references.[16] They revived a strong feeling of happiness, even of rebirth, which had been experienced by Matisse in

15 Conversation with Brassaï, 1946, quoted in *Henri Matisse. Paper Cut-Outs*, Jack Cowart, Jack D. Flam, Dominique Fourcade, John Hallmark Neff (ed.), Saint-Louis and Detroit, 1977, p. 282 [*"Je ne sais pas encore ce que ça donnera... Ça fera peut-être des panneaux, des tentures murales."*]
16 On the impact of Matisse's trip to Tahiti, see John Klein, 'Matisse après Tahiti, la maturation d'une expérience esthétique', *Matisse et l'Océanie*, Dominique Szymusiak (ed.), Le Cateau-Cambrésis, 1998, pp. 179–219.

Detail of the wall in Matisse's flat in Paris, Boulevard du Montparnasse, October 1946

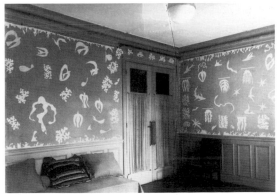

Matisse's flat in Paris, Boulevard du Montparnasse, with *Océanie* on the wall, October 1946

a Tahitian lagoon fifteen years previously. There was a sense of playfulness in them, of gratuitousness and rejuvenation. They had no fixed frame, they spread out over the rectangular surfaces of the wall, reached up over the door, and, at the same time, they were the lightest and most transient visual marks one could possibly imagine. This strange combination of frailty and expansion, of nothingness and plenitude is one of the definitions of ornamentation. And what happened is that Matisse enthusiastically embraced this unexpected aesthetic dimension, encouraged by Zika Ascher's commission—prompted by what he discovered on Matisse's walls—of two large linen panels and two scarves. This accounts for Matisse's letter to Paul Rosenberg at the time, explaining that he would be dropping painting for the foreseeable future. This is also why he insisted time and again, in his correspondence with Ascher, on the decorative status of these works in progress. They announced his arrival onto the decorative art scene: "*Art et décoration*, an old-established art magazine and one of the most important in Paris, is going to reproduce photographs of the two panels. It is very important for you… I want to offer one of the prints to the Musée des Tissus in Lyon. I will show these hangings at the Salon des décorateurs in Paris."[17] For the rest of his life, he would tirelessly promote not only decorativeness per se but also the decorative status of his cut-outs. One sign of this is the clear difference he always wanted to make between the final products, created for a specific context, and the designs for them, whose meaning was more conceptual and thus were better suited to inclusion in museum collections. As he wrote to his son Pierre in January 1952: "Making stained-glass windows is just what I feel like doing now. A stained-glass window carried out in France, under my supervision, with glass panes chosen by me and properly cut in strict keeping with my design: that I can sign. Once the stained-glass window is executed, I give the design to a museum, mentioning the place where the window has been made (it would be an absolute nonsense to put both the window and its design in the same house)."[18]

Hence, Matisse's position is not without contradictions. He still desires the museum's involvement and he still does not wish to be stripped of the prestige that had always been conferred on the artist since the Renaissance. Therefore, he found himself confronted with threats from two quarters. The first threat is that of falling into complacent colourism, far removed from any revolutionary impulse, as had once happened at the end of the Twenties. This lack of upsets in the course of his career is a recurrent source of anxiety for him. Maillol's life, in this respect, was an object lesson, as he wrote to his daughter in April 1953:

17 Letter to Zika Ascher, 24 October, 1946, in *Henri Matisse. Paper Cut-Outs*, 1977, p. 282 ["*Art et décoration, revue d'art ancienne et une des premières de Paris, va reproduire les photos des deux panneaux. C'est très important pour vous. Un panneau va paraître dans un journal d'art de Paris très répandu en Amérique dans quelques semaines. Je veux offrir une des épreuves au musée des tissus de Lyon. J'exposerai cette tenture au salon des décorateurs de Paris.*"]

18 Letter to Pierre Matisse, 28 January, 1952, Pierre Matisse Archives, Pierpont Morgan Library, New York ["*Faire des vitraux en effet me convient actuellement. Le vitrail exécuté en France entièrement sous ma surveillance, moi choisissant les verres, les verres coupés fidèlement d'après mon carton, - je puis signer ce vitrail. Une fois le vitrail réalisé, je donne le carton dans un musée avec la mention de l'endroit dans lequel le vitrail a été exécuté (ce serait un contresens ab-solu que de mettre dans la même maison le vitrail et son carton).*"]

19 Letter to Marguerite Duthuit, 19 April, 1953, Henri Matisse Archives, Paris ["*Ce qui a nui beaucoup au progrès du bon sculpteur Maillol, c'est de s'être souvent arrêté au stade satisfaisant. Et ce qui m'a servi beaucoup, c'est de dépasser ce point, malgré les risques certains.*"]

20 Letter to Zika Ascher, 24 October, 1946 in *Henri Matisse. Paper Cut-Outs*, 1977, p. 282 [*"Pensez que vous avez une œuvre importante de moi, appelée à un grand retentissement. Considérez-la comme je vous dis, car j'ai raison. C'est une chose importante pour moi mais beaucoup plus importante pour vous. Vous faites une chose qui doit être aussi respectée qu'une gravure d'art. Elle est appelée à devenir célèbre. Je suis certain de ce que j'avance."*]

21 Christian Zervos, 'A propos de l'Exposition Matisse au Musée d'Art Moderne de Paris', *Cahiers d'art*, 1949, n° 1, pp. 159–160. 160 [*"Est-il besoin de dire qu'on ne saurait faire aucun cas de ces papiers découpés qui constituent avec les tentures décoratives la grande affaire de l'exposition Matisse? Pour mon compte, ils sont totalement négligeables et d'un mauvais voisinage à l'égard des tableaux. Ce qui rend de telles occupations inacceptables, c'est non seulement qu'elles ne touchent à aucune des initiatives esthétiques de Matisse, ne laissent rien soupçonner de la tournure de son imagination et ne mettent en lumière aucun de ses soucis des questions de fond, mais qu'elles nous laissent indifférents quand elles ne nous peinent de voir l'artiste trahi par son pouvoir de discrimination bien plus que par son talent."*] Such a repulsion is all the more striking when one thinks that Matisse had made a remarkable cut-out design for the cover of the number 3–5 of the *Cahiers d'art* in 1936.

22 Interview with André Verdet, around 1952, quoted in Flam, 1995, p. 292 [*"Un divertissement qui n'est pas facilité ni apparence légère ni amusement frivole. Sans doute d'aucuns, critiques ou confrères, diront: 'Le vieux Matisse, à la fin de sa vie, s'amuse à découper. Il vieillit mal, il retombe en enfance'. Cela évidemment ne me fera pas plaisir."*]

23 Letter to Pierre Matisse, 7 November, 1946, Pierre Matisse Archives, Pierpont Morgan Library, New York [*"J'ai été aussi voir chez Carré l'exposition Calder qui m'a beaucoup beaucoup intéressé. J'y retournerai. Lui-même est très remarquable. Quand on voit ce robuste fermier américain souffler sur ses petites créations pour les mettre en mouvement, c'est touchant."*]

"What has been most harmful to Maillol's development, despite his being a good sculptor, is that he often stopped at a *satisfactory* stage. And what has helped me a great deal is to have gone beyond that point, regardless of the obvious risks."[19] But one of these risks, on the other hand, is to be cast out of the realm of art. This is the second threat, which the cut-outs very dangerously actualised. Matisse's sense of unease shows in the way he emphasises to Zika Ascher the artistic importance of the Océanie panels: "*Think* that you have an important work of art by me, and that it will create a considerable stir. See it as I want you to, *because I am right*. It is an important thing to me, but even more important to you. You are doing something which deserves the same respect as a fine art print. It is destined to be famous. *I am sure of what I say.*"[20]

This fear was well-founded. In 1949, when Matisse exhibited an important series of cut-outs for the first time, at the big retrospective organised by the Musée national d'art moderne in Paris, Christian Zervos, the director of the still influential *Cahiers d'art*, reacted with extreme violence: "Need we even concern ourselves with these cut-outs which, together with the decorative hangings, are the big attraction of the Matisse show? I consider them utterly insignificant and they harm the paintings hanging next to them. Such practices are unacceptable: not only do they bear no relation to Matisse's aesthetic initiatives, they don't allow us to glimpse what his insights may be, nor do they shed any light over his deeper concerns. They leave us indifferent. Worse still, it saddens us to see the artist betrayed by his own better judgement even more than by his talent."[21] As late as 1952 Matisse still felt that his cut-outs were subjected not only to the usual sniping of critics but to a sort of covert scorn, which wrote them off as works of an artist in his dotage: "Amusement that is neither facile, nor superficial, nor frivolous. Some, critics or colleagues, will say: 'Old Matisse, nearing the end of life, is having fun cutting up paper. He is not wearing his age well, falling into a second childhood'. That won't make me happy of course."[22]

One way of reassuring him, at that time, was to focus his attention on similar works, halfway between decoration and 'great' art, and to insist both on the effort that artists devoted to such things and on the quality of the results. In November 1946, he admired the 'small creations' of Calder, praising them to his son: "I went to see the Calder show at Carré, and I was very, very interested. I will go back again. He himself is very remarkable. When we see this sturdy American farmer blowing on his small creations to make them move, we are touched."[23] He showed the same keen interest when he saw Picasso's ceramics

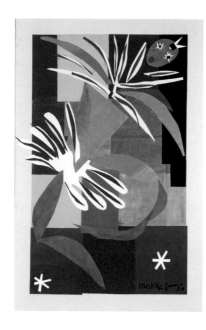

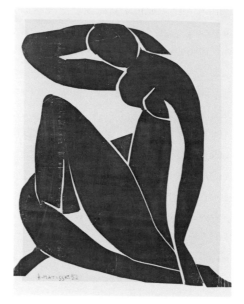

Henri Matisse, *Creole Dancer*
(Danseuse créole), 1950,
205 x 120 cm, paper cut-out,
Musée Matisse Nice

Henri Matisse, *Blue Nude II*
(Nu bleu II), paper cut-out, 1952,
116 x 88.9 cm, MNAM/CCI Centre
Pompidou, Paris

in March 1948: "I saw them, and I must say that they are an extraordinary thing. He's been working on them every afternoon for seven months."[24]

Matisse's works themselves display this fear of being cut off from the realm of Fine Arts. If some of the cut-outs appear amazingly free from the grand rules of representational painting—consider the all-over expansion of the *Océanie* panels or the mixture of cut and torn-out edges of the colour blocks in *L'Escargot*—others look back to more traditional methods. *Zulma*, *La Danseuse créole*, or even *Apollon* are among the latter, with a centred human figure, not so much shaped out of colour than simply embellished by it, with a dash of exoticism or mythology to justify their cheerful, though somewhat superficial, expansiveness. Characteristically, in the same letter in which Matisse told his son Pierre he would gladly do only stained-glass windows from then on, he mentioned *La Danseuse créole* as a work that, though excellent, was not based on the same principles: "I did understand that you liked my Créole… I think it is of outstanding quality, and I find it pleasant and useful to keep it with me, at least for a while. But you misunderstood if you thought I wanted to make a similar thing by copying it. All I meant to say is that I'm not sure I can manage things of the same quality, in any medium whatsoever, and that's why I want to keep it. Making stained-glass windows is just what I need now…"[25] etc. The cut-outs are caught between an ambition for museum status and the desire to make a radically decorative, almost iconoclastic impact. It is tempting to say that, in

24 Letter to Pierre Matisse, 9 March and 3–5 April, 1948, Pierre Matisse Archives, Pierpont Morgan Library, New York [*"Je les ai vus et je dois dire que c'est quelque chose d'extraordinaire. Il y a 7 mois qu'il y travaille toutes les après-midi."*]
25 Letter to Pierre Matisse, 28 January, 1952, Pierre Matisse Archives, Pierpont Morgan Library, New York [*"J'ai bien compris que ma Créole t'a plu. […] Je la trouve d'une qualité exceptionnelle et il m'est agréable et utile de la garder au moins pendant quelque temps. Tu m'as mal compris si tu crois que je veux refaire une chose semblable en l'imitant. Je voulais simplement dire que je ne suis pas certain de pouvoir faire encore des choses de la même qualité, dans quelle branche que ce soit [sic], et c'est pourquoi je tiens à la garder. Faire des vitraux en effet me convient actuellement" etc.*]

this conflict, victory was soon achieved, since the vast majority of the cut-outs are now in the hands of museums. But is this a genuine victory?

Another conspicuous characteristic of the cut-outs is that, in the final result, the process of its making remains visible, or, to be more precise, understandable. A painting, as a vivid pattern of brushstrokes, always, to some extent, recalls the moment of its creation; but it is the lasting testimony of a creative act, in the full meaning of the word, with its aura of mystery, made of indecipherable mixtures prepared on the palette, of vibrant gestures made by the brush. There is nothing of this kind in the cut-outs: what is made visible here is the humble if exacting process of fabrication, something which, once again, refers to craftsmanship as opposed to artistry. Observe how these shapes are often made of several fragments, organised like a house of cards, meticulously dovetailed; look at the clear intricate web of relationships between them on the surface of the larger panels; see how fragile they look, lightly pinned onto the surface, with the innumerable pin holes all over, suggesting each position the artist tried. In some original works—*Nu bleu IV*, among others—this process of positioning shapes becomes the image's *raison d'être*. This legibility of a painstaking shifting of shapes is of course intentional: it underscores the 'utmost seriousness'[26] implied in the making of the cut-outs and of which Matisse was always most anxious to convince his public. The visual result is indeed striking: it gives the viewer a new sense of responsibility in the act of looking. When we look at these surfaces, we are led to speculate with the artist as to the most effective position for each form. We are by no means overwhelmed nor lost in pure contemplation. On the contrary, our awareness of the image as the outcome of a slow, delicate and precise elaboration, is heightened. The artist puts his cards on the table, and we become partners in the game. In the process of looking, there is an continuous interplay between visual emotion and critical reflection. Thus, making and looking become practically one and the same thing. They are part of a shared responsibility, between the artist and the viewer, for the making of visual forms.

To what extent are these two aspects—the idea of decoration and the reflexivity involved in the image making process—central to Matisse's aesthetics from 1905 onwards? To what extent, in other words, had Matisse 'remained the same' at the time of his cut-outs? Decoration, in fact, had always been the key weapon in his theoretical arsenal, in his life-long struggle to distance himself from the Western tradition of mimesis while preserving a link between the created image and the outside world. As has often been stated, decoration is a term

26 Interview with André Verdet, around 1952, quoted in Flam, 1995, p. 292 [*"Oui, je me suis beaucoup amusé à découper!… Mais avec le plus grand sérieux."*]

which, for him, means that he has moved beyond the task of representation and that, through this, the very idea of art has been revitalised: "The decorative for a work of art is an extremely precious thing. It is an essential quality. It is not pejorative to say that the paintings of an artist are decorative."[27] This decorative-nature—as opposed to decorative art—was fostered in Matisse by his explorations of cultures, primarily Islamic, where there is no such thing as a hierarchy between high and low art forms, cultures where the making of a single tile is as much worthy of respect as the most spectacular canvas for a Western artist. Nevertheless, in Matisse's work, it seldom took the form of actual decorative objects: he used decorativeness in painting, drawing and sculpture, as a means of turning the Western visual tradition against itself.

There are two apparently contradictory consequences of this strategic use of decorativeness. The first is the principle of defocalisation:[28] in an image, the decorative aspect implies that the viewer is required not so much to meditate on what he sees, as to experience an all-over visual effect which draws the eye away from the picture surface to the total environment. He achieves this by various means: a centrifugal-type composition, characteristic of most of his paintings and drawings, the use of flat colour-fields, the accent on dynamic relationships between forms rather than on isolated motifs, the identity between 'expression' and 'decoration' (formulated by Matisse in 1908, meaning that for him there was no longer any distinction between the so-called subject of a painting and its visual appearance).[29] The image is not seen as an end in itself; it is instrumental, as Matthew Stewart Prichard, one of Matisse's few devotees in around 1910, and a strong influence on the artist at this time, stated as early as 1911: "If you pay *attention* to his paintings, you will find they represent nothing, that your function of analysis and comparison fails you: the intelligence is baffled in the presence of a Matisse. Attention to Matisse as attention to music will lead to a mystical ecstatic state, such as that produced by drugs or music, where you have visions of the *au-delà* but learn nothing of the reality which Matisse has given you. If you receive them in a state of distraction, that is when they are used in an applied fashion and your attention is given to some vital matter of action—as your attention should be employed in life—they will aid you to keep your attention fixed."[30]

Still, Matisse's pictures also require a kind of intellectual attentiveness. The second fundamental principle on which they are based is a principle of critical enquiry. This was Matisse's concern when he said that he had never been content to stop at a 'satisfactory' stage in his work, and also when he told Paul

27 Interview with Léon Degand, 1945, in Flam, 1995, p. 165 ["Le décoratif pour une œuvre d'art est une chose extrêmement précieuse. C'est une qualité essentielle. Il n'est pas péjoratif de dire que les peintures d'un artiste sont décoratives."]
28 On this subject, see Yve-Alain Bois's analysis in "Matisse and 'Arche-drawing'" *Painting as Model*, Cambridge Mass. and London, 1993, pp. 24–28
29 See one of the most famous passages of the *Notes of a Painter* in December 1908: "The thought of a painter must not be considered as separate from his pictorial means. […] The entire arrangement of my picture is expressive: the place occupied by the figures, the empty spaces around them, the proportions, all of that has it share. Composition is the art of arranging in a decorative manner the diverse elements at the painter's command to express his feelings," Flam, 1995, p. 38 ["La pensée d'un peintre ne doit pas être considérée en-dehors de ses moyens. […] L'expression […] est dans toute la disposition de mon tableau: la place qu'occupent les corps, les vides qui sont autour d'eux, les proportions, tout cela y a sa part. La composition est l'art d'arranger de manière décorative les divers éléments dont le peintre dispose pour exprimer ses sentiments."]
30 Matthew Stewart Prichard, Notebook, early 1911, quoted in Labrusse, 1999, pp. 101–102 and p. 278

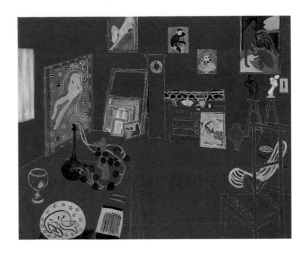

Henri Matisse, *The Red Studio*
(L'Atelier rouge), 1911, oil on
canvas, 181 x 219.1 cm,
The Museum of Modern Art,
New York

Rosenberg, in 1939: "My strength comes from my almost permanent doubts."[31]
What the artist shares with the viewer is an anxious questioning about the
picture within the picture, about its making, its structure, its power, its frailty.
As soon as the mimetic goals no longer justify the figurative image, as soon as
decorativeness (largely derived from the example of non-European cultures)
has been incorporated into traditional picture-making—easel paintings, still-
lives, portraits, etc.—the image itself becomes a question: how does it come to
be? What is its function? One of Matisse's most searching paintings, *L'Atelier
rouge* of 1911, with its all-over flat red colour-field, which anticipates the tech-
nique of the cut-outs, is itself a painting on the power of painting. And there are
innumerable motifs in Matisse's work which investigate the meaning of visual
representation: reflections in a mirror, glimpses through a window, or representa-
tions of the artist at work. Technically, all the signs of an unfinished work—stains,
scratches, drippings, rubbings-out, rifts in the painted surface, variations in the
speed of brushstrokes, compositional dissymmetry, etc.—question the paradox-
ical way in which the visual effect is achieved. The same can be said of two
systems often present in the paintings, each one conflictual in and of itself: first,
the frequent effect of spatial de-adjustment (with abrupt juxtapositions of contra-
dictory viewpoints, sharp contrasts of scale, and tensions between flatness and
depth); second, the friction between drawing and colour (with, for instance, the
lines duplicating themselves, or displaced in relation to the edge of the colour-
fields, as, most tellingly, in Matisse's very last painting, *Katia en robe jaune*).

So, aesthetically speaking, what makes the cut-outs different from the rest
of Matisse's work? A primary characteristic is simplification: "The paper cut-out

31 Letter to Paul Rosenberg,
24 November, 1939, quoted in Labrusse,
1999, p. 253 *["Ma force vient de mon
doute presque constant."]*

allows me to draw into the colour. For me, it is a simplification… This simplification permits precision by combining two means into one."[32] "I use the simplest colours. I don't transform them myself, it is the relationships that take care of that. It is only a matter of enhancing the differences, of revealing them. Nothing prevents composing with a few colours, as in music that is built on only seven notes."[33] "The cut-out is what I have now found to be the simplest and most direct way to express myself,"[34] etc. This concerns colour first and foremost: those flat fields, based on a limited range of tones, out of which the shapes are cut, provide the most accomplished demonstration of the 'quality-quantity' equation which Matisse learned from Cézanne and which he always gave as one of the founding principles of his aesthetics from the Fauvist period onwards ("At the time of the Fauves," he said in 1929, "what created the strict organisation of our works was that the quantity of colour was its quality.")[35] Colour simplification in the cut-outs not only implies a rejection of subjective brushwork, it achieves more than just effects based on the relationships between colours. As a consequence, it produces a new equilibrium where the former conflicting systems of forces in the paintings are more or less eliminated: the spatial shocks on the two-dimensional surfaces are replaced by a simple all-over flatness, and the fretfulness of the lines in and around the colour fields by a perfect clarity of contour.

In this way, the cut-outs give free rein to Matisse's decorative proclivities. From then on, he seemed more than ever to consider that his whole career had not only followed a clear path, but also that it had now led him to his final destination. As always with Matisse, this feeling had to be based on sound ideas, ideas which posited a clear chronological division between the final mastery of drawing and colour (true, once again, to the classical categories of Western painting). Drawing, Matisse says, was mastered by him between the end of the thirties and the publication, early in 1943, of the book *Thèmes et variations*, which was intended to illustrate this achievement. His "natural, unformulated and completely concealed drawing, that will spring directly from [his] feeling" was now flourishing so naturally that he thought Toulouse-Lautrec's exclamation could apply to himself: "At last, I've forgotten how to draw!"[36] Then comes colour, as he writes to his son Pierre in November 1945: "My idea is to deal with the colour as I did with drawing. If I succeeded, I would gladly pack my bags. I would have accomplished what I had set out to do in this world."[37] In other words, by making the cut-outs, Matisse was made able to say: "At last, I've forgotten how to paint!" This is the reason why, from then on, he so often labelled his cut-outs 'masterworks' (see p.129 ff.). The Vence chapel, of course, he con-

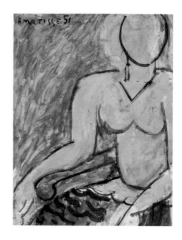

Henri Matisse, *Katia in Yellow Dress* (Katia en robe jaune), 1951, oil on canvas, 81 x 60 cm, private collection

32 Interview with André Lejard, 1951, in Fourcade, 1972, p. 243 [*"Le papier découpé me permet de dessiner dans la couleur. Il s'agit pour moi d'une simplification. […] Cette simplification garantit une précision dans la réunion des deux moyens qui ne font plus qu'un."*]
33 'Le Chemin de la couleur', 1947, in Flam, 1995, p. 178 [*"J'utilise les couleurs les plus simples. Je ne les transforme pas moi-même, ce sont les rapports qui s'en chargent. Il s'agit seulement de faire valoir des différences, de les accuser. Rien n'empêche de composer avec quelques couleurs, comme la musique qui est bâtie uniquement sur sept notes."*]
34 'Témoignage', 1951, in Flam, 1995, p. 208 [*"Le découpage est ce que j'ai trouvé aujourd'hui de plus simple, de plus direct pour m'exprimer."*]
35 Interview with Tériade, 1929, in Flam, 1995, p. 85. [*"Au moment des 'Fauves', ce qui faisait l'ordonnance sévère de nos œuvres, c'était que la quantité de la couleur était sa qualité."*] For the link with a supposed saying of Cézanne, see, notably, Matisse's statement to Tériade in 1936, in *ibid.*, p. 123. See also Yve-Alain Bois's commentary in Bois, 1993, pp. 37–39.

36 Letter to Henry Clifford, 14 February, 1948, in Flam, 1995, p.183 ["[…] un dessin naturel, non codifié et tout à fait dissimulé, qui viendra directement de ma sensation ; ce qui permettait à Toulouse-Lautrec, à la fin de sa vie, de s'écrier : 'Enfin, je ne sais plus dessiner'!."]

37 Letter to Pierre Matisse, 30 November, 1945, quoted in Labrusse, 1999, p.186 ["Je pense faire avec la couleur ce que j'ai fait avec le dessin. Si j'y arrive, je plierai bagages volontiers. J'aurai fini ce que j'ai à faire dans ce monde."]

38 Letter to his Lordship Rémond, June 1951, in Fourcade, 1972, p.257 ["Je la considère, malgré toutes ses imperfections, comme mon chef-d'œuvre."]

39 Letter to Pierre Matisse, 12 November, 1952, quoted in Pierre Schneider, Matisse. Visages découverts 1945–1954, Paris, 1996, pp.48–50 ["Je suis heureux que tu m'aies donné des nouvelles du panneau de céramique et ton appréciation me touche beaucoup. Je crois moi aussi que c'est mon chef d'œuvre. [...] J'éprouve un grand soulagement à mes inquiétudes quand je me fais conduire devant ce panneau de céramique."]

40 Letter to Pierre Matisse, 16 October, 1953, Pierre Matisse Archives, Pierpont Morgan Library, New York ["Je viens d'entendre à la Radio le célèbre Kyrie de la messe en Si mineur de J.S. Bach, devant mon carton de vitrail et devant le grand dessin pour la porte qui y est accolée. Je suis convaincu maintenant que mon œuvre est une sorte de chef-d'œuvre. Comment la défendre devant Madame Lasker?"]

41 Conversation with Brother Rayssiguier, 20 April, 1948, in Billot, 1993, p.59 ["Cette Vierge sera byzantine."]

42 Conversation with Brother Rayssiguier, 20 November, 1948, in Billot, 1993, p.107 ["C'est une composition chinoise."]

43 Conversation with Brother Rayssiguier, 13 June, 1950, in Billot, 1993, p.340 ["A propos du Saint Dominique, il me redit qu'il paraît 'comme les grands bouddhas qui sont dans de petits temples asiatiques'."]

44 Conversation with Brother Rayssiguier, 28 March, 1950, in Billot, 1993, p.319 ["Cela fera comme un tapis d'Orient."]

siders, "despite all its imperfections, [his] masterpiece."[38] A year later, he uses exactly the same word for his *Grande Décoration aux masques* (see p.72), meant at this time as a design for a ceramic mural: "I'm glad that you've written to me about the ceramic panel," he writes to Pierre. "I'm very touched by your appreciation. I also think that it's my masterpiece… I feel greatly relieved from my anxieties when I ask to be taken to see it."[39] And, again, for the Lasker mausoleum commission in October 1953, one year before he died: "I just heard on the radio the famous Kyrie of J.S. Bach's Mass in B minor, in front of my stained-glass window project and the big drawing for the adjoining doorway. I am now convinced it is a kind of masterwork. How can I recommend it to Mrs. Lasker?"[40] How do we explain this new burst of self-confidence? Not only was he approaching the end of a fifty-year-long career more or less true to the same principles, but also, the cut-outs seemed to bring about a resolution of Matisse's main contradiction, which had been to challenge the very idea of 'art' in the Western tradition while remaining himself an 'artist' in the traditional meaning of the word. The cut-outs are amazingly free of the old pictorial recipes, they are almost miraculously endowed with the grace of ornamentation, and still, they are unmistakably Matissean. Though they are made deliberately understandable, to the extent that everyone will feel he could make them, they also appear as the most recognisable signature of the master. Thus, Matisse felt that his old dream had been fulfilled, that he had at last succeeded in combining into himself the honesty of an anonymous craftsman and the glory of the great artist.

Matisse's positive attitude of mind is also apparent in the prophetic tone of his statements at that time. His utopian vision of a complete shake-up of Western aesthetics is ripe with cultural and ethical consequences. He is more than ever comparing his work with other cultures—European Middle Ages, Buddhism, Byzantium, Islam, Mesopotamia, etc.—all blended together, in a way that exemplifies the end of the Renaissance tradition. This is particularly striking as far as the Vence chapel is concerned. There, he successively describes his drawing of the Virgin as 'Byzantine'[41] and as 'a Chinese composition',[42] the one of Saint Dominique as comparable to 'the big Buddhas placed in the small Asiatic temples',[43] and the global effect as analogous to 'an Oriental carpet'.[44] He also refers to Coptic fabrics, to Sumerian carvings, etc.—and, finally, to an ideal mosque: "We will have a chapel where there will be hope for everyone. Whatever his faults are, he will be able to leave them behind at the doorway, as the Muslims leave their shoes, dusty from the streets, at the threshold of the

mosques."[45] The wars waged about the meaning and function of images are over. They have been superseded by a pacific message of 'relief' and by a proud announcement of 'what is happily coming'.

In the cut-outs, however, decoration remains consistent, in its own way, with the ancient rifts in Matisse's work. Proof of this, once again, is the severe dissociation between colour and line in the most important cut-outs, which means that the original tensions have not simply been overcome, but have been set at a decorative distance. The essential critical process, the everlasting aesthetic debate on the status of the image still exist, but they have been subsumed into a unifying ornamental framework. It is a secondary decoration, a decoration beyond decoration. The ultimate question, for Matisse, had always been to know whether an image could still be meaningful by breaking its own rules and adhering to the rules of ornamentation. Now, the two elements—meaning and ornament—are clearly separated: quite traditionally, Matisse seems to give the drawing the task of bearing meaning, while the ornamental function is assumed by colour. This is what happens in *Jazz*, with Matisse's thoughts hand-written on a page, and the colour plate printed on the opposite. This is also what happens in the Vence chapel, where the wall drawings, Matisse says, "explain the meaning of the monument."[46] But, strangely enough, this rather crude division is suddenly subverted: the handwriting in *Jazz*, he goes on to say, although it appears to have a plain meaning, bears a 'decorative rapport' with the plates, of which it is only an 'accompaniment,'[47] And the two sides of the chapel are also 'decorated differently'.[48] If you take *Grande Décoration aux masques*, the linear depiction of two human faces clearly carries the meaning, while the cut-out floral motifs all around serve nearly as a magnificent halo. But, as it is virtually infinite, this peculiar halo dilutes as much as it celebrates the meaning of the faces. In other words, in all these occurrences as in many others, a decorative whole is formed of two conceptual elements: the idea of decorativeness on the one hand, and its traditional opposite—the problem of meaning—on the other. The intellectual conflicts which have scarred so many paintings, are, in the cut-outs, dissolved into a radiant—albeit highly theoretical—overall decoration.

Exceptions to this paradoxical simplification still exist. In *L'Escargot* (see p. 111), for instance, the question of the status of the image is still open. Though the decorative effect is breathtaking—with an admirable sense of spatial expansion, based on an utterly non-mimetic relation to an element of the living world—some edges of the colour blocks are quite violently torn. Thus, the viewer is inevitably led to temper his initial rapture with a critical questioning of the creative process,

45 Conversation with Brother Rayssiguier, 24 October, 1948, in Billot, 1993, p. 86 [*"Nous aurons une chapelle où tout le monde pourra espérer, quelle que soit sa charge de fautes qu'il pourra laisser à la porte comme les mahométans laissent la poussière des rues à la semelle de leurs sandales abandonnées à la porte des mosquées."*]
46 "La Chapelle de Vence, aboutissement d'une vie", 1951, in Flam, 1995, p. 198 [*"Les céramiques sont l'essentiel spirituel et expliquent la signification du monument."*]
47 *Jazz*, 1947, in Flam, 1995, p. 171 [*"La dimension exceptionnelle de l'écriture me semble obligatoire pour être en rapport décoratif avec le caractère des planches de couleur. Ces pages ne servent donc que d'accompagnement à mes couleurs."*]
48 "La Chapelle de Vence, aboutissement d'une vie", 1951, in Flam, 1995, p. 198 [*"[…] les deux grands côtés de la chapelle qui, décorés différemment, se soutiennent en s'opposant."*]

a process which, in this case, has dispensed not only with the mastery of the brush, but also of the line. What, therefore, makes such an image effective? Matisse does not provide an answer. He merely—but splendidly—leaves the question to his viewers. More generally, this leads us to one final paradox: rid of the basic elements of painting, the cut-outs might amount to 'almost nothing'— but an 'almost nothing' which, as Dominique Fourcade has pointed out, mysteriously alludes to 'something else'.[49] At the very moment when everything that makes up the substance of an image seems to vanish, it is as present and as powerful as ever. Forceful in their fragility, brilliant in their humility, the cut-outs emerge as the unexpected embodiment of what had always seemed impossible to the Western world: the eternal presence of the image unites with the fleeting grace of the ornament.

49 Dominique Fourcade, 'Something Else', *Henri Matisse. Paper Cut-Outs*, 1977, p. 55

I wish to thank Michael Stokes and Lulu Norman for correcting my English, Claude Duthuit for allowing me to use the Henri Matisse Archives in Paris, Paul Matisse for giving me access to the correspondence between Henri and Pierre Matisse, now at the Pierpont Morgan Library in New York, and Robert Parks, Curator of Literary and Historical Manuscripts at the Morgan Library, for enabling me to read these letters. I am also indebted, for their help and their conversation, to Olivier Berggruen, Yve-Alain Bois, Dominique Fourcade, Wanda de Guébriant and Pierre Schneider. Parts of this text are developed from previous analyses, particularly from chapter VIII of my book *Matisse. La Condition de l'image*, Paris, 1999.

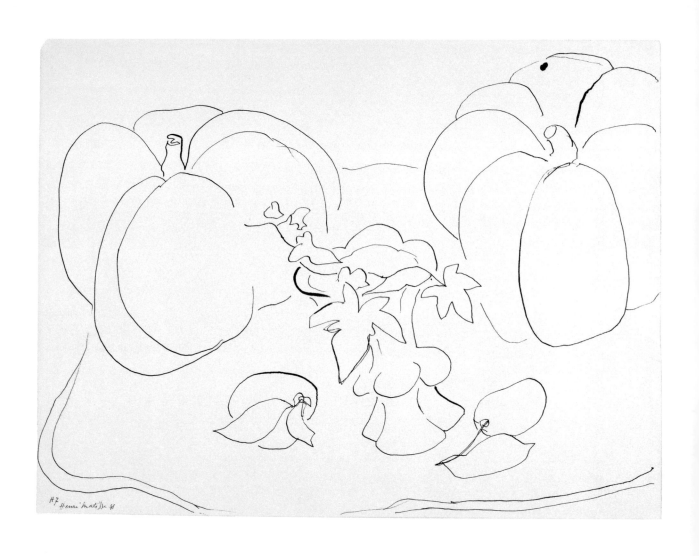

31 **Theme H Variation 7** Thème Variation 7 1941

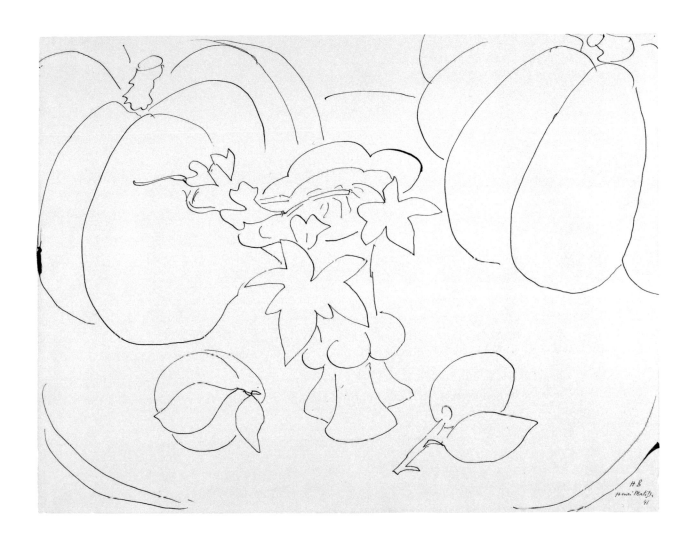

32 **Theme H Variation 8** Thème Variation 8 1941

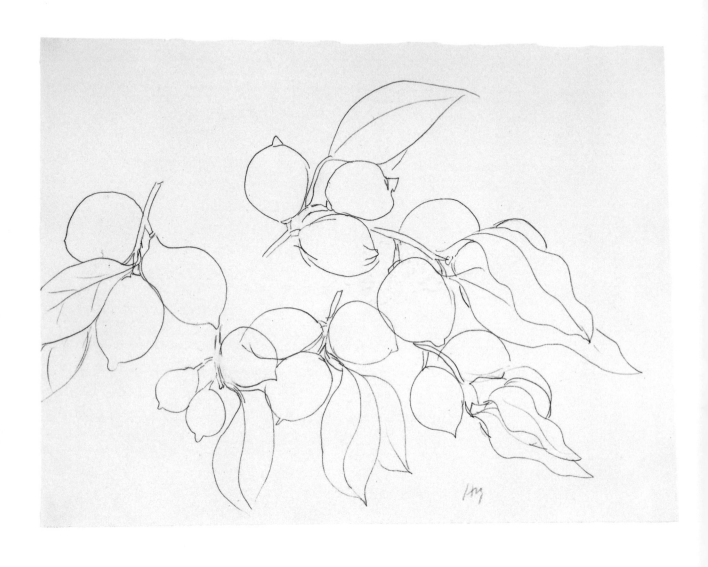

33 **Study with Lemons** Étude citrons 1945

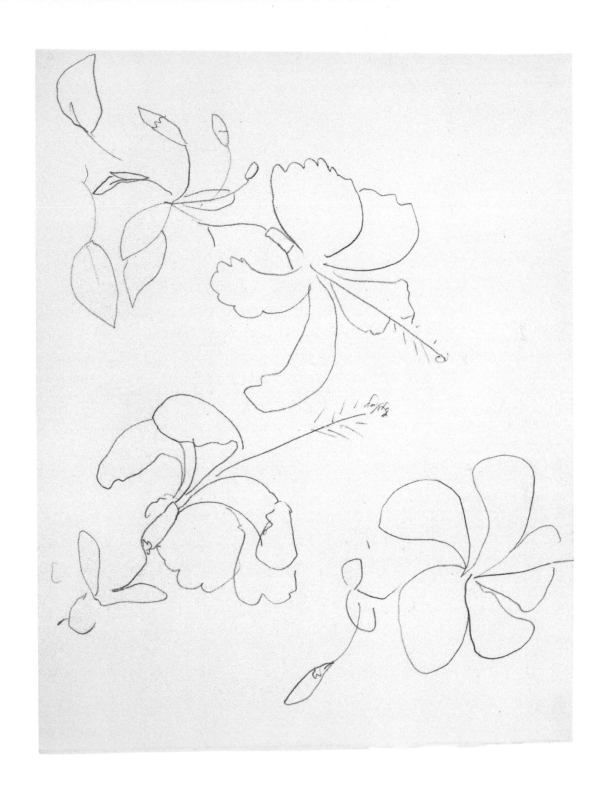

34　**Hibiscus Flowers**　Fleurs d'hibiscus　*c.*1940

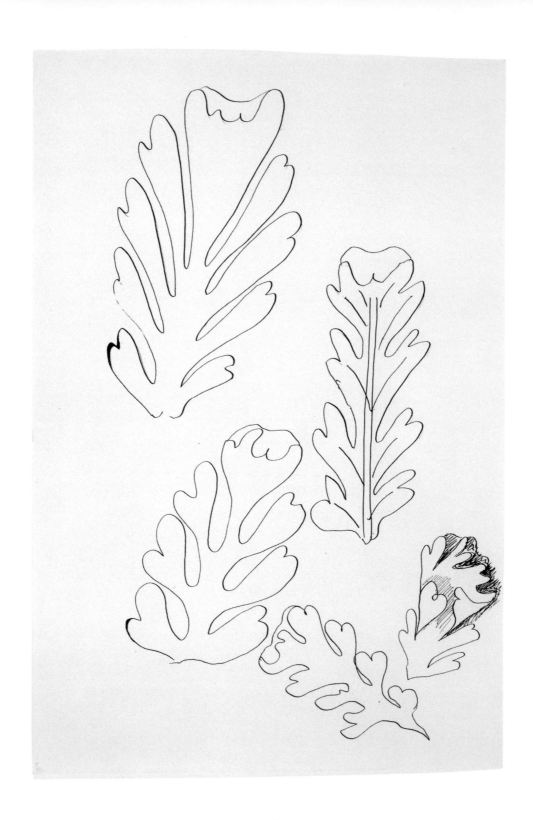

35 **Study with Oak Leaves** Études feuilles de chêne 1945/46

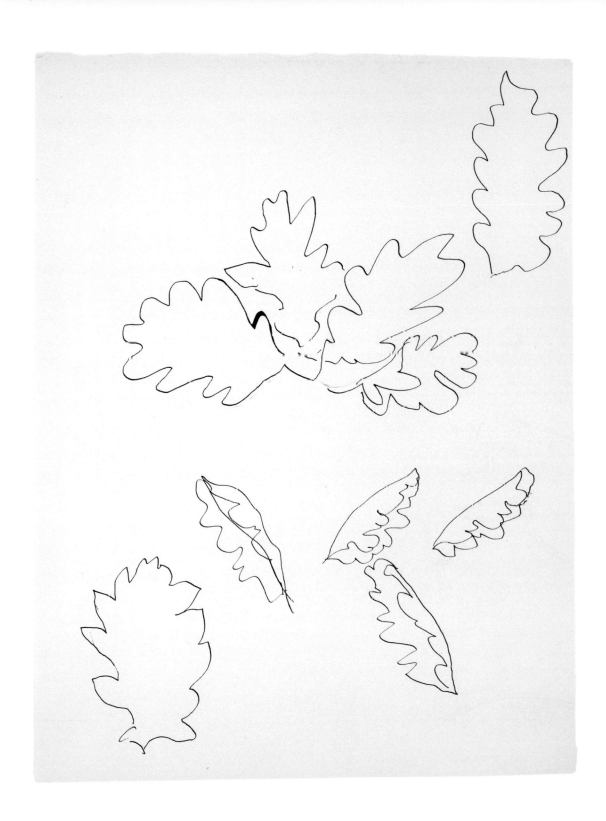

36 **Study with Oak Leaves** Études feuilles de chêne 1945/46

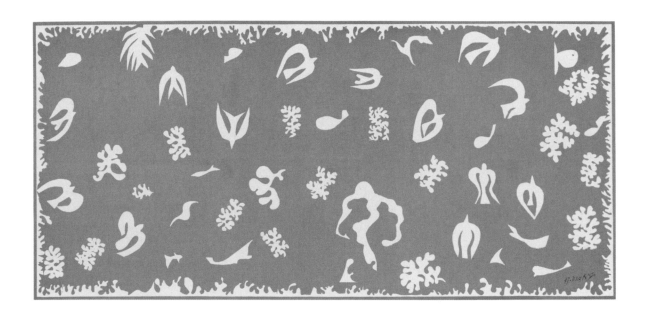

37 **Oceania, the Sky** Océanie, le ciel 1946

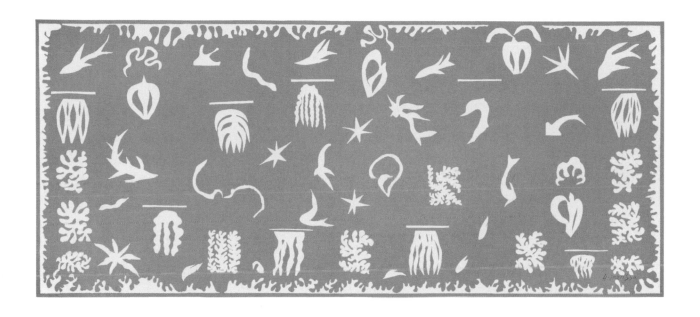

38 **Oceania, the Sea** Océanie, la mer 1946

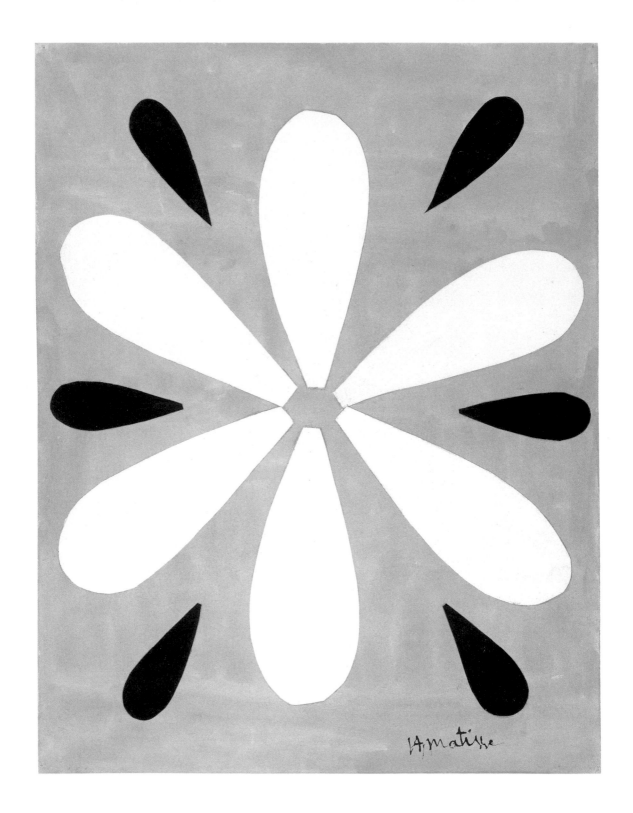

39 **The Daisy** La Marguerite 1945

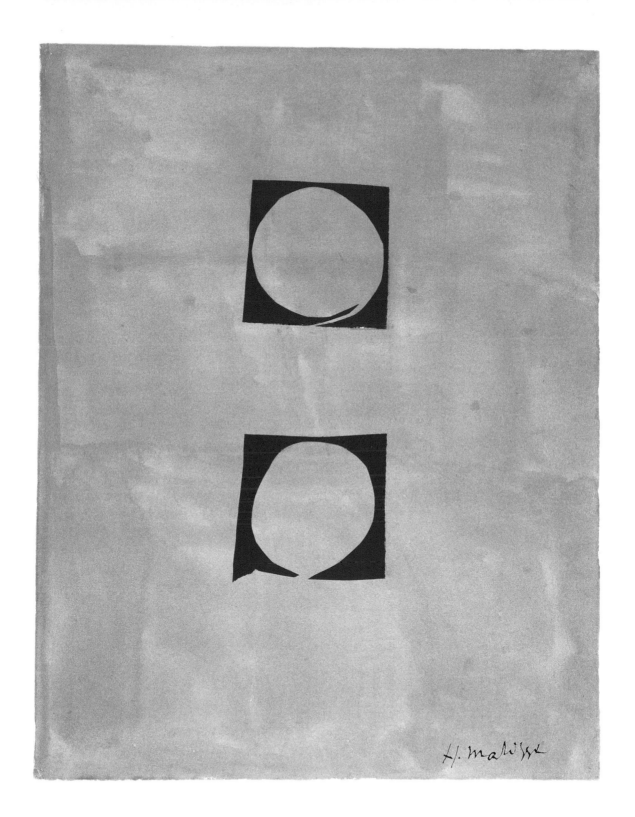

40 **Red and Gold** Rouge et or 1945/46

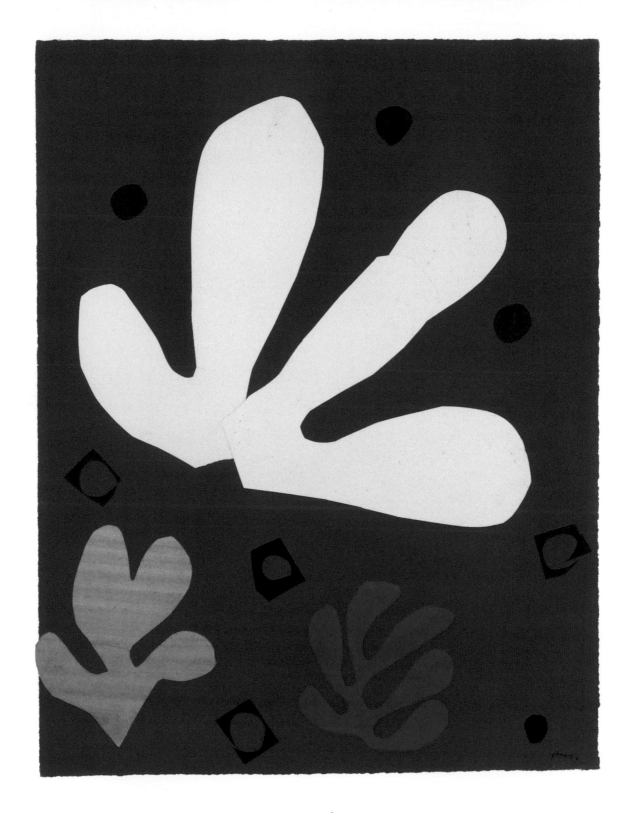

41 **Vegetal Elements** Éléments végétaux 1947

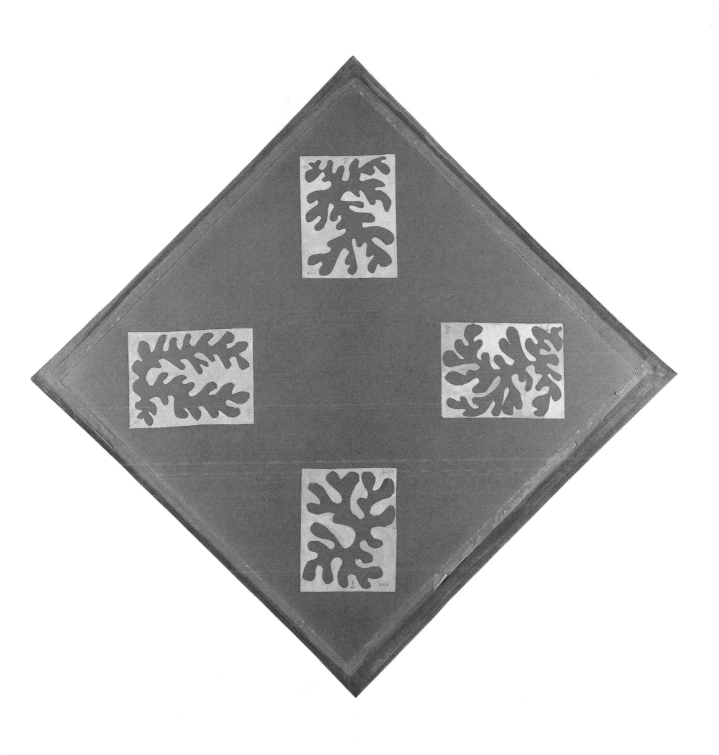

42 **Ascher Square—Model 'A' for a scarf** Ascher Square – maquette de fichu «A» 1946

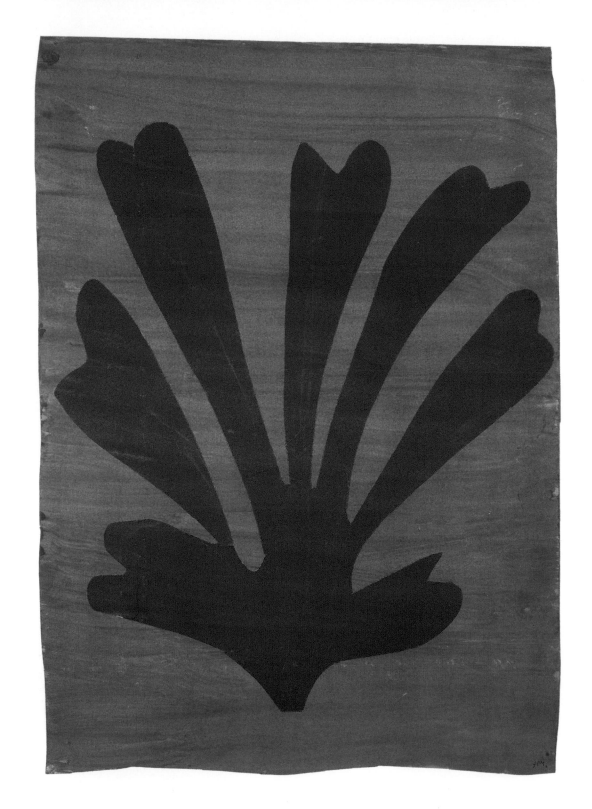

43 **Palmette** 1947

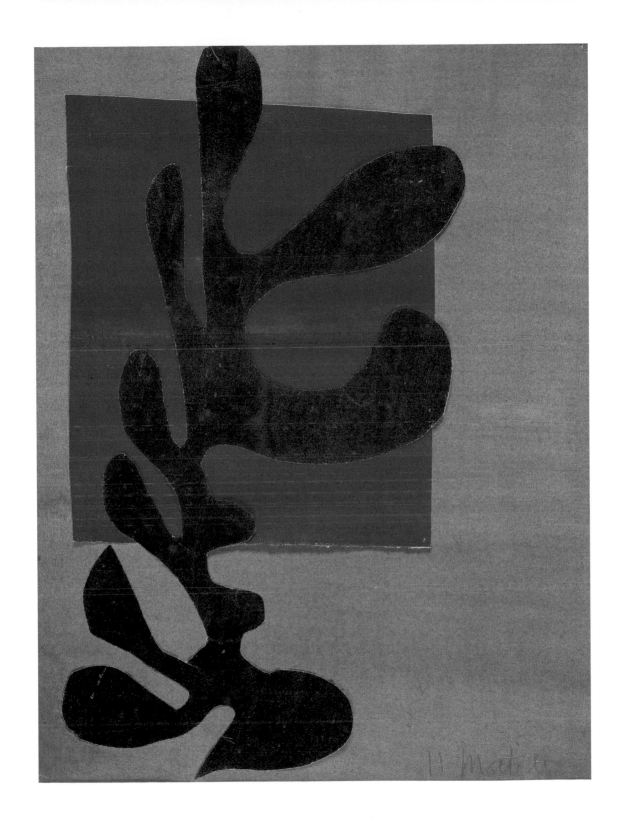

44 **Negro Boxer** Boxeur nègre 1947

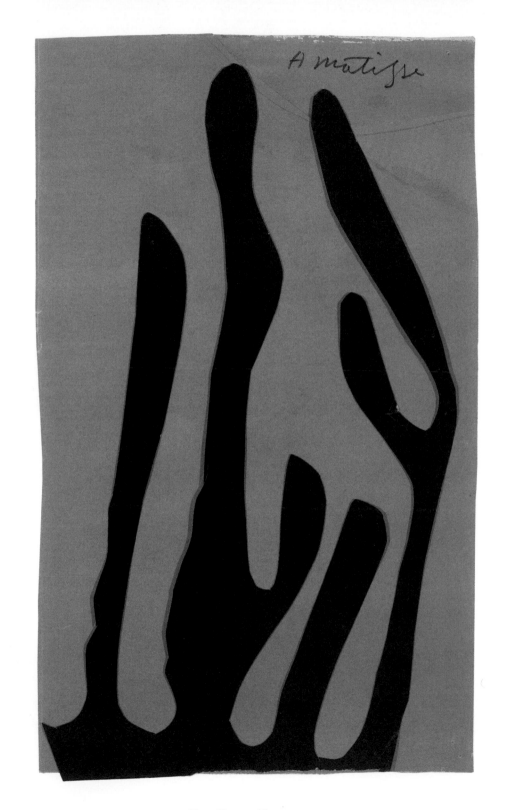

45 **Algae** Algues 1947

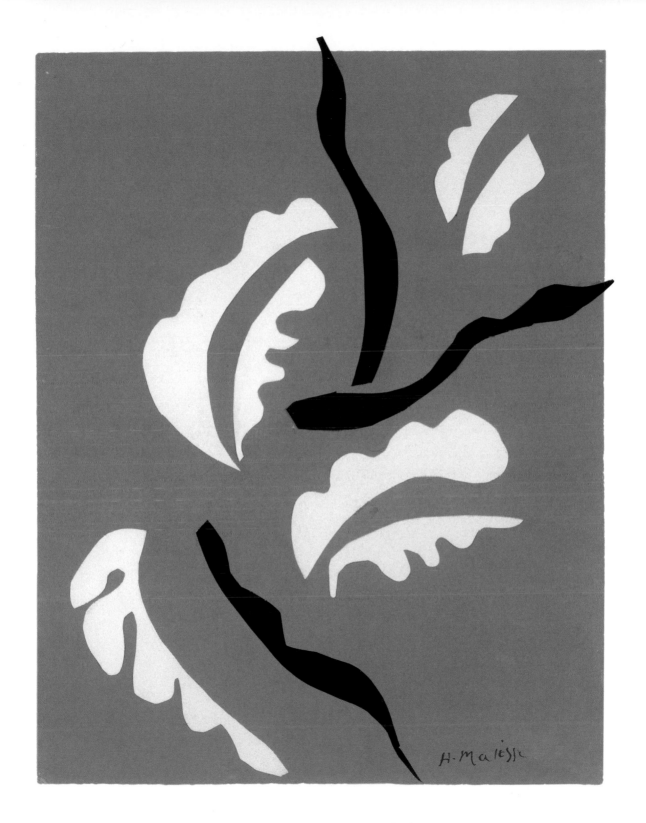

46 **Acrobatic Dancer** Danseuse acrobatique 1949

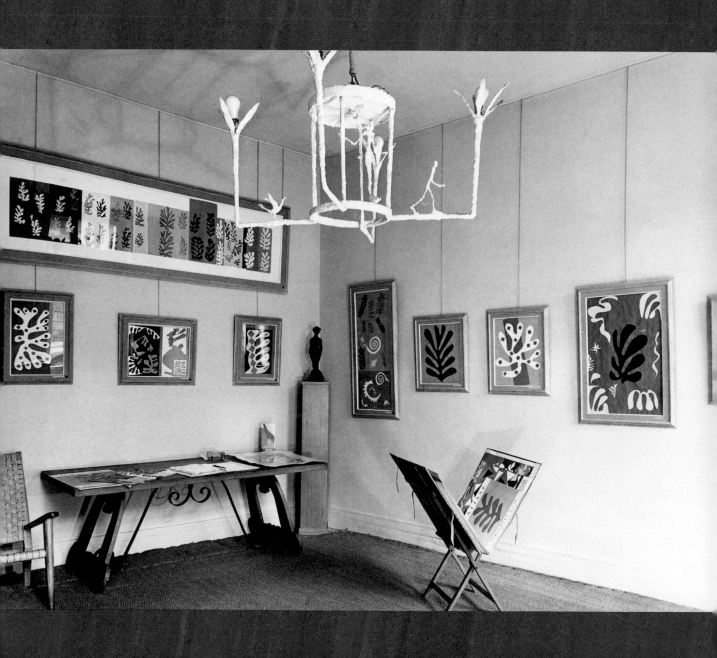

Resonance and Depth in Matisse's Paper Cut-Outs

Olivier Berggruen

In the late thirties, Matisse started experimenting with a new technique in which he cut and then glued sheets of paper primed with gouache. Fairly soon, the enormous potential of this approach became apparent to him, for it was neither drawing nor painting, but a combination of the two. He wrote: "Instead of drawing an outline and filling in the colour… I am drawing directly into colour."[1] Perhaps his lifelong dream of reconciling drawing and colour could be achieved. But if the cut-outs represent a new departure, Matisse remained faithful to the artistic principles of his youth. Underlying his practice from its earliest days was the idea of faithfulness to his senses; and its corollary in the form of a deep distrust of theory. This is not to say that Matisse did not reflect on his practice; indeed, his conversations with Paul Signac, whom Matisse saw in the summer of 1904, were crucial in defining his general aesthetic outlook. In particular, he embraced some of Signac's utopian aspirations: the idea of a mythical golden age, situated far away in the past, but which holds the promise of a radiant future.

This utopian vision found its aesthetic expression in a decorative approach to painting, one that stresses the play of surfaces, the relation between coloured planes at the expense of illusion and representation. With the *papiers découpés*, the artist's deeply felt experience of nature was synthesized into an order which proclaims its own autonomy. In a letter to Bonnard from 1946, Matisse declared that his ambition was to be a modern Giotto.[2] I take this to mean that he conceived his work as the embodiment of a synthetic aesthetic vision, one that affirms its validity beyond time and place, just as Giotto's frescoes seem to reconcile various tendencies of his age. The concern was with integrating all aspects of experience, including the recognition of the artistic practice's own demands, instead of a narrow approach through representation and mimesis. Matisse knew that a work of art is the result of a precarious equilibrium. It can never replicate the experience of nature; but without the latter, art has no purpose. This realization became the ground upon which the artist regained a sense of authenticity. In other words, his only choice was to embrace nature,

1 Quoted in John Elderfield, *Henri Matisse: A Retrospective*, New York 1992, p. 413

2 "Giotto est pour moi le sommet de mes désirs…" Letter dated 7 May, 1946. Quoted from Jean Clair and Antoine Terrasse, eds., *Bonnard Matisse Correspondance*, Paris 1991, p. 127. Incidentally, one cannot help but notice the same concern for luminosity, with the use of a vibrant blue background, in Giotto's frescoes for the Scrovegni Chapel in Padua—which Matisse had visited—and in the blue and white cut-outs.

even though nature proved elusive. With his last works, the paper cut-outs, Matisse attained a sense of trust in his own creative powers.

Matisse's ideal was that of a working practice perfectly attuned to what he called the 'rhythms of nature'. This required a tremendous discipline whereby all constricting mental attitudes had to be rejected. To make use of ready-made, learned concepts was to distrust one's own visual impressions. The 'apparent ease' hinted at by Matisse is not unlike that of children, whose practice is devoid of rhetoric and obsessive mimesis.[3] Visual innocence, in particular, was a common concern sweeping through much of nineteenth-century art. Witness for example Cézanne, who dreamed of an innocent eye. Many artists have attempted to reject tradition, which they felt to be constricting, without quite succeeding. For Matisse, the intense gaze that was directed towards identification and complete absorption into the subject matter meant that the conventions of academic painting had to be discarded. They could only be replaced by a vision in which inner and outer world, the observer and the thing observed, are merged.

But it seemed that the relation between man and nature had suffered a decisive blow in the course of the nineteenth century. Nature was no longer felt to be innocent, and it was uncertain whether it could be retrieved. This kind of disenchantment took many forms, not least the baudelairean attitude according to which nature does not fulfill its promise and art should correct and redeem it. The following generation, under the influence of Mallarmé's poetics, sought to redirect the experience of nature in an imaginary realm that was divorced from the immediate and the present reality. Such aesthetics were deeply ingrained in Matisse, who was, after all, Gustave Moreau's pupil and admirer. Symbolism stressed feeling over intellect, suggestion over description. Above all, the work

Giotto, Joachim is driven from the Temple, part of the fresco in the Scrovegni Chapel, Padua, c. 1303–05, 185 x 200 cm

3 To André Verdet Matisse declared: "One must know how to maintain childhood's freshness upon contact with objects, to preserve its naivety. One must be a child all one's life, even while a man, take one's strength from the existence of objects—and not have imagination cut off by the existence of objects." André Verdet, *Prestige de Matisse*, Paris 1952, p. 59. Quoted in Jack D. Flam, *Matisse on art*, Berkeley & Los Angeles 1994, p. 145. Also see H. Matisse, *Looking at Life with the Eyes of a Child*, 1953. Reprinted in Flam, op. cit., pp. 148–9

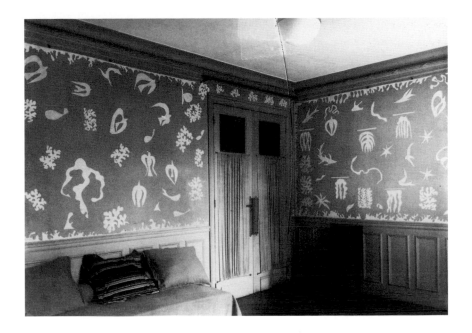

of art had to be evocative and emotionally resonant. According to this aesthetic stance, intuition was crucial to artistic practice, and one should strive to communicate ideas and feelings derived from nature by means of the simplest forms. The Symbolists felt a general disdain for anything too literal, too mimetic in the depiction of reality. Matisse was deeply influenced by the belief that images do not simply depict, but are suggestive in ways which can never be objectified and remain open-ended in their symbolism.

In the summer of 1946, Matisse pinned a series of white motifs reminiscent of tropical seas and skies onto the warm, earthy tone of the sizing paper covering the walls of his Parisian studio. The various elements—corals, starfish, algae, leaves and birds—were arranged in an informal, yet orderly manner. Against the sable-like ground, they seemed to be infused with an incandescent light. The artist placed a decorative border which frames the composition along the edges. The overall effect was one of playfulness. In the following years, Matisse turned his 'improvisation' into the two panels known as *Océanie, le ciel* and *Océanie, la mer*. Zika Ascher, the English pioneer in printing techniques on cloth, reproduced them on a thick linen canvas, and it is in this form that they are known to us.

In conceiving these works, the first large-scale *papiers découpés*, Matisse drew on the memory of his travels to French Polynesia. In this journey to the islands, dating back to 1930, nature seemed to regain some of its lustre, appeal

and innocence under the stark tropical sun. But the exoticism of the islands also succeeded in creating anguish in his mind: "In Tahiti I could appreciate the light, light as pure matter, and the coral earth. It was both superb and boring. There are no worries in this land, and from our tenderest years we have our worries; they probably help keep us alive. There the weather is beautiful at sunrise and it does not change until night. Such immutable happiness is tiring."[4] The sheer lushness of the tropical landscape was overwhelming. For many years, Matisse did not know what to make of his experience. It seems that a period of maturation—the mental distancing from the source of creation—was required. Then, in the Forties, the fear of paralysis had vanished and was replaced by a renewed sense of freedom. The memory of Tahiti, purified and decanted, allowed for this late creative flowering.

As we saw, his ideal consisted of creating images in which the experience of nature is fully absorbed, so that the artist can "identify himself with her rhythm."[5] But clearly, Matisse was a modernist who derived little satisfaction from the 'enslavement' that naturalism entailed; instead, the residue of past experience became the conduit for a self-sufficient artistic practice—one that refers to reality without necessarily inviting for a comparison with an ineffable 'model' that is supposed to be behind it. The work functions within its own realm, neither divorced from reality nor espousing it. In other words, for Matisse representation is primarily a vehicle for channeling sensations and emotions, and not a pursuit in itself. The desire to reawaken memories such as the journey to Tahiti, rendered more vivid by the passage of time, has clear symbolist overtones, in particular if we think of Mallarmé's notion of *absence*. The longing for a lost paradise is perhaps tied to this symbolist notion, whereby the absence of things can create within oneself a resonance that echoes the effects of the original impression. Just as the written word can evoke the smell of a flower, the experience of the Pacific isles finds its virtuality through recreation. Instead of an immediate presence, we have the delayed presence of memory. The lesson learnt in French Polynesia hinges on a renewed sense of the *presence* of the world. Perhaps the key impression that endured in Matisse's mind was that of a unifying light, of its unparalleled vibrancy; a landscape in which sky, earth, sea —and its many creatures—and the human figure are one. Images appeared as if the painter dreamt with his eyes open.

Matisse sensed that the natural world could only be retrieved in its authenticity through a complete rearticulation of the original experience. But he rejected subjectivism, which is based on a mistaken assumption that inner con-

4 "Matisse speaks, entretien avec Tériade," *Art News Annual*, no. 21, 1952. Quoted in Flam, op. cit, p. 135. At the end of that year, Matisse published a text in a literary review that served as a presentation to the two panels of *Océanie* which were then in the process of being printed: "This panel, printed on linen, white for the motifs and beige for the background, forms, together with a second panel, a wall tapestry composed during reveries which came fifteen years after a voyage to Oceania. From the first, the enchantments of the sky there, the sea, the fish, and the coral in the lagoons, plunged me into the inaction of total ecstasy. The local tones of things hadn't changed, but their effect in the light of the Pacific gave me the same feeling as I had when I looked into a golden chalice. With my eyes wide open I absorbed everything as a sponge absorbs liquid. It is only now that these wonders have returned to me, with tenderness and clarity, and have permitted me, with protracted pleasure, to execute these two panels." *Labyrinthe*, 23 December, 1946. Quoted in Flam, op. cit., p. 110
5 Letter to Henry Clifford, 1948. Reprinted in Flam, op. cit., p. 121

tents can be transcribed without distortion and interpretation. This is why he was careful to dissociate himself from the Surrealists. Their technique of automatic writing, though it appealed to the unconscious forces at play in the artist's psyche, did not seem to transform the content of experience in a satisfying manner. Matisse believed that the epiphany manifested by the work of art owes its powers to something which lies beyond the subjectivity of the painter; rather, the artist breaks with the 'received sense of identity and time', to use Charles Taylor's expression.[6] In fact, the work bears witness to a heightened sense of his presence in the world. This speaks of the necessity for the artist to transcend his day-to-day concerns so as to become an 'instrument' of the spiritual power of being. In John Elderfield's perceptive words, "Matisse's whole career was a constant emptying himself of emotion into images constructed from the world."[7]

To his friend Father Couturier he declared, on the subject of drawing, or rather 'creative drawing' as he put it: "Then my mind empties of everything—and I am merely a bystander looking at what I am doing."[8] Or his words to Brother Rayssiguier in a conversation about the Vence Chapel: "I'll go as far as to say that any painter who manages to produce necessarily attains the religious. Thus I am conscious of assembling materials, of working to try and put them into some kind of order, but when the picture is done, I have the feeling that I am not the one who painted it; God is." To which Rayssiguier replied: "In short, a kind of alter ego." "Yes, answered Matisse, someone other than myself… It can't have been me, a human being."[9] It seems that he deliberately avoided any reference to an ego, the kind of mythical, romantic view of the artist as a demiurge. Matisse's practice was not primarily a self-reflective activity. More accurately, the exploration of outside sources that resonated deeply within him—some of them unconscious—meant that he had to make himself as transparent as possible to the content of his experience.

Once the artist had reached the point of complete identification with his subject, the execution of the work was a *natural process*. Back in 1929, Matisse had executed a series with the eyes closed: "I must be so penetrated and immersed in my subject that I can draw it with closed eyes."[10] However, the last comment refers to the particular discipline of draughtsmanship. When it came to the cut-outs, Matisse's practice could no longer display such a fluency. Indeed, the *papiers découpés* bear witness to the artist's delicate, considered, not to say fractious, assembling of coloured surfaces. Moments of hesitation were part of this process: pin-sized nail marks adorn the coloured sheets, revealing multiple shifts in the placing of the paper. And sometimes, added strips of paper give the

6 Charles Taylor, *Sources of the Self: The Making of the Modern Identity*, Cambridge, MA, 1989, p. 465. The notion of a retrieval through the work of art of lost experience is, needless to say, a paradigm in much twentieth-century art and literature. Proust, Adorno and Walter Benjamin are some of the examples given by Taylor.
7 John Elderfield, *The Drawings of Henri Matisse*, London 1984, p. 134
8 M.-A. Couturier's Diary, 14 November, 1950. Quoted in Marcel Billot, ed., *The Vence Chapel: The Archive of a Creation*, Milan 1999, p. 366
9 Rayssiguier's Diary, 4 December, 1947. Quoted in Billot, op. cit., p. 40
10 Matisse to M.-A. Couturier, December 1948. Quoted in Dominique Fourcade, ed., *Henri Matisse: Écrits et propos sur l'art*, Paris 1972, p. 269

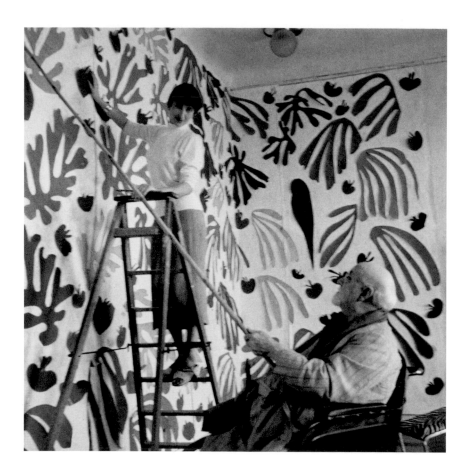

Paule Martin and Matisse
in the Hôtel Régina, Nice,
*c.*1952

shapes a new fullness or direction. Often Matisse asked Paule Martin, his assistant in the early Fifties, to move some compositional elements until a point of equilibrium had been reached. Very small shifts had to be effected. Often the yet unfinished cut-outs remained pinned to his bedroom-walls for long periods of time. He was careful to give precise instructions to his assistant, but sometimes these were misinterpreted or had to be clarified. *Blue Nude IV* took several weeks to be completed, and the shifts in the placing of the coloured elements are visible.[11] In comparison, the subsequent *Blue Nudes* were quickly executed, almost effortlessly.

Let us add that once a cut-out was completed, the artist felt elated and appeased, almost surprised by the result of his own work. This was akin to a mental distancing in which he became the bemused spectator of his own practice, one that had exerted its own power and control over him. "There is no intelligence in my work," he said to Father Couturier in July 1952, in reaction against André Breton's intellectual interpretation of his work. "I am not intelligent enough,

11 Conversation with Paule Martin,
Paris, January 2002. I am grateful
to Paule Martin for her precious insights
into the artist's studio practice.

I'm incapable of doing anything other than whatever flows from me of its own accord."[12] In other words, what Matisse is conveying here is that his practice amounts to more than individual self-expression. Creation is seen as exceeding the activity of the self; rather it is a transformative process in which inner and outer forces cannot truly be distinguished. Subjective activity is not pure creation but transformation of sources that lie outside of the self. It is the *Nachbildung* that Friedrich Schlegel alluded to in his aesthetic writings. Thus, the work of art carries certain forces which are never those of the subject alone; they are embedded in the images and the culture that permeate his consciousness. The artist is no longer at the origin of all activities, but the intercessor who produces new forms taken from a shared cultural environment.

Matisse certainly shuns in his late work any mimetic impulse; his art never defines itself as an investigation into the nature of reality. Compositional elements refer to the natural world—a coral, a dancer, an acanthus leaf—they are sign-posts for the viewer. But this is not to say that they are mere disembodied presences. It would be more accurate to describe them as representations in which mimesis plays a relatively minor role. They point to a presence, a decorative fullness in which the notion of context—as it is understood in the Western tradition—is almost obliterated. Nothing is made visible in terms of narrative content: neither story nor context, save for the eternal tropical summer; these

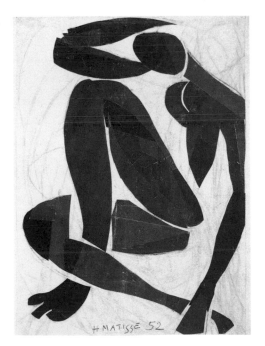

Henri Matisse, *Blue Nude IV* (Nu bleu IV), paper cut-out, 102.9 x 76.8 cm, Musée Matisse, Nice

12 Quoted in Billot, op. cit., p. 416

images lack in human intimacy and everyday occasion. For instance, in *La Perruche et la sirène*, the grenadines and other fruit and leaves do not hold the promise of a bacchanalia; we seem to be at the antipodes of traditional genre painting. The *Blue Nudes* are not objects of desire; strangely absent, lacking in sexuality, they are hardly about nudity, but suggest a presence within a gener-alised decorative scheme. Most of all, the artist eschews realistic details; spe-cific physical traits are lacking. *Recognition* of a subject remains a possibility; but faithful *representation* is left behind, as are the painted illusions of the past, and in particular perspective. Space is no longer theatrical, and certainly less architectural than traditional easel-painting.

Colour, too, is divorced fom any realistic intention: it is the nude that is blue, whereas sky and sea are white to the point of incandescence. It seems as if the nude had internalized the feeling of purity of the natural elements. Matisse's technique of cut paper—'drawing' with scissors—was the means to define in a new architecture of the image, based on the relation between coloured sur-faces. A feeling of harmony between the various cut-out elements was essential to this endeavour. Favourite schemes emerge, such as the light cadmium red and bright blue of the *Composition with Red Cross*. Foreground and back-ground have equal weight; and images seem to shift accordingly. Since all the colours are brought to the highest degree of intensity, a vibrating energy is released. This was already noticed by Bernard Berenson in connection with Matisse's much earlier *Dance* of 1912. In his letter to the painter from December

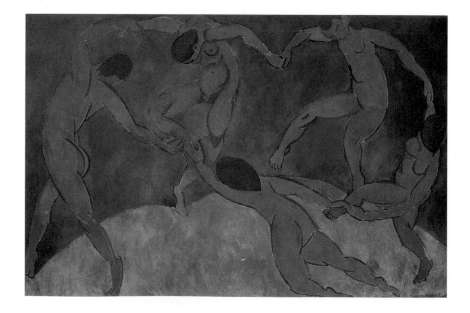

Henri Matisse, *The Dance* (La Danse), 1909–10, oil on canvas, The State Hermitage Museum, St. Petersburg

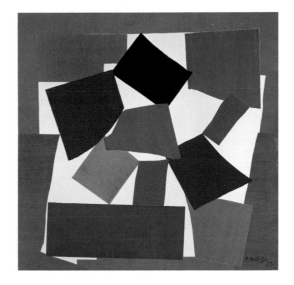

Henri Matisse, *The Snail*
(L'Escargot), 1952–53,
paper cut-out, 287 x 288 cm,
Tate Modern, London

1912, Berenson wrote: "Today I received the photograph of your *Dance*. How good of you to send it to me! The composition charms me and I look at the void spaces with my eyes, and I feel the rhythm with my entire body."[13]

Such purity of colour, already a feature of Matisse's early work, seems to induce in the beholder a feeling of liberation from all that is material. Most significantly, the viewer feels a vibration, the intimation of a wavering movement, when confronted with Matisse's surfaces, as in *The Snail*.[14] Here the large blocks of colour are juxtaposed without any 'resting' areas between them. There are no neutral zones within the picture. The surfaces are spatially so strong that each plane becomes equivalent to a volume. The pure, saturated colour permeates the beholder's field of consciousness at the expense of everything else, almost to the point of dizziness. Needless to say, Matisse's approach rested on observation and sentiment, and was never derived from scientific theories. He wanted to induce independent sensations and feelings in viewers by means of pure colour—colour almost detached from depicted objects.[15] Colour was the open window to abstract states of mind. However, it should be said that such feelings are not necessarily at odds with the physical, tangible presence of the artwork. That is to say, the experience of a spiritual depth has its source in the architecture of the coloured surfaces. If the effect produced by the *papiers découpés* is one of lightness, of immateriality, then the physical, tangible presence of the paper, the thinly applied layers of gouache, the intimation of a gesture carried by the scissors, or perhaps directed by the hand, lie at the root of the image's functioning.

13 Letter dated 9 December, 1912. Matisse Archives, Paris

14 In his conversation with André Verdet, Matisse declared: "Dans une composition chaque élément doit être élevé à son maximum de rayonnement, de densité. Cet élément, bien que perçu à part, doit nécessairement concourir à l'harmonie de l'ensemble." Verdet, op. cit., p. 27

15 Matisse would certainly have agreed with Baudelaire's comment on Delacroix: "Il semble que cette couleur, qu'on me pardonne ces subterfuges de language pour exprimer des idées fort délicates, pense par elle-même indépendamment des objets qu'elle habille." Charles Baudelaire, "Exposition universelle (1855)" in *Œuvres Complètes*, Paris 1976, vol. II, p. 595

For Matisse, nature was always the starting point, but his desire to eschew the specific details of visual appearance meant that his art veered towards abstraction. The two panels from *Océanie* articulate a surface deployed along a horizontal axis, with the seemingly regular arrangement of white forms; this ordering introduces a sense of repetition since the motifs are of comparable size. Repetition succeeds in stripping the objects of identity, so that the purely referential character of the various sea and sky creatures is kept to a minimum. We can perhaps speak of the 'hyperbolic expression' of symbolic representation, as Jean Cassou has said, the exaggeration of distinctive marks, something almost, but not quite, formulaic.[16] This reduction of visual signs to mere symbols is the device which allows the beholder to look at the work in all freedom: according to Matisse in a conversation with Georges Duthuit "in such a way that he leans on the picture but is able to think of something altogether different than the particular object depicted."[17] The painter felt that one should reject 'imitation'—the copying of perceived reality through the production of objects which are similar to some concrete model—and thus conceive the work as a network of signs, forms and coloured surfaces of which representation is only one aspect.

There is a tendency to assume that since the picture is deployed along a flat surface, it is inherently static; but Matisse viewed his work as primarily dynamic. The elements of unity and rhythm which give the cut-outs their distinctive character can never be interpreted as wholly static. The work of art sets off certain reactions in the mind of the beholder; it acts like a field of energy. Matisse's friend Matthew Prichard wrote of him that he "accepted the position that a picture by Corot was meant to be looked at, while his own painting was meant to be felt and submitted to, that it did not express a subject but incited us to create in a given direction."[18] He was one of the few artists in the Western tradition to realize that a work of art acquires its identity by the nature of the gaze directed at it. It requires an effort of collaboration on the part of the spectator to reach its full potential. I think that the aesthetics developed in the cut-outs succeed in liberating the viewer from mimesis without plunging him into the unknown void of abstractness. The work of art becomes a starting point and does not make us think only of the depicted object. Matisse rejects a vision which draws the viewer firmly into the picture-space, an enclosed space which is supposed to link the inner vision of the artist with that of the beholder. On the subject of the Barnes *Dance*, Matisse said that it "functions according to the depth of expression and the depth of spirit of the beholder."[19] Such images are relational without being solely dependent on a model. The relational aspect involves the work of art and its

16 Jean Cassou, *Matisse*, Paris 1939. Introduction (no page number)
17 Georges Duthuit, *Représentation et présence. Premiers écrits et travaux. 1923–1952*, Paris 1974. Quoted in Rémi Labrusse, *Matisse. La condition de l'image*, Paris 1999, p. 147
18 Quoted in Labrusse, op. cit., note 447, p. 302 (Archives Duthuit)
19 Quoted in Labrusse, op. cit., p. 250. On the 'relational' dimension of Matisse's art, see Labrusse, pp. 250–5

beholder. Instead of being confined by a closed proposition about the world, the viewer may reach a movement of abolition of the self, a mechanism of identification and absorption.

An aesthetic response can never be objectified. But the kind of experience Matisse was aiming for in his late work is strangely akin to what Kierkegaard alluded to in his analysis of the aesthetic; by tracing the development of the beautiful, "one will find that the direction of this movement is from spatial categories to temporal categories, and that the perfecting of art is contingent upon the possibility of gradually detaching itself more and more from space and aiming toward time."[20]

Perhaps the idea Matisse had of his craft was derived from the Oriental tradition which he admired so much. He once declared: "I believe my role is to provide calm. Because I myself have need of peace."[21] This is a conception of art as expressive and harmonious, a stimulus to meditation and elevation of spirit. Here it is worthwhile to refer back to the Indian philosophical tradition, which meant little, if nothing, to Matisse. But it is relevant in describing what the viewer might feel while engaged in the act of aesthetic contemplation; indeed it may point to a particular realm in which the paper cut-outs function at the height of their powers.

The Indian medieval discourse points to a particular response from the viewer which coincides with Matisse's aims. The Indian school or *darśana* known as Vedanta shows that the experience of aesthetic bliss is not unlike that of liberation (*mokṣa*). Vedanta does not really expound an aesthetic theory—this task would be left to Kashmir Shaivism—but stressed that the separation between subject (beholder) and object tends to dissolve in the act of contemplation; or if it does not exactly dissolve, it is transformed. Time and space are momentarily abolished. The work of art becomes an object of awareness at the expense of all others; as such it has the power to transform consciousness. A new kind of intuitive knowledge comes to the surface. The saturation of the senses can lead to a feeling of emptiness, which is actually a plenitude of being. Subject and object, man and the world can regain the promise of blissful co-existence.[22]

Thus aesthetic experience has a metaphysical dimension: the erasing of the predisposition that individualizes consciousness, whereby we espouse the rigidity of organic and mental structures. This paradoxical experience—which possesses the power of ordinary emotion, but decanted, purified of all references to the ego of the experiencer—is described in traditional Indian aesthet-

20 Soren Kierkegaard, *Either/Or— A Fragment of Life*, Part II. Quoted in Howard H. Hong and Edna H. Hong, *The Essential Kierkegaard*, Princeton 2000, p. 69

21 Quoted in Flam, op. cit., p. 140

22 The work leads to nothing but silence, a plenitude which is a foretaste of Brahman, the Absolute. Eliot Deutsch wrote in this context: "For waking consciousness, ordinary things are just there 'at hand' for us; they are the Other, as objects to us. For the deeper, or at least higher integrated consciousness associated with aesthetic experience, the 'object', the artwork, is seen, experienced, recognized to be grounded in, and imbued with, spiritual being. It becomes for us like *īśvara*, like *saguna* Brahman, the supreme, but self-surpassing and fulfilling illusion." E. Deutsch, "Outline of Advaita Vedanta Aesthetics" in P. Bilimoria and J. N. Mohanty, eds.: *Relativism, Suffering and Beyond: Essays in Memory of B. K. Matilal*, New Delhi 1997, p. 346

ics as rasa. The viewer who tastes or perceives the 'tonality' of a particular rasa is not entirely divorced from time and space. He is transported into a 'here-and-now' that is indeterminate, an ideal observation post where, devoid of personal fears and hopes, he remains highly interested by what he sees. Thus in a sense rasa theory places the aesthetic experience somewhere between a state where the ego is manifested and one where it has vanished. Indian medieval philosophy distinguishes nine rasa-s, each corresponding to a particular mood or emotion—the last one being that of appeasement (śāntarasa).[23] It is also interesting to note that traditionally, rasa-s have designated colours; for the dominant rasa, śāntarasa, it is the colour of jasmine and the moon. And perhaps one should add with regard to Matisse's cut-outs that their surfaces of saturated colours, when combined and absorbed by the mind, give birth to something that can only be described metaphorically: as the moon or the *blancheur* so precious to Mallarmé. Colours, in the cut-outs, have the remarkable ability to provoke sensations which are not purely visual but appeal to all our senses. To say that the large, late *papiers découpés* are suggestive of musical harmonies is almost a cliché.

Aesthetic pleasure is induced by means of the formal qualities of the work of art; however, in exceptional circumstances, the work and its physical characteristics disappear from the viewer's mind. Then one experiences a state of quiescence (śāntarasa), a generalized emotion which is suggested and not merely given or prescribed; in other words, the aesthetic emotion is hardly an habitual one, such as those we experience in daily life, but a sublimation akin to a feeling of liberation.

Perhaps the key notion in Kashmir Shaivist poetics—underlying rasa-theory—is that of *dhvani*, or suggested meaning.[24] It points to the capacity of language to develop indirect means of communication. *Dhvani* does not refer to the metaphorical or figurative meaning of words, which would amount to little more than a stretching of their initial sense. Rather, words are suggestive in other ways, disconnected from pure denotation, as in the unexpected word-combinations of poetry. Thus *dhvani* introduces the idea of implicit meaning arising by suggestion. This brings us back to Mallarmé, in his emphasis on suggested meaning—the symbolist conception whereby the poet is capable of liberating words from their everyday usage. The Symbolists certainly influenced Matisse, who realized that artistic forms have meanings which are not directly connected to the things they depict. Instead, meanings are dependent upon the functioning of the image as a whole. In *La Perruche et la sirène*, the visual signs

23 There is some debate as to whether this experience is truly mystical; the viewer is not a 'pure' witness in that aesthetic experience is related to an object. But during aesthetic contemplation, the subject-object relation is transformed; in this sense the level of pure experience is reached. The attainment of such experience is never a given, but at least the work of art contains its promise. For a discussion of the nine rasa-s, see Adya Rangachara (ed.), *The Nātyaśāstra, English Translation with Critical Notes*, New Delhi 1986; Daniel Ingalls, J.M. Masson and M. V. Patwardhan, *The Dhvanāyloka of Anandavardhana with the Locana of Abhinavagupta*, Cambridge, MA and London, 1990
24 See D. Ingalls, op. cit., *Dhvanyaloka* 1.13

such as the algae and the grenadines, as well as the main figures that give the work its title, remain subservient to the overall balance and mood of the work. Matisse eschews the promise of reification held by the individual elements; to do otherwise would compromise their logical place within the decorative order.

The paper cut-outs represent the culmination of Matisse's emphasis on the formal aspects of his art. He explored sources drawn from the outside world but which resonated deeply within him. What the work reveals is a certain consistency of feelings—one could say specific moods—manifested as *articulated form*. The hope, of course, was that these forms would resonate within the beholder as well. Matisse's focus on ornament and decoration affirms the universality of structures underlying nature's intelligible order. In this sense, the artist is the recipient of energies which are embedded in the work of art. As the work comes into being through the eyes of the beholder, it creates in us a dynamic which has its origin within—as well as outside—us. This dynamic principle recomposes and transforms the work's meaning constantly. Feelings associated with aesthetic contemplation can vary dramatically; but it is indisputable that the emotions triggered by Matisse's work, because they are qualitatively so different from ordinary ones, contain the promise of a release akin to spiritual experience.

I would like to express my thanks to Bettina von Hase, Malcolm Turvey, David Mellins and Rémi Labrusse for their stimulating comments. The idea of a discussion of Matisse in the light of Indian aesthetic theory stems from a conversation with Professor Rashmi Poddar, Mumbai University. I would also like to acknowledge the invaluable help I received from Wanda de Guébriant who kindly made correspondence from the Matisse Archives available to me.

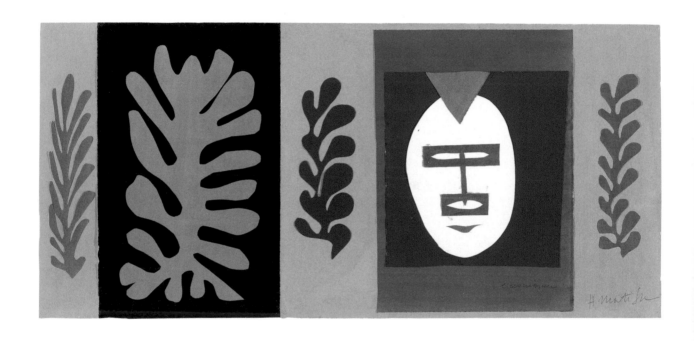

47 **The Eskimo** L'Esquimau 1947

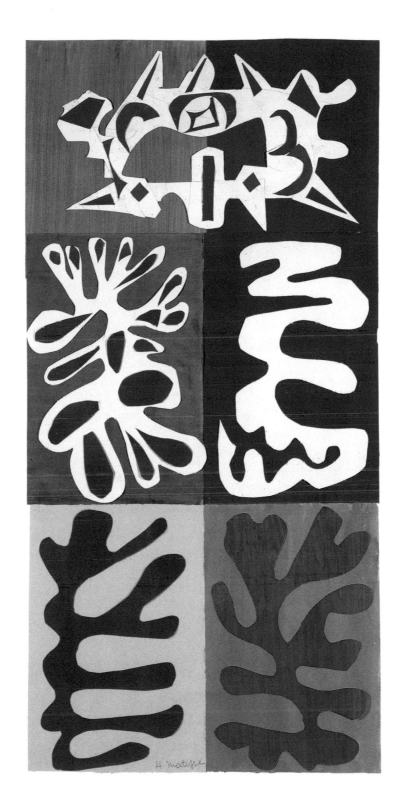

48 **Mask Sign** Le Panneau au masque 1947

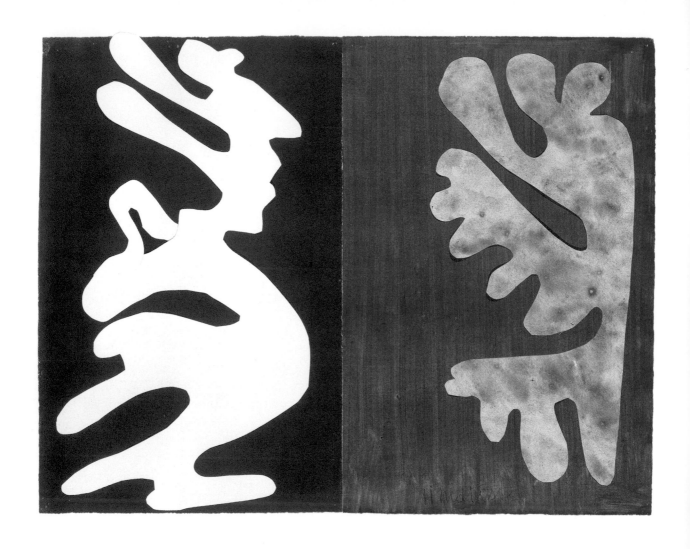

49 **Violet and Blue Composition** Composition violet et bleu 1947

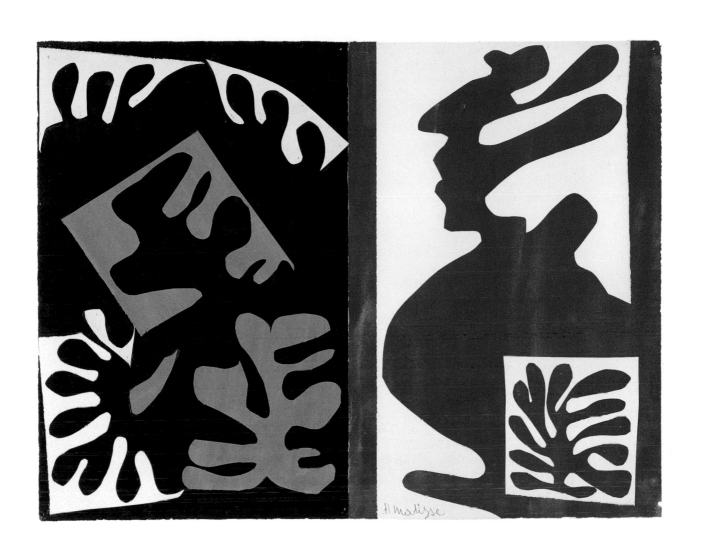

50 **Black and Red Composition** Composition noir et rouge 1947

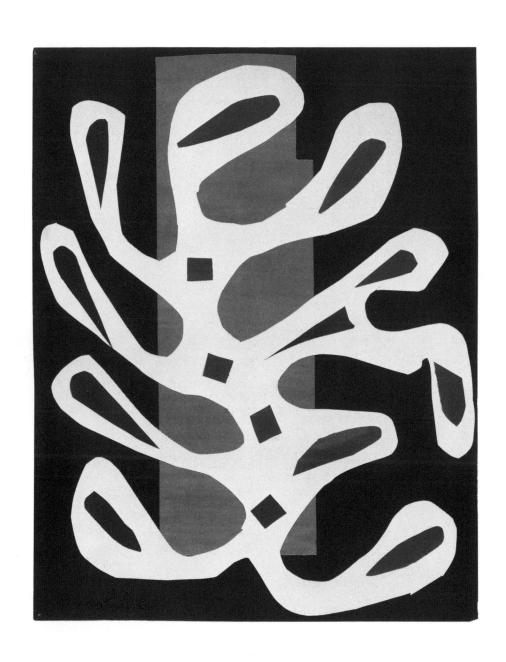

51 **White Alga on Red and Green Ground**
Algue blanche sur fond rouge et vert 1947

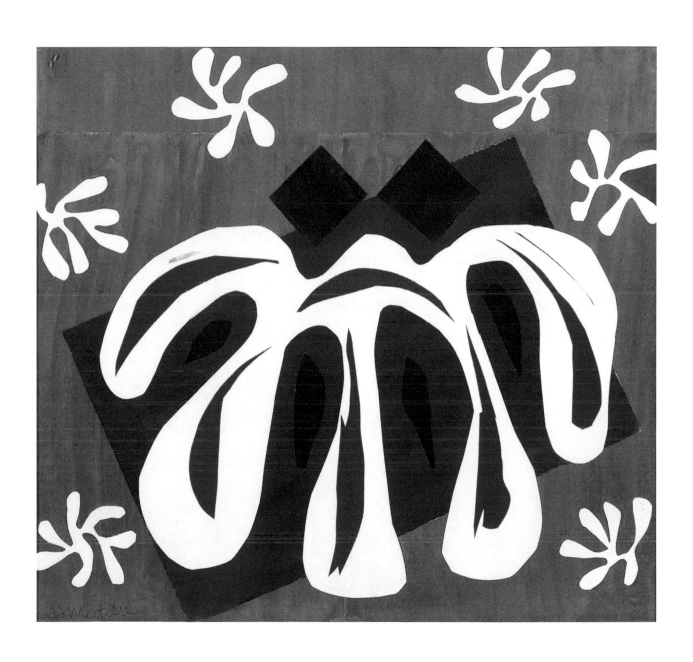

52 **Two Masks (The Tomato)**
Deux masques (La Tomate) 1947

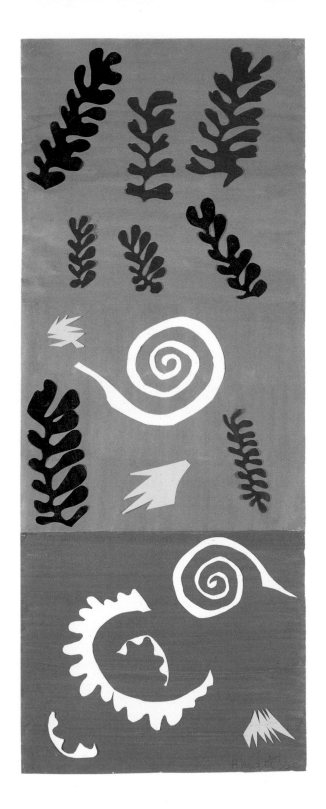

53 **Composition on a Green Ground** Composition fond vert 1947

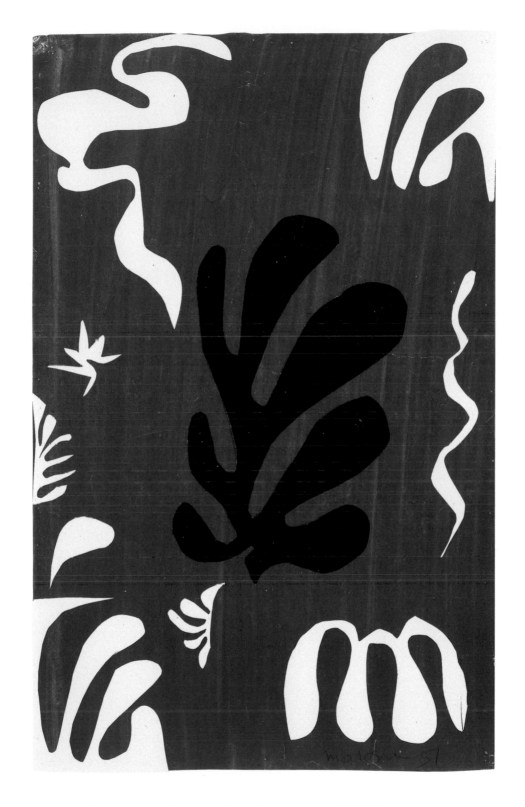

54 **Composition on a Blue Ground** Composition fond bleu 1951

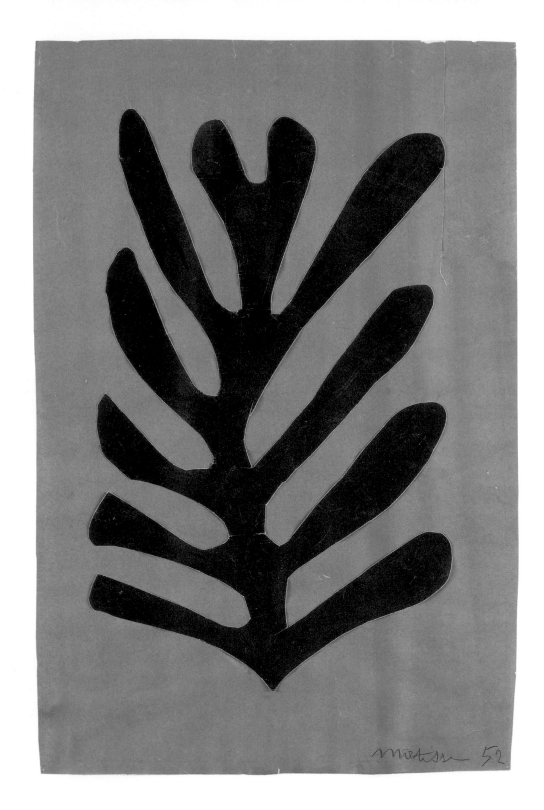

55 **Black Page on a Green Ground** Feuille noire sur fond vert 1952

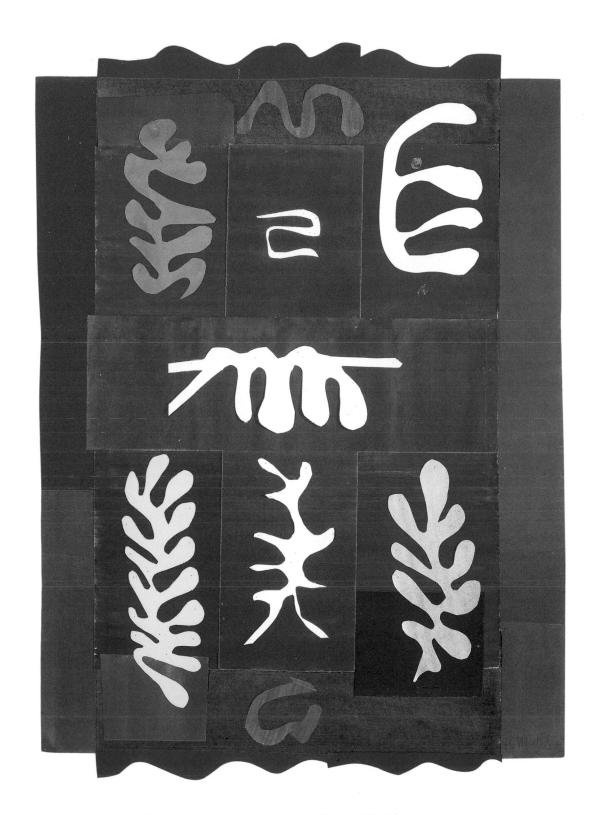

56 **Composition with Red Cross** Composition à la croix rouge 1947

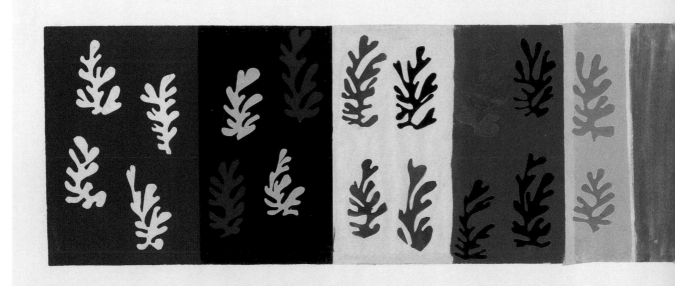

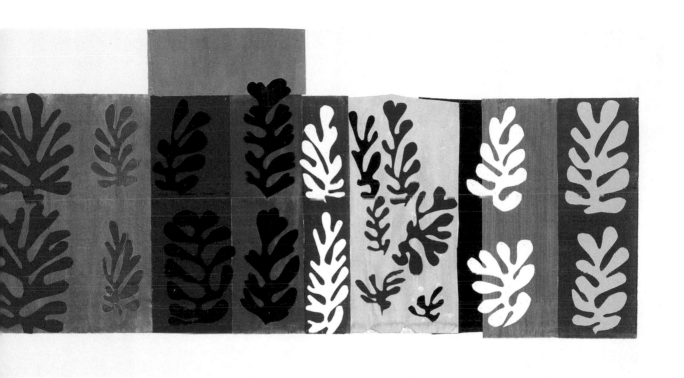

57　**Composition (Velvets)**　Composition (Les Velours)　1947

The Windows in the Chapel of the Rosary in Vence

Ingrid Pfeiffer

This Chapel is for me the culmination of a life of work.[1]

Matisse saw his work at the chapel in Vence between 1948 and 1951 as a high point of his artistic career. He came into contact with the initiators[2] of the project through Monique Bourgeois, who nursed him in 1942 and later entered the Dominican nunnery in Vence under the name Sister Jacques-Marie. Though the original idea was only that he should design stained glass windows, in the end Matisse worked out the whole chapel in every detail, from the architecture via the complete interior furnishing to the designs for the priest's robes. Building matters were discussed with the young Dominican monk Father Rayssiguier, but as the latter was not a trained architect, he also consulted a friend, the famous architect Auguste Perret, on whose advice the plans for the chapel were changed.[3]

Matisse's design for the interior of the chapel is based on the concept of light as the bearer of infinite space, as a place of spirituality and as dualism: "In the Chapel, my chief aim was to balance a surface of light and colour against a solid wall with black drawing on a white background," is how he described his objective.[4] Interior shots of the chapel show the contrasts he sought in material and subject matter between the walls with painted windows and the surfaces covered with white ceramic tiles. The coloured, translucent parts emphasise the black lines on white. Matisse himself drew attention to the parallels with *Jazz*, where (black) writing and (coloured) image are similarly juxtaposed.[5]

The three large wall drawings depict St Dominic on the north wall of the choir, the Virgin and Child on the long south wall and scenes from the Via Crucis on the narrow east side of the chapel.[6] For the long wall on the south side, divided into separate areas for nuns and lay congregation, Matisse designed a succession of tall, narrow, round-headed, lancet-style windows, reaching to the ground. In these, the overall theme is the Tree of Life, the *arbor vitae* from the Apocalypse,[7] though the surface treatment of the window front on the south side and high degree of stylisation and simplification of shapes is very different from the tall, narrow two-light window of the same name in the west wall of the choir.

1 Matisse in an article for the Christmas issue of *France Illustration*, quoted from Jack D. Flam (ed.): *Matisse on art*, Oxford 1973, p. 128

2 Thanks to the enthusiasm of art-minded Dominican priest Marie-Alain Couturier, a whole series of artist-designed chapels were created apart from Vence, notably those by Fernand Léger in Assy and Mark Rothko in Houston/Texas. Cf. also *The Vence Chapel. The Archive of a Creation*, ed. Marcel Billot, Milan/Houston 1999

3 Stephan Mann, *Von Matisse bis Mack. Die Künstlerkapelle im 20. Jahrhundert*, (doctoral thesis, Marburg 1996), Frankfurt 1996, p. 19.

4 Quoted from Flam, p. 128

5 "I may say that the *Jazz* book afterwards gave rise to my stained glass windows." Quoted from Flam; cf. also Stuffmann, p. 23 ff.

6 "In sum, the ceramic tiles are the spiritual essential and explain the meaning of the monument," wrote Matisse on this point (quoted from Flam, p. 130). The principal point of interest in this article is on the cut-outs for the glass windows; the drawings are not analysed here in detail.

7 Revelation 22:2. "In the midst of the street of it, and on either side of the river was there the tree of life, which bare twelve manner of fruits, and yielded her fruit every month: and the leaves of the tree were for the healing of the nations." Genesis 2:9: "And out of the ground made the Lord God to grow every tree that is pleasant to the sight and good for food; the tree of life also in the midst of the garden, and the tree of knowledge of good and evil."

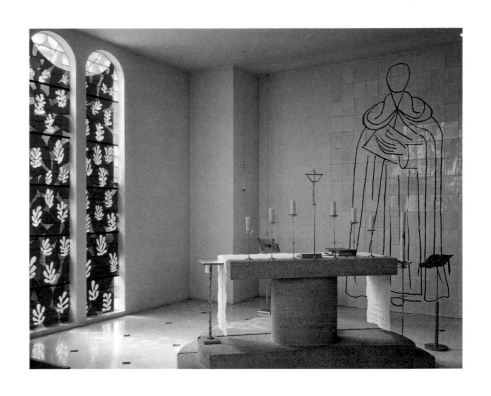

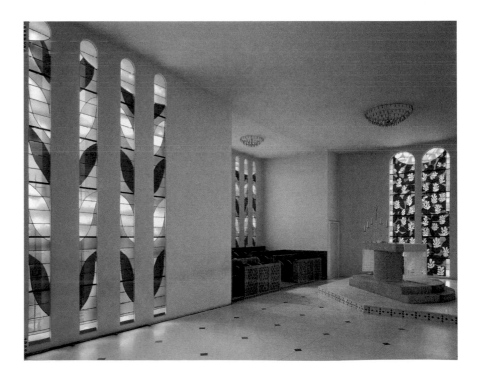

Henri del Olmo,
Chapel of the Rosary,
view towards the choir

In the tall, narrow lights, the leaf shapes are arranged regularly as if growing on stalks, echoing Matisse's words on the subject of the Tree of Life: "The spine of plant life is the basis for all this."[8]

The above-mentioned Arbor Vitae west window—*L'Arbre de vie (l'apse)*—in the apse besides the altar is an essential element of the whole design of the chapel. It features the alga motif, widely used by Matisse from 1947 in an extensive series of cut-outs. These basic floral forms are executed in yellow—always similar to nature but never exactly the same—and loosely arranged against a background of blue leaf-like shapes with a green ground. Matisse described the colours as follows: "These stained-glass windows are composed of three carefully chosen colours of glass, which are: ultramarine blue, a bottle green, and a yellow colour… These colours are of quite ordinary quality; they exist as an artistic reality only with regard to their quantity, which magnifies and spiritualizes them. To the simplicity of these three constructive colours is added a differentiation of the surface of some of the pieces of glass. The yellow is roughened and so becomes translucent only while the blue and the green remain transparent and thus completely clear. This lack of transparency in the yellow arrests the spirit of the spectator and keeps it in the interior of the chapel, thus forming the foreground of a space which begins in the chapel and then passes through the blue and green to lose itself in the surrounding gardens."[9]

Looking at the two cut-out designs that preceded this final window design, the conceptual development is remarkable. The first vertical window design and predecessor of the Arbor Vitae was *Jérusalem Céleste*, of 1948. It is an unusual composition for Matisse in the interaction of purely geometrical basic forms in very bright colours dominated by red and yellow.[10] This very architectural-looking window design was only half as high as the two following cut-outs, *Vitrail bleu pâle* and *L'Arbre de vie*. The latter was of course the one finally carried out.

Vitrail blue pâle is already correctly sized to a height of 515 cm and contains the widest range of colours of the three—various tones of blue and green, tones from lemon yellow to orange, and bright pink to carmine. The characteristic 'algae', mostly in yellow, already feature here, scattered over a geometrical background similar to the one in the first cut-out design. However, both first and second designs lack any indication of the lead or iron cames needed to transpose the image into a stained glass window. Only in the third design did Matisse accommodate the elements separating the areas of colour.

The shape of the round-headed two-light Arbor Vitae window and the 'hanging' design in it have more than once been compared with a tapestry.[11]

Henri del Olmo, Chapel of the Rosary, view of the south and east walls

8 Schneider, p. 685, quoted from Mann, p. 30
9 Quoted from Flam, p. 129
10 Matisse initially planned to have a corresponding window also for the long south wall, wholly dominated by rectangles and squares in various colours—the *Les Abeilles* (The Bees) cut-out is now in the Musée Matisse in Nice. *Henri Matisse. Paper Cut-Outs*, exhib. cat., St. Louis 1977, p. 151
11 Mann, p. 28 ff.

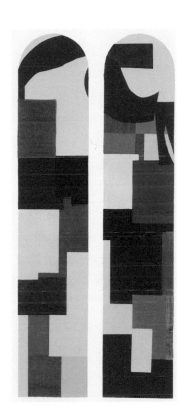

Henri Matisse, cut-out design for the double windows *Jérusalem Céleste*, 1948. The Vatican Museum, Rome

Matisse's great interest in decorative art and the reference to the *sanctuarium* in Byzantine art that separated the altar area from the rest of the church[12] makes such an interpretation plausible. However, the notion of a tapestry is certainly incompatible with Matisse's light metaphor and the function of the window as part of it. The window in the chapel in Vence is not there to hide or screen anything. On the contrary—it is supposed to introduce light and colour into the building by being transparent. Standing inside the chapel opposite the altar, the west window is of key importance. The light of the setting sun shines through it, throwing coloured patterns on the figure of St Dominic opposite. Similar effects are observable earlier in the day on the large figure of the Virgin on the north wall, illuminated by the light from the south windows.

As mentioned earlier, Matisse scaled back the colour effects to concentrate on just three basic colours as he strove for greater spiritualisation. The process tallies with the sobriety and purity of the linear figures on the white ceramic tiles. "Blue, green and yellow create a light in the interior that does not actually correspond to any of the three colours used but is the living product of their harmony and mutual relationships," said Matisse. "Colours and lines are forces, and the secret of creation lies in the interaction of these forces and their balance."[13] This 'interplay of equivalences' and attaining of harmony via the 'law of contrasts', to use Matisse's terms, is the core concept of the Vence chapel.

Inside and outside, light and dark, colour and non-colour, line and surface are the elements that Matisse assembles to create an atmospheric and varied *Gesamtkunstwerk*. To some extent, he takes the image of the heavenly Jerusalem and the Garden of Eden quite literally, choosing the shapes and colours of nature—cactus flowers, leaves, stalks, algae—and condensing them into symbols. In the Tree of Life image, these come close to Christian symbolism. As an artist, Matisse strove to create an 'infinite space'[14] seeking purity and harmony and quite deliberately used materials and compositional means that generate and promote this impression. The result—the extraordinary, spiritual effect of the interior—thus has less to do with the function of the building as a chapel than with Matisse's artistic objectives, always consistently pursued but first brought together as an ensemble here. That these objectives coincided with the wishes of the client, the Dominican nuns of Vence, at least in matters of design, and that Matisse was not forced into compromises, was a rare, not to say ideal situation.

The role of the cut-outs in the process of developing the entire chapel was fundamental. The success of his work here reinforced Matisse's decision to concentrate on the medium of cut-outs in the last years of his life.

12 *Henri Matisse. Paper Cut-Outs*, p. 154.
13 Quoted from Flam, p. 129
14 Loc. cit.

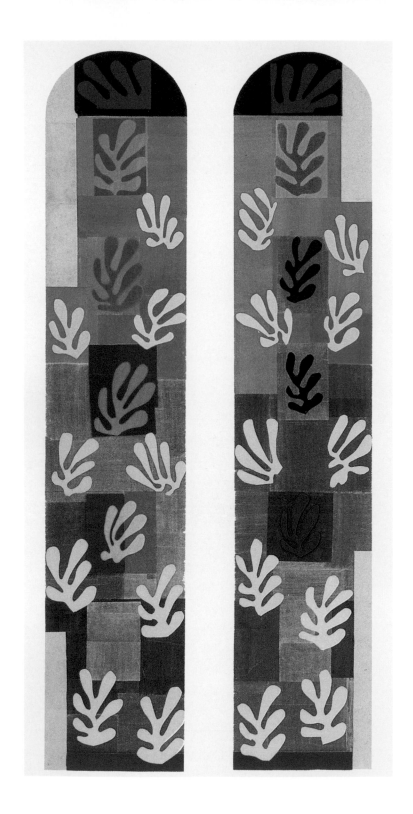

58 **Light blue glass window** Vitrail bleu pâle 1949

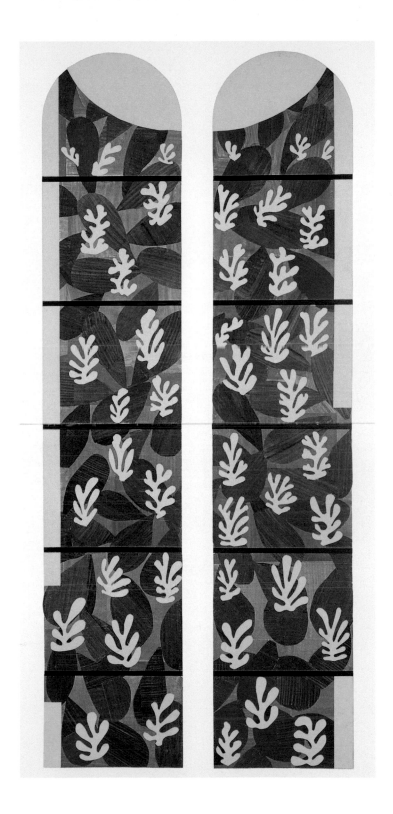

59 **The Tree of Life** L'Arbre de vie 1949

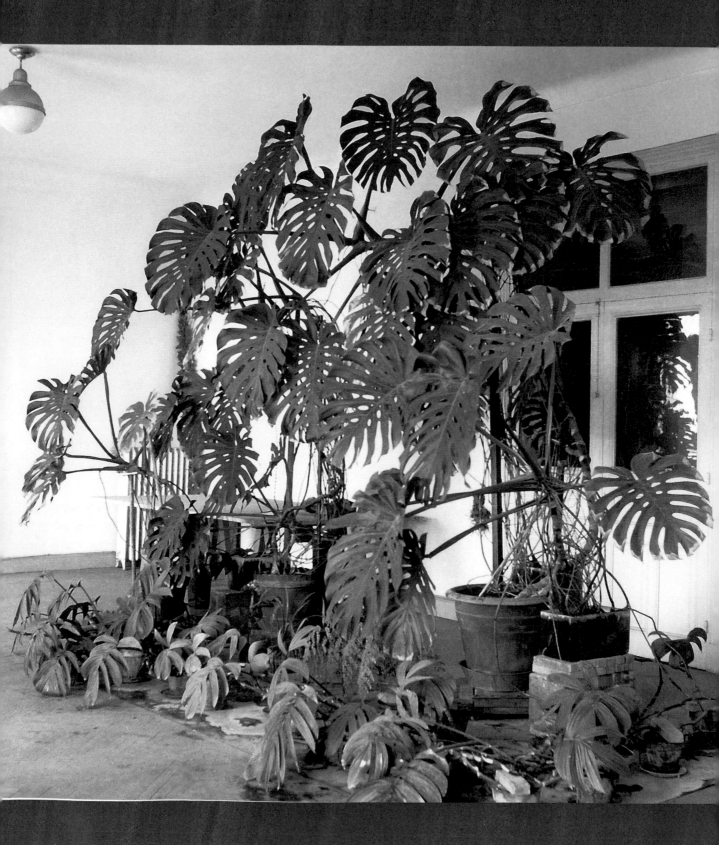

Philodendros[1]

Hannes Böhringer

Matisse liked easy chairs. Early in his career he wrote : "What I dream of is an art of balance, of purity and serenity, …an art which …[is] soothing, …something like a good armchair."[2] Matisse was a modernist, but he was also aware that the old was not just to be cast aside. He was at ease in the armchair of tradition. He had absorbed its poetics—beauty, grace and sentiment. His principal concern was emotion. That was his bed. "How often I found him working in bed," wrote Marguette Bouvier. "The room was arranged so that he could work lying down. Everything was to hand without him having to move. Within reach was a revolving bookstand with dictionaries and classical works. The drawers contained a carefully arranged assortment of pencils, a rubber and paper, and of course the telephone was at the head of the bed. No-one could have been less bohemian than this artist, who demanded well-considered convenience like a *grand bourgeois*."[3]

Convenience is not just physically comfortable but also comforting and empowering. Feeling requires a springing point, an impost to rest on. Matisse yielded to emotion, but did not abandon himself to it: "If I trust my hand to draw, it's because I never allowed it to take control of my emotion when I was teaching it to serve me. I knew exactly when it was straying or if there was any disagreement between us—between it and that *je ne sais quoi* in me that seems to be subject to it. The hand is nothing more than the extension of one's sensibilities and intelligence. The lighter it is, the more it obeys. The servant must not be the master."[4]

The thinking being is always both lord and vassal, at once dominating, determining and yet 'subject', flooded with emotions. Matisse had himself under control, he had the drawing under control, but guided his hand with emotion while prone, yielding to feeling. He sat on the residuum of tradition. He swam in a Tahiti lagoon rather than Monet's water-lily pond, but was later long chained to his bed and wheelchair. "I very much wanted to experience light on the other side of the Equator, to have contact with its trees …," he said. "I remember that

1 Tree-lover (Greek)
2 *'Notes of a Painter'* (1908), in *Matisse on art*, Jack D. Flam (ed.), Oxford 1973, p.38
3 'Henri Matisse at Home', in ibid., p.96
4 Henri Matisse: *Jazz*, Munich 1959, p.43

first of all, on my arrival, it was disappointing. And then, little by little, it was beautiful, beautiful, … it is beautiful! The leaves of the high coconut palms, blown back by the trade winds, made a silky sound. This sound of the leaves could be heard along with the orchestral roar of the sea waves, waves which broke over the reefs surrounding the island. I used to bathe in the lagoon. I swam around the brilliant corals … I would plunge my head into the water … and then suddenly I would lift my head above the water and gaze at the luminous whole."[5]

Siren voices lured Europe's artists outside. They sought the exotic orient. They took their bearings from the presumed origin of art. The orient was east, south or west—Egypt, Arabia, Africa, the South Seas. Matisse went there, but came back. He remained in Nice. His workroom there was his Tahiti. Lying in bed, he swam in the 'absinthe-coloured' lagoon, surrounded by palms, flowers, fruits, philodendrons and aviaries.

Lagoons are standing water, flat. Matisse's drawings and paintings became flatter and flatter. In the end he cut symbolic shapes from brilliantly monochrome painted papers and assembled them in arabesques, to make *gouaches découpées*. Painting and drawing ended up as decorative cut-outs in which shapes are reduced, simple, symbolic, almost abstract. Depth and gravity of meaning dissolve in the calm water of the lagoon. Everything swims on the surface.

"I have nothing to say, and I say it, and that is poetry," began John Cage in his lecture on nothing.[6] He did not say nothing. He made rhythms of his sentences, and gradually repeated them. Silence was music to him, listening to the rhythm of noises. Matisse enlarged his handwriting, to balance his cut-out collages in *Jazz*. He needed black and white and the flow of handwriting on one side to offset the *gouaches découpées* on the other. But what should he write? He would really like to have copied out La Fontaine's fables "as I did as a lawyer's clerk, copybook handwriting, recording court decisions that no-one reads, not even the judge, and where the only thing that matters is to use up the quantity of taxed document paper that the importance of the case merits."[7]

As he copies things out, *peu à peu* the writer distances himself from the content. Letters and words lose their meanings and become lovely figures created from lines. Matisse wrote, spoke and cut something out. It was as light as a leaf, a breath of wind would carry it away. Almost nothing. Palm leaves and breaking waves rustled and hissed. The abstraction of writing and coloured

5 'Interview with Verdet' (1952), in *Matisse on art*, p. 145
6 John Cage: *Silence*, Frankfurt 1987, p. 7
7 *Jazz*, p. 44

shapes became rhythm, music, agreeable rustling, rhythmicised by colours and intermissions, interspaces,[8] a chord of movement and almost static calm. In this easily moved balance, everything became weightless like dancing, swimming or flying. Weights cancelled each other out.

Shapes and symbols move together in abstraction without wholly merging. But they are on their way to a 'shining wholeness'. What is the difference between the shape of a leaf and the symbol for algae, the lagoon and a snail shell? A parrot sits in the leaves. It repeats the sounds it hears. The repetition engenders patterns and ornamentation and sloughs off meanings. Shapes become increasingly alike.

Matisse drew and painted still lifes and women again and again. The women sit or lie in a room. The window is open. They are dressed or naked: 'Love, yes, love.'[9] The women turn into leaves: Venus, seductive foliage,[10] rustling and gleaming of leaves, siren harmonies. Between the fingered leaves that touch and feel, apples, pomegranates: the breasts and buttocks of the little mermaid. The parakeet could be her tail. The parakeet remains seated. The repetition stays. She herself gets the boot—flies aloft, as in Andersen's story. The leaves finger the cut-out, dismembered, duplicated limbs, the pomegranates: full of pips, sumptuous life, paradisical immortality

Matisse took the snail out of the garden. He called the arabesque *Jardin*, but it was later renamed *La Perruche et la sirène*. The snail spoilt the "musical movement of the whole combination," he said.[11] Its symbol, the snail shell, is a leaf house made of philodendron leaves turned inwards. The snail revels in the lagoon garden. It looks at it and tastes it with its horns. The snail was Matisse himself. He carried his house with him. Like a philosopher of old, he had everything with him. "He has collected around his bed everything which pleases him. He has remade a world of his own taste in his bedroom."[12]

8 Flam, op. cit.
9 Ibid., p. 260
10 Jost Trier: *Venus. Etymologien um das Futterlaub*, Cologne, Graz 1963
11 Flam, p. 146
12 Flam, p. 96

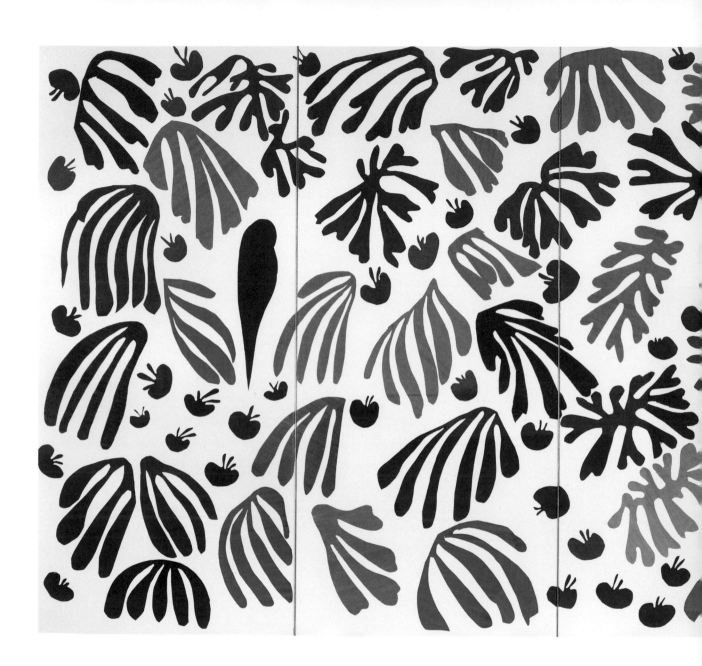

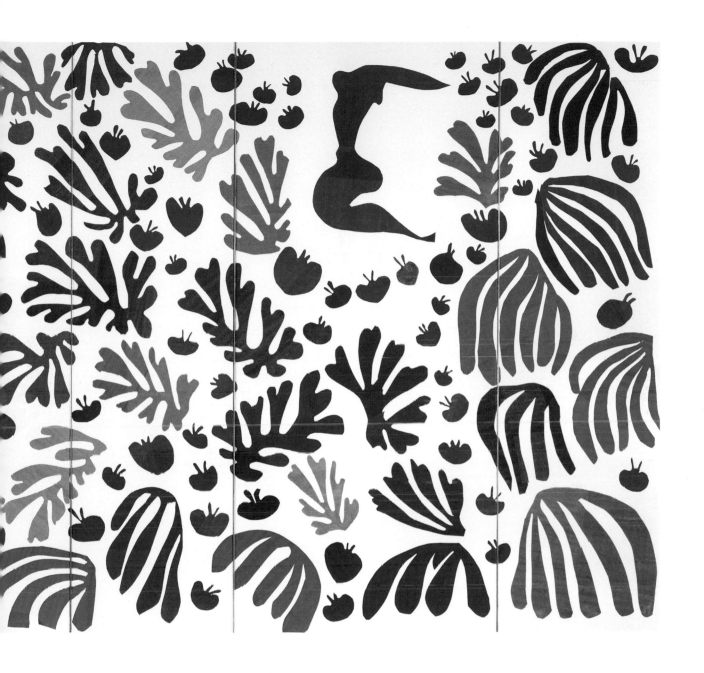

60 **The Parakeet and the Mermaid** La Perruche et la sirène 1952

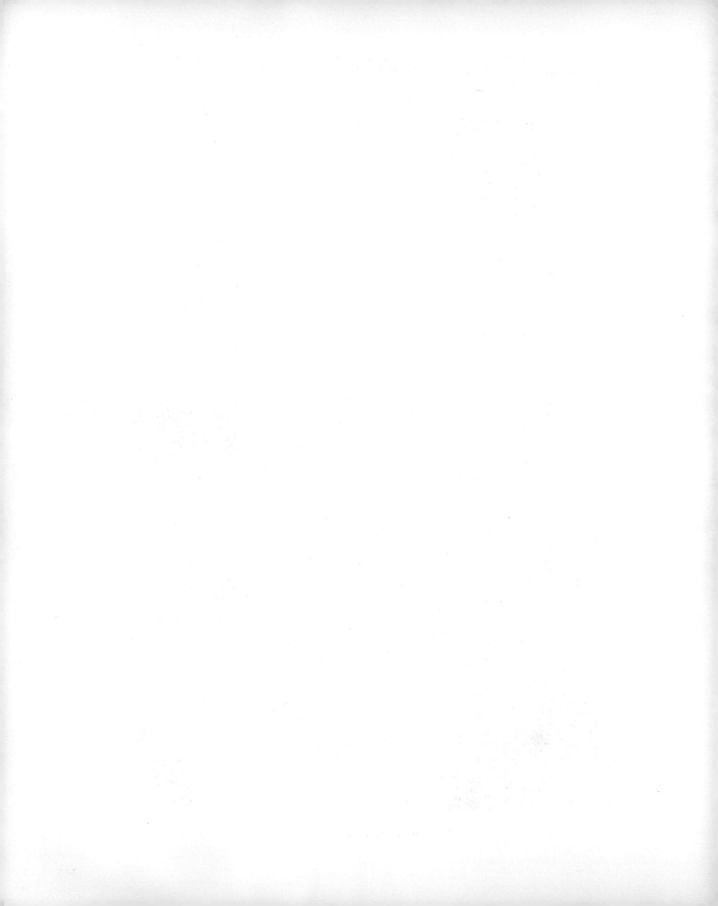

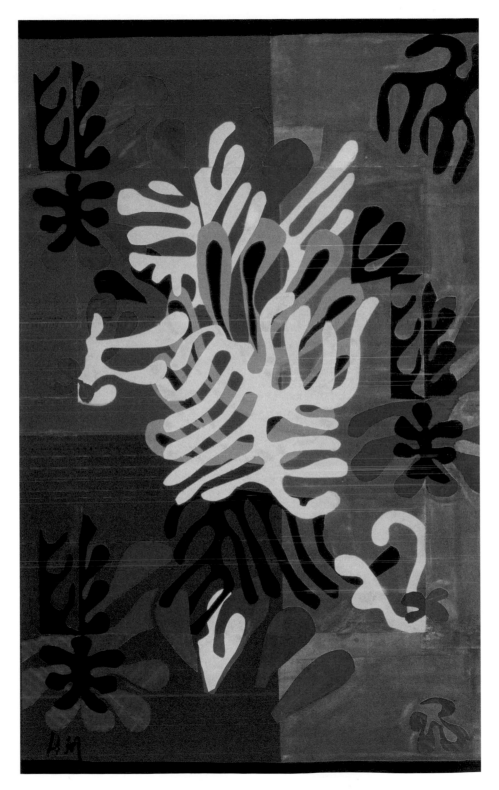

61 **Mimosa** Mimose 1949–1951

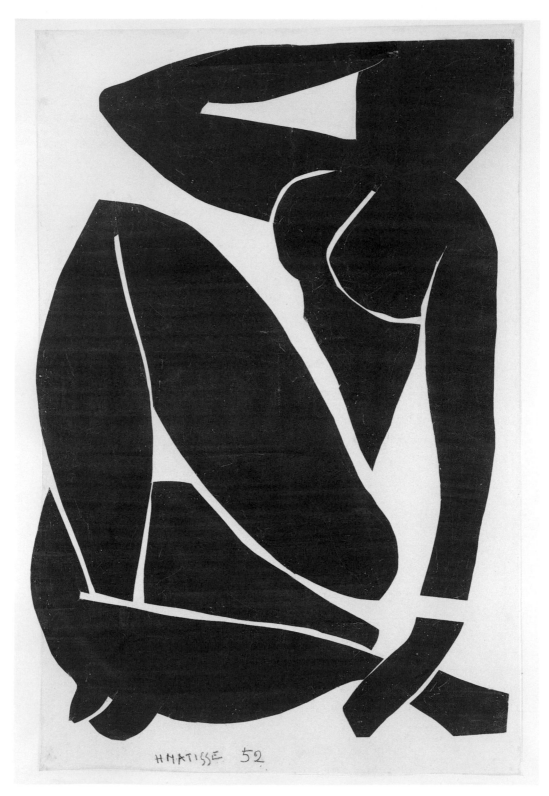

62 **Blue Nude III** Nu bleu III 1952

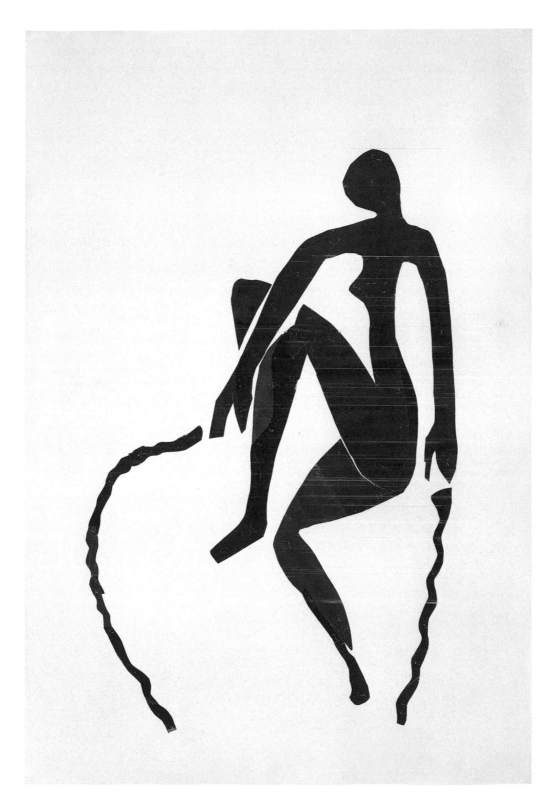

63 **Blue Nude, Skipping** Nu bleu, sauteuse de corde 1952

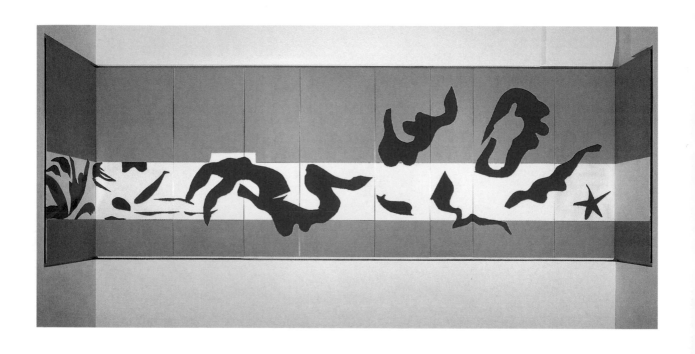

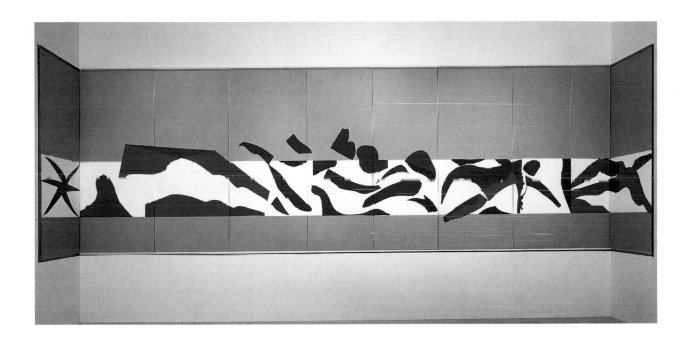

64 **The Swimming Pool (ceramics 2000)** La Piscine (céramique, 2000) 1952

65 **The Bell** La Cloche 1951

66　**The Japanese Mask**　Le Masque japonais　early 1950

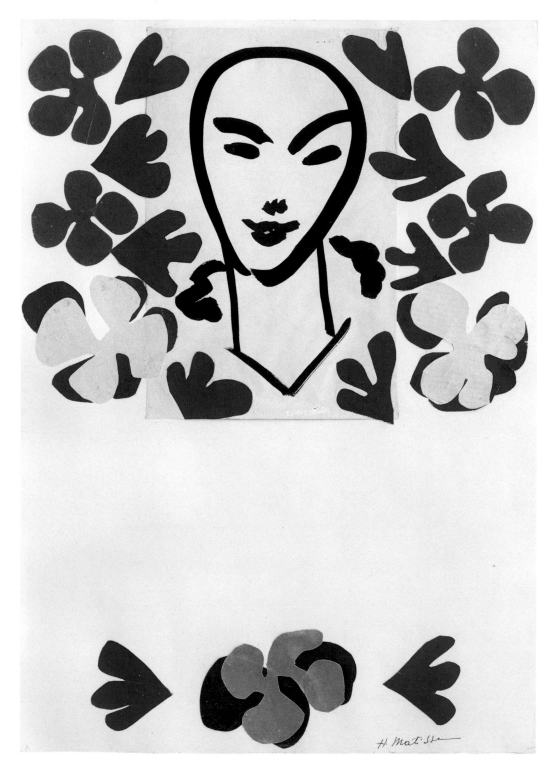

67　**The Sculpture of Henri Matisse (poster design)**
The Sculpture of Henri Matisse (maquette de poster)　1952

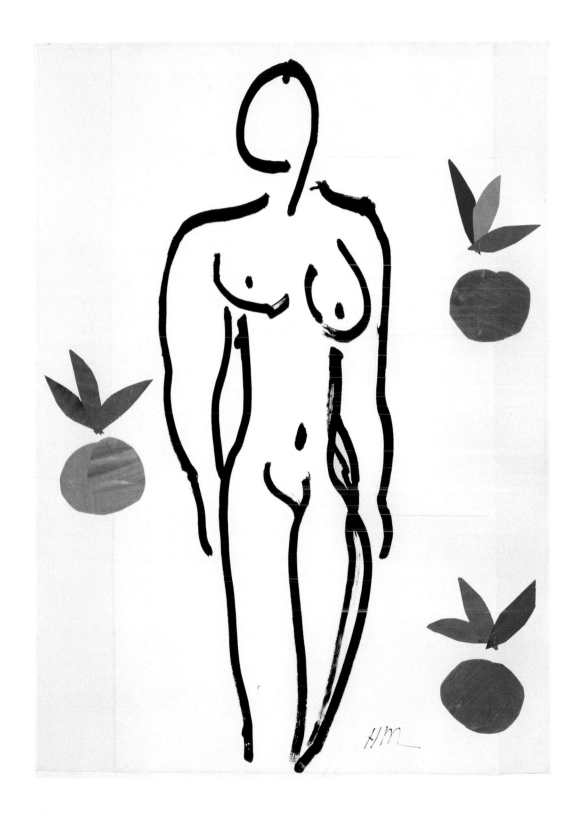

68 **Nude with Oranges** Nu aux oranges 1953

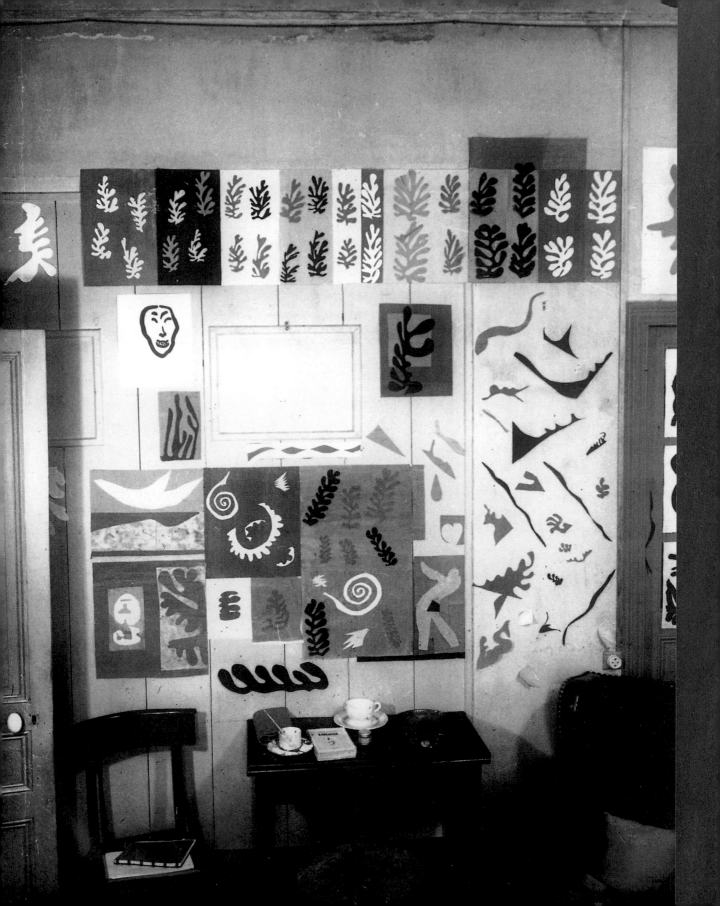

'Painting alone remains full of adventure'[1]
Matisse's Cut-Outs as an Inspiration for Nicolas de Staël, Ellsworth Kelly and Andy Warhol

Gunda Luyken

1 Nicolas de Staël to Théodore Schempp, 8 January, 1953, quoted from Louis Aragon, *Henri Matisse, Roman*, Vol. II, from the French by Eugen Helmlé, Stuttgart 1974, p. 268

2 Yannis Ritsos (1909–90), *The Blue Woman*, 1966, quoted from Louis Aragon, op. cit., p. 232

3 Max Bill, quoted from *Du, Europäische Kunstzeitschrift*, June 1976, p. 34. Cf. also Viola Weigel, in exhib. cat., *Ornament und Abstraktion. Kunst der Kulturen, Moderne und Gegenwart im Dialog*, ed. by Markus Brüderlin, Fondation Beyeler, 2001, p. 183

4 Quoted from Franz Meyer, *Matisse und die Amerikaner*, in exhib. cat., *Henri Matisse*, ed. by Felix Baumann, Kunsthaus Zürich, 1982, pp. 64–75, p. 67. The connection between Matisse and Pollock was explored for example in the celebrated *Westkunst* exhibition, where cut-outs by Pollock and Barnett Newman were contrasted. Cf. also Philippe Büttner, *Jackson Pollocks 'Drip Paintings' und die 'papiers découpés' von Henri Matisse*, in *Ornament und Abstraktion.*, op. cit., p.160

5 Cf. Henri Matisse, *Über Kunst*, ed. by Jack D. Flam, from the English by Elisabeth Hammer-Kraft, Zurich 1982, p. 226

6 "A young artist must be aware that he does not have to invent everything anew; his job is to sort out in his mind the compatibility of the different approaches in the works of art that impress him and at the same time question nature," Henri Matisse in *Verve*, Vol. IV, No. 13, Paris 1945, quoted from Jean-Luc Duval, *Das Wiederaufgreifen des Sichtbaren*, in exhib. cat., *Nicolas de Staël, Retrospektive*, ed. by Thomas M. Messer, Kunsthalle Schirn, Frankfurt, 1994, pp. 13–27, p. 20

7 "I think of myself as an American artist. I like it here, I think it's so fantastic. I'd like to work in Europe, but I wouldn't do the same things." Quoted from *Andy Warhol in his own words*, ed. by Mike Wrenn, London/New York/Sydney 1991, p. 27

The Blue Woman

She dipped her hand in the sea.
It turned blue.
That pleased her.
She fell full-length into the sea.
She turned blue.
Blue in voice and silence.
The blue woman,
Many admired her
No-one loved her.[2]

Yannis Ritsos, 1966

Cut-outs were both the climax and close of Matisse's long career. Younger artists saw them as an innovation, but often equated that with ditching academic tradition. Max Bill, who had acquired the *Composition sur fond bleu* of 1951 (cat. 54) for his collection that same year, described the cut-outs as 'one of the most important groups of works' of the twentieth century,[3] while after visiting the Matisse retrospective exhibition in New York in 1951 Jackson Pollock asked a friend visiting Paris whether he had already been to see the chapel in Vence.[4]

The examples of Bill and Pollock show that artists with very different views of art on each side of the Atlantic were interested in Matisse and his cut-outs but did not emulate the painter by producing *papiers découpés* themselves.[5] Matisse had made a particular point of emphasising that young painters should use tradition after their own fashion.[6] And many of them—consciously or not—seem to have taken his advice.

What follows traces the effect of the cut-outs on Nicolas de Staël, Ellsworth Kelly and Andy Warhol. The cut-outs persuaded de Staël to use brighter colours, while Kelly was impressed by the forms Matisse used and Warhol by the flat surfaces. In this context, de Staël represents Europe, Warhol America[7] and Kelly, as an American who spent some years in Paris, a linking element between the continents. All three artists came into contact with the cut-outs during Matisse's

151

lifetime. Nonetheless, it sometimes took years for their impressions to work through into their own works.

Astonishingly, what the art world thought of the cut-outs has received very little critical attention. Though general works on techniques of collages mention time and again that the *gouaches découpées* influenced artists in Europe and America, specific examples are not mentioned.[8] There are indeed studies investigating the influence of Matisse on American artists,[9] but nothing similar looking at Europe. Yet, as Nicolas de Staël showed, European artists were interested in Matisse, and especially in his cut-outs.

Nicolas de Staël

"We need a technical answer to the question of what makes beauty beautiful in our eyes."[10] Nicolas de Staël

Born in St. Petersburg in 1914, Nicolas de Staël went to the academy in Brussels, moving on to Paris in 1938, where he became acquainted with Jeanne Bucher. In 1939, he may have seen the exhibition of Hans Arp's *papiers déchirés* at her gallery. In 1940, he fled to the south of France, specifically Nice, where he met Arp and his wife Sophie Taeuber-Arp, the Delaunays, Alberto Magnelli and Le Corbusier. De Staël's direct contact with these artists marked a turning point in his work. In 1944 he put on his first solo exhibition openly and consciously aligning himself with the abstract artists. Even so, he refused to accept the designation of abstract artist, and always averred: "Every picture has a theme, whether you want it or not."[11]

At that time, de Staël's painting was notable for its extreme materiality of colour. How thickly he must have applied the paint is indicated by Pierre

Henri Matisse, *Sorrow of the King*, paper cut-out, 292 x 396 cm, Paris, MNAM/CCI Centre Pompidou

8 Cf. Diane Waldman, *Collage und Objektkunst vom Kubismus bis heute*, from the American by Manfred Allié, Cologne 1993, p. 200
9 e.g. Stephanie Barron and Larry Rosing, *Matisse and contemporary art*, in *Arts Magazine*, May 1975, pp. 66–68, Franz Meyer, *Matisse und die Amerikaner*, op. cit.; Margot Klütsch, *Der Einfluß von Matisse auf Lichtenstein und Wesselmann*, in exhib. cat., *Europa-Amerika, Die Geschichte einer künstlerischen Faszination seit 1940*, ed. by Siegfried Gohr and Rafael Jablonka, Museum Ludwig, Cologne, 1986, pp. 184–97, Haidrun Brauner, *'Natürlich ist das Dekoration' – Perspektiven eines Begriffes in der Kunst des 20. Jahrhunderts, ausgehend von Henri Matisse*, Frankfurt 1993, Martina Ward, *Tom Wesselmann: Studien zur Matisse-Rezeption in Amerika*, Münster 1993, Eric de Chassey, *La violence décorative. Matisse dans l'art américain*, Paris 1998, Eric de Chassey and Rémi Labrusse, *Henri Matisse-Ellsworth Kelly. Dessins de plantes*, Paris 2002
10 Nicolas de Staël, quoted from Jean-Luc Duval, op. cit, p. 20
11 Nicolas de Staël to Pierre Lécuire, 3 December, 1949, quoted from Jean-Luc Duval, op. cit., p. 32. Cf. also Nicolas de Staël to René Char, 10 February, 1952, in: *Nicolas de Staël, Catalogue raisonné de l'œuvre peint*, ed. by Françoise de Staël, Ides et Calandes, Neuchâtel 1997, p. 968

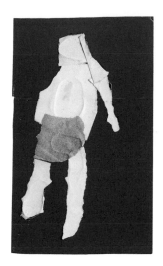

Nicolas de Staël, *Personnage*, 1954, paper collage, 32.5 x 19.5 cm, private collection, Paris

Courthion, who reported that he needed both arms to lift a small-scale work in the studio because "it was so heavy with paint."[12]

Although de Staël was not particularly interested in his contemporaries' work—he is supposed to have told Michel Seuphor: 'Braque, Matisse et Cézanne, et rien d'autre'[13]—we may assume that he was familiar with *Jazz* and the *papiers découpés* exhibited at the Musée d'Art Moderne in 1949 and the Maison de la Pensée in Paris in 1950.[14] However, it was the *Sorrows of the King*, 1952, which he admired at the May Salon in Paris in 1952, that first affected him profoundly.[15] The bright colours of this paper work impressed him so much that he decided to give up his pastose style in favour of a thinner, more brilliant colour application. During a trip to America in 1953, he was particularly fascinated by the lunettes at the Barnes Foundation, which were prepared with paper cut-outs.[16] When de Staël returned to Paris, the famous exhibition of Matisse cut-outs was just taking place at the Galerie Berggruen, with around 20 *papiers découpés* on show for the first time.[17]

The cut-outs and the decision to settle in the south of France again brought about a radical change in de Staël's style. He had meantime come to the conclusion that there could only be two kinds in art—'a bright certainty and a bright hesitation.'[18] Brimming with admiration, he revelled in the discovery that the eighty-four-year-old Matisse could express brightness even with bits of paper. Spurred on by the cut-outs, the younger artist now likewise tried out the technique of collage. In contrast to Matisse, whose paper materials were painted by hand and carefully cut out, de Staël selected for his collages ordinary coloured or crepe paper, which he tore up. Like Hans Arp, he was looking for rough, tactile surfaces and believed in chance effects, which Matisse always tried to exclude. Difficult it may be to compare works of different sizes, but nonetheless de Staël's collage *Personnage*, 1954 and Matisse's *Blue Nude I*, 1952, which is three times the size, do reflect the fundamental differences in the two artists' approaches. The sensu-

Henri Matisse, *Blue Nude I* (Nu bleu I), 1952, paper cut-out, 116 x 78 cm, Fondation Beyeler, Riehen/Basel

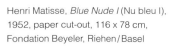

12 Quoted from Jean-Luc Duval, op. cit., p. 22
13 Quoted from *Nicolas de Staël, Catalogue raisonné de l'œuvre peint*, op. cit., p. 906
14 Cf. ibid. p. 1012
15 Ibid. and Eliza E. Rathborne, *Nicolas de Staël in America*, in exhib. cat. *Nicolas de Staël in America*, ed. by Eliza E. Rathborne, Phillips Collection, Washington DC, 1990, pp. 11–39, p. 27. Rathborne mentions that de Staël also showed a work at the May Salon
16 Ibid., p. 27
17 Because life in America did not appeal to him, de Staël returned to Paris earlier than planned, i.e. on 13 March, 1953. Cf. *Nicolas de Staël, Catalogue raisonné de l'œuvre peint*, op. cit., p. 136. The exhibition with the Matisse cut-outs was on from 27 February–28 March, 1953 at the Galerie *Heinz Berggruen et Cie*
18 Nicolas de Staël to Pierre Lecuire, 14 May, 1953, in: *Nicolas de Staël, Catalogue raisonné de l'œuvre peint*, op. cit., p. 1093

ousness and decorative flow of line that distinguish Matisse's nudes give way in de Staël to abrupt, sparely placed surfaces that express spontaneity and directness rather than calm and harmony. The act of tearing the paper produced tatty, frayed edges, which here and there reveal the layers underneath the coloured surface. This characteristic is common to de Staël's collages and paintings alike, the latter likewise often allowing underlayers to show through. In fact, the artist initially considered his rough paper works only as studies for oil paintings. However, they developed more and more into works in their own right, so that by the winter of 1953 they had become large, monumental formats that could serve as cartoons for tapestries or lithographs.[19] The collage *Composition* of 1953 is so reduced that it manifests similarities with Kelly's later 'curve' pictures.

De Staël's paper works remained completely unknown during his lifetime. Only in 1958, i.e. three years after his tragic suicide, did the Galerie Dubourg put on the first exhibition of this group of works.[20]

In his collages, de Staël achieved a synthesis that links Matisse's bright coloration with Hans Arp's use of chance effects and tearing technique. One almost gets the impression that the artist did indeed follow Matisse's advice and combined two separate approaches. At any rate, in 1953 he said: "All my life I have had to think in pictures, look at paintings and paint pictures, just to live, just to free myself from my impressions, my feelings, my helplessness. I have never found any other way out except painting."[21] The avowal of 'having to see paintings' indicates that, like Matisse, de Staël was a revolutionary *malgré soi*. In contrast to many other artists, neither man saw breaking with tradition as the way forward, preferring to absorb everything they could of it and then continue the history of painting with their own work.

Ellsworth Kelly

"Mystery is only worth anything if it comes about despite the precision atmosphere of an engineer."[22] Robert Musil

At the same time that de Staël was admiring Matisse's *papiers découpés*, the latter were also casting a spell over Ellsworth Kelly, an American ten years his junior. Kelly came to Paris in 1948 to study art, but had already encountered and admired Matisse's works in America.[23] Like de Staël, he was nevertheless basically rather uninterested in contemporary art.[24] Also like de Staël, he was a fan of Byzantine mosaics[25] and French church glass.[26] De Staël's enthusiasm for the

Nicolas de Staël, *Composition*, 1953, paper collage, 32 x 24.7 cm, private collection, Paris

19 An astonished De Staël told his wife in August 1952: "Figure-toi que Matisse fait tirer ses collages en litho comme moi mais sur du zinc très plat, pour cela." Quoted from *Nicolas de Staël, Catalogue raisonné de l'œuvre peint*, op. cit., p. 1012. It is also mentioned which collages were used as cartoons for tapestries for the firm of Picaud in Aubusson.
20 Quoted from Eliza E. Rathborne, op. cit., p. 27
21 Nicolas de Staël is referring here to his exhibition in New York in February 1953. Quoted from Jean-Luc Duval, op. cit., p. 19
22 Quoted from Max Wechsler, *Expeditionen in den Raum der Malerei und der Skulptur und darüber hinaus*, in: *Imi Knoebel, Retrospektive 1968–96*, Ostfildern 1996, pp. 11–18, p. 11
23 Cf. E. C. Goossen, *Ellsworth Kelly*, Museum of Modern Art, New York 1973, pp. 11, 103
24 Cf. Natalie Brunet, *Chronologie, 1943–1954*, in exhib. cat., *Ellsworth Kelly. Die Jahre in Frankreich 1948–1954*, Westfälisches Landesmuseum für Kunst und Kulturgeschichte, Münster, 1994, pp. 177–94, p. 180
25 Ibid. p. 178 and Diane Waldman, *Ellsworth Kelly*, in exhib. cat. *Ellsworth Kelly*, ed. by Diane Waldman, Haus der Kunst, Munich, 1997, pp. 10–39, p. 14. Cf. *Nicolas de Staël, Catalogue raisonné de l'œuvre peint*, op. cit., p. 959
26 Cf. Natalie Brunet, op. cit., p. 182. Cf. *Nicolas de Staël, Catalogue raisonné de l'œuvre peint*, op. cit., p. 41

former was furthered by Byzantine scholar Georges Duthuit, Matisse's son-in-law, who worked as a curator at the Louvre and whom de Staël met in 1949.[27] Kelly's enthusiasm resulted in visits to the library of the Byzantine Institute in the Rue de Lille, an offshoot of Harvard University run by archaeologist Thomas Whitmore, who was a friend of Gertrude Stein.[28] Although Kelly later claimed that Matisse had been of no interest to him during his time in Paris,[29] working with cut-out forms was one of the things he did at the time.

His painting *Plant I,* 1949 was inspired by a green plant, which he sought to render in black and white as a flat surface. The result is already reminiscent of cut-outs, but the connection becomes explicit in the collage *Head with Beard,* 1949, which is actually a paper cut-out. Unlike de Staël, Kelly displayed interest in the surfaces and outlines of cut-outs. He later declared: "The shape of my painting is its content."[30] As the example of the green plant shows, Kelly's shapes are based on an observation of reality. His view of an object is neither personal nor abstract. His aim is a maximally objective observation of shape. When he moved on to subjects like a section of vaulting in Notre-Dame or a spot of tar in the street, the starting point was no longer obvious. What remained was an isolated surface without recognisable perspective. Kelly breathed life into it. The technique of collage enabled him to test the effect of shapes without wasting much time.[31] In a letter to his friend, the composer John Cage, he did nonetheless concede that "my collages are only ideas for much larger, wall-filling things. Basically, I would like to see everything I have done much larger. I have no interest in painting in its traditional, long established form—painting in the form of pictures you hang on the wall. To hell with pictures—they should *be* the wall, or even better, appear on the outsides of large buildings. Or be exhibited in the open like large hoardings or as a kind of modern icon… They should hit the eye—directly."[32] In short, advertising seemed to him to promise the ideal circumstances for presenting his pictures.

27 In 1950, Georges Duthuit wrote at some length about de Staël, an extract from which was reprinted in *Cahiers d'Art*, No. 2, 1950, pp. 383–86 and the *Nicolas de Staël* catalogue, Grand Palais, 1981. Cf. *Nicolas de Staël, Catalogue raisonné de l'œuvre peint*, op. cit., p. 722

28 Cf. Nathalie Brunet, op. cit., p. 180

29 "Contrary to what has been said about me, Mondrian and Matisse did not interest me during my time in Paris." Ellsworth Kelly, *Aufzeichnungen von 1969*, in exhib. cat., *Ellsworth Kelly. Gemälde und Skulpturen 1966–1979*, Staatliche Kunsthalle Baden-Baden, 1980, pp. 89–94, p. 94. Diane Waldmann writes on the other hand: "When he took up residence in Paris after World War II with the help of the GI Bill, he was fascinated by the artistic innovations of a whole series of other artists of the early twentieth century, including Henri Matisse, Hans Arp and Sophie Taeuber-Arp." Diane Waldman, *Ellsworth Kelly*, op. cit., p. 10

30 Ellsworth Kelly, *Aufzeichnungen von 1969*, op. cit., p. 91

31 Cf. Ellsworth Kelly in an interview with Henry Geldzahler (1964), quoted from Diane Waldman, *Collage und Objektkunst vom Kubismus bis heute*, op. cit., p. 234

32 Ellsworth Kelly to John Cage, 4 September, 1950, quoted from Natalie Brunet, op. cit., p. 187

Ellsworth Kelly, *Plant I*, 1949, oil on canvas, 35.6 x 27.9 cm, Rijksmuseum Kröller- Müller, Otterloo

Interestingly, the simple colours and 'blocky shapes' of Matisse's cut-outs also reminded the writer Gary Indiana of advertising: "They looked like corporate advertising, and I suppose in many ways they were."[33] Corporate identities are expressed through strongly abstracted images or symbols whose recognisability is enhanced by colour concepts. Matisse emphasised in connection with his cut-outs: "I have achieved a shape pared down to essentials only by means of greater abstraction. All I have kept of the objects I once used to depict in the complexity of their three-dimensionality is *signes*, the minimum needed to make them exist in their actual shapes and in the entities I intended them for."[34]

If Kelly was wanting to create simple flat paintings or objects as large as hoardings at that time, the cut-outs must have fascinated him on account of their monumentality and symbolic nature. He finally achieved the result he wanted with the help of shaped canvases, which served him as 'bodies' for precisely predetermined quantities of colour. The 'canvas bodies', in which colour and shape blend, also emphasise the relationship of the picture or object to the wall. Kelly himself felt his colour-shapes were filled with a certain 'lasciviousness'.[35] His choice of word makes it clear how much he was aiming at natural, living pictures. He paid particular attention to aspects of colour that were decided intuitively.[36] Matisse himself stressed over and again that his choice of colours was not based on academic theory but on perception, feeling and experience.[37] Unlike Signac, for example, he said he had not slavishly studied complementary colours, but simply tried to choose colours that matched his feelings.[38] Consequently, René Huyghe was able to say of Matisse that his art consisted basically in "intensifying our experience of pleasure in colours into an experience of pure joy, preserving their boldness."[39] In a work such as *City Island*, 1958, Kelly seems to be continuing the 'lineless' coloration of Matisse. Of course, in his case the colours now no longer neutralise each other within a painting but demand a wall as a reference surface.

It was often said critically of Matisse that his art is decorative. He himself commented: "The characteristic feature of modern art is that it is part of our lives. A picture in a room disseminates pleasure around it by colours that cheer us up. The colours are clearly not arranged indiscriminately but placed next to each other expressively."[40] Kelly took this idea a step further and said in 1993: "Today, many artists think that form and color are not sufficient for a work of art. The current fashion dictates art must contain political, environmental or minority issues. Personally, I believe in art for art's sake, and I believe Matisse did also."[41]

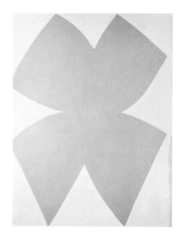

Ellsworth Kelly, *City Island*, 1958, oil on canvas, 184 x 152cm, private collection

33 Gary Indiana, in: *Matisse A Symposium*, in *Art in America*, May 1993, pp. 74–87, p. 82
34 Quoted from Jean Guichard-Meili, *Henri Matisse. Sein Werk und seine Welt*, from the French by Susanne B. Milczewsky, Cologne 1968, p. 122
35 Quoted from Mark Rosenthal, *Die Gegenwärtigkeit erfahren*, in *Ellsworth Kelly*, op. cit., ed. by Diane Waldman, pp. 62–65, p. 63
36 Ibid.
37 Cf. Jean Guichard-Meili, op. cit., p. 131
38 Ibid.
39 Ibid.
40 Ibid., p. 211
41 Ellsworth Kelly, in *Matisse A Symposium*, op. cit., p. 76

Andy Warhol

"Everything is beautiful"[42] Andy Warhol

Even Andy Warhol, whose name is virtually never linked with that of Matisse,[43] examined the cut-outs very closely and drew conclusions from them. His remark "I want to be Matisse"[44] is even supposed to relate specifically to the paper works. After all, it was Warhol's friend Charles Lisanby who wrote assuringly: "What interested Andy in Matisse was not so much his work as the fact that Matisse had reached a point where all he had to do was tear out a little piece of paper, and glue it to another piece of paper, and it was considered very important and valuable."[45]

Philip Pearlstein declared that in 1951 he and Warhol went to the Matisse exhibition in New York, which also fascinated Pollock.[46] Warhol must therefore have first seen the *papiers découpés* at around the same time as de Staël and Kelly. Even in the 1950s, his graphic work such as the book cover *The Wonderful World of Fleming Joffe* (p.158) was notable for its colour or areas of colour existing as separate elements without contour and volume alongside the actual structure of the picture composition. This coloration reminded Rainer Crone of "decorative spots of colour, as in the later Matisse."[47]

Warhol's first exhibition at the New York Leo Castelli Gallery (1964) showed silkscreen prints with flower motifs radiant in rich Day-Glo colours. Almost all the pictures were square and had the same subject—four flowers seen from above, that appeared to float. To David Bourdon, they looked as though "someone

42 Quoted from Roberta Bernstein, *Warhol als Grafiker*, in *Andy Warhol, Prints. Werkverzeichnis der Druckgrafik*, ed. by Frayda Feldmann and Jörg Schellmann, Munich 1985, pp. 9–23, p. 14

43 Lebensztejn ends his *Eight Statements, Interviews by Jean-Claude Lebensztejn* with a quote from Warhol: 'What can we say about Matisse, Fred? Couple of lines…', in *Art in America*, July/August 1975, pp. 67–75, p. 75

44 On 16 October, 1978 Patrick S. Smith interviewed David Bourdon, during which he asked: "Did Andy ever mention Matisse to you, to your recollection?" Bourdon replied. "No, he never did. I have to say that when I read the Calvin Tomkins profile on Andy… how Andy always wanted to paint like Matisse, … I mean, it sounded absolutely apocryphal… I have never heard Andy mention Matisse…" Quoted from Patrick S. Smith, *Andy Warhol's Art and Films*, UMI Research Press, Ann Arbor, Michigan, 1986, p. 230.

45 Quoted from Wrenn, op. cit., p. 12. Elsewhere Lisanby said: "Matisse was *in a way*, perhaps, an influence. At that time, Matisse was doing that chapel, where he drew on the tiles, just in black-and-white, and Andy did know that was being done at the time.' Patrick S. Smith interviewing Charles Lisanby, 11 November, 1978, in: Patrick S. Smith, *Andy Warhol's Art and Films*, p. 87

46 Cf. Rainer Crone, *"Es ist zu wahr, um schön zu sein,"* Zu den Zeichnungen Andy Warhols, in exhib. cat., *Andy Warhol. Das zeichnerische Werk 1942–1975*, ed. by Rainer Crone, Württembergischer Kunstverein, Stuttgart 1976, p. 74

47 Ibid., p. 55

Andy Warhol, *Flowers*, 1964, stencil print on canvas, 61 x 61 cm, Museum moderner Kunst Stiftung Ludwig, Vienna

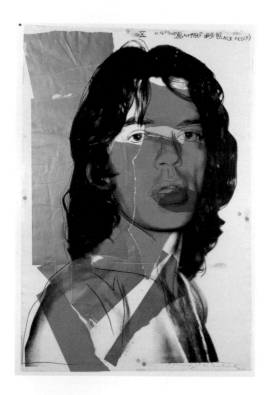

Andy Warhol, *Mick Jagger*, 1975, collage and stencil print, acetate on paper, 127 x 94 cm, Museum moderner Kunst Stiftung Ludwig, Vienna

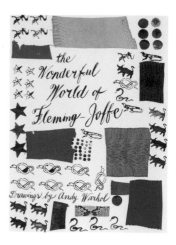

Andy Warhol, *The Wonderful World of Fleming Joffe*, c.1955, ink, aniline colour and snake skin on Paper, 49.8 x 36.2 cm, The Andy Warhol Museum Pittsburgh

had cut out gouaches of Matisse and cast them adrift on Monet's water-lily pond."[48]

Flowers was Warhol's first conscious venture into decoration. At the time, the decorative element was something he treated with care. If the flower motif (which incidentally manifests much similarity to Matisse's choice of subject) and the wallpaper presentation of the pictures gave it a harmlessly pretty air, the gaudy, aggressive coloration and crude print quality saved it from excessive cuteness. The later series of celebrity portraits from the mid-70s on the other hand are avowedly decorative.

Unlike the early silkscreen prints, which were mostly constructed in two layers, the later ones reveal three separate printing processes. The background often consisted of coloured paper strips which subdivided the picture—for example the face of Mick Jagger, 1975, into individual fields. Lazlo Glozer concluded from the typical fragmentation of the pictorial surface in Warhol's work: "Warhol's 'surface' does not have an original."[49] Yet Ronnie Cutrone, who was Warhol's assistant in making the portraits, confirmed that the brightly coloured torn paper surfaces went back to Matisse: "Matisse was Andy's favorite artist. Collage is an easy way to make a background. It looked artsy because we didn't cut the

48 David Bourdon, *Andy Warhol*, in: *The Village Voice*, 3 December, 1964, p. 11, quoted from David Bourdon, *Warhol*, Cologne 1989, p. 193
49 Lazlo Glozer, *Gastspiel im Olymp der Maler*, in: *Andy Warhol. Art from Art*, ed. by Jörg Schellmann, Munich 1994, pp. 12–15, p. 15

paper, we tore it, so you get that 'artsy' edge."[50] Here Warhol was resorting to a technique used by Matisse, but he made completely different use of it. Whereas Matisse endeavoured to unite colour and drawing, outlines and inner spaces in his cut-outs, Warhol arranged colour and drawing alongside or on top of each other.

As before, the second level of the silkscreen prints was photography, which converted them into serigraphs for printing. So that the result should not appear too realistic, Warhol coarsened the contrasts. The third level was the addition of linear outline drawings, the style of which is likewise reminiscent of Matisse. In the celebrity portraits, these drawings bring out the subject's hairdo or lips more prominently. Though Warhol claimed that the drawing was only done in response to his clients' wishes,[51] the various forms of interaction in the three pictorial layers he henceforth used must undoubtedly have fascinated him.

While Matisse could still credibly assert that the decorative element was an important and valuable component of his works,[52] it is often implied that Warhol's pared down linear drawings or his striking coloration was derived from advertising, where the decorative value of an object facilitates rapid identification. Yet, as already mentioned, Matisse had already exploited the characteristics of advertising for his cut-outs. Warhol and Matisse are also linked by their playful treatment of colour and form. Matisse introduced cut-outs to painting, while Warhol enriched it with the technique of silkscreen printing.[53]

The cut-outs and Warhol's silkscreen strips have features in common even on a general level. Admittedly Matisse is supposed to have frowned scornfully when Louis Aragon once called his cut-outs wallpaper or *papier-peint*.[54] Yet Aragon was thinking primarily of Matisse the magician, who wanted to control the mood of people looking at his works just as wallpaper determines the atmosphere of a room. After all, the characteristic feature of new art for Matisse was that it was a part of life and gave pleasure.

Thus, if we regard the cut-outs, which sometimes cover several walls and whose forms Matisse invented as 'real illusion', and Warhol's *Cow Wallpaper* (1966), in which the subject already existed before the artist selected it for duplication, as 'false illusion', what links the two artists is the desire to affect the mood of the viewer.

If Warhol had been familiar with Ritsos's *Blue Woman*, she might have inspired him to make a pattern for a silkscreen strip. But even without any such strip, John Cage was right in observing that by means of repetition Warhol showed that there is no repetition in art.[55]

50 Ronnie Cutrone, *An Artist's Take on the Work of Warhol*, in *Unseen Warhol*, ed. by John O'Connor and Benjamin Liu, New York 1996, pp. 55–70, p. 57
51 "As ever, I'd prefer to just make prints of the face, without all the trappings, but people simply expect a bit more. That's why I put in all the drawing bits." Andy Warhol, quoted from Roberta Bernstein, op. cit., p. 17
52 "It's an essential component. It's not running them down to say of an artist's works that they're decorative." Henri Matisse, quoted from *Ornament und Abstraktion.*, op. cit., p. 95
53 It should be mentioned in this context that the British artist Simon Periton, who has been making doily cut-outs since the late 1990s, cites Warhol rather than Matisse. Like Warhol, he repeats his motifs in gaudy colour combinations. A particular preference is fluorescent pink because that is the colour of 'emptiness', the colour of our time, the colour that, according to Periton, Yves Klein would choose today under the influence of Ecstasy. Cf. Marion Ackermann, *Schatten und Schnitte in der zeitgenössischen Kunst*, in *Schatten-Risse, Silhouetten und Cut-outs*, ed. by Helmut Friedel, Städtische Galerie im Lenbachhaus, Munich 2001, pp. 233–50, p. 236
54 Cf. Louis Aragon, op. cit., p. 283
55 Lazlo Glozer, op. cit, p. 15

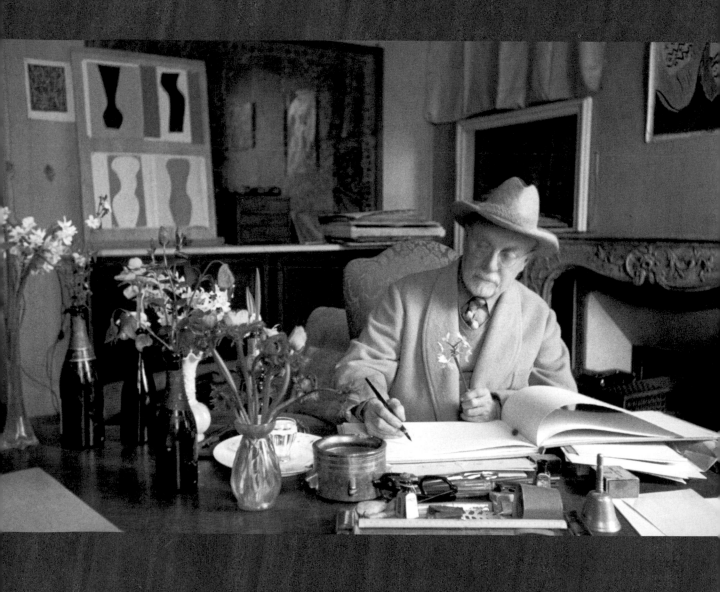

Biography

1869

Henri Émile Benoît Matisse born on 31 December in Le Cateau-Cambrésis in northern France.

1887–88

Studies law in Paris. After graduating in August 1888, becomes a clerk in the law practice of Maître Duconseil in Saint-Quentin.

1890

Matisse begins to paint following complications after an appendix operation which confined him to bed. Still lifes are his favoured subject matter at first.

1891

Matisse gives up law and continues his artistic training. Attends the Académie Julian in Paris, as a preparation for enrolment at the École des Beaux-Arts.

1892–93

In February, Matisse fails the entrance exam to the École des Beaux-Arts. However, Matisse is admitted to Gustave Moreau's studio. Frequently visits the Louvre, where he copies works by Annibale Carracci, Nicolas Poussin, Raffael, Ruysdael and Chardin. Works with Albert Marquet and Henri-Charles Manguin.

1894

Birth of his daughter Marguerite from his liaison with Caroline Joblaud.

1895

Begins to paint in the open air, especially during a trip to Brittany. In the early summer, visits the Corot exhibition at the Palais Galliéra. In December, visits a solo exhibition of works by Cézanne in Paris, which has a lasting influence on his style.

1896

First public exhibition at the Salon des Cents in April, organised by the Symbolist periodical *La Plume*. Also in April Matisse shows two paintings at the Salon de la Société Nationale des Beaux-Arts. The state buys his painting of *La liseuse* (Woman Reading, 1894) for the Château de Rambouillet. Matisse is appointed a Membre Associé of the Société Nationale by its president Puvis de Chavannes.

1897

In February, accompanied by Camille Pissarro, he visits the exhibition of impressionistic paintings in the Musée du Luxembourg. Matisse develops an enthusiasm for the paintings of Claude Monet.

1898

Marries Amélie Noémie Alexandrine Parayre from Toulouse. On Camille Pissarro's advice, studies Turner's pictures during his honeymoon in London. He sees pictures by Signac, Pissaro, Cézanne and Monet in different exhibitions in Paris. Paul Signac's book *D'Eugène Delacroix au neo-impressionnisme* is published in *La revue blanche* in early summer.

1899

His first son Jean is born in Toulouse. After his return to Paris Matisse works at the École des Beaux-Arts under the guidance of Fernand Cormon, Moreau's successor. Meets André Derain and Jean Puy. Evening courses on sculpture at the École de la rue Étienne-Marcel. In May Matisse exhibits at the Salon of the Société Nationale for the last time. Buys Cézanne's *Les Trois Baigneuses* (Three Bathers) from the art dealer Ambroise Vollard, Rodin's plaster bust from Henri Rochefort, a boy's head by Gauguin and a second van Gogh drawing.

1900

On the occasion of the Paris World Fair Exposition, he works with Albert Marquet on decorations for the Grand Palais. In June his second son Pierre is born. Despite financial problems, he buys (*inter alia*) two pastel drawings by Odilon Redon. Works in the studio of Émile-Antoine Bourdelle at the Académie de la Grande Chaumière. At the École d'Art Municipal he attends evening classes in sculpture, and works under the guidance of Antoine Bourdelle.

1901

Recuperates from a bout of bronchitis in Villars-sur-Ollon in Switzerland. Visits the van Gogh retrospective at Bernheim-Jeune in March. Becomes acquainted with Maurice Vlaminck via Derain. First exhibition at the Salon des Indépendants, where ten of his works are shown. They include sketches, still lifes and figure studies. Matisse is elected a *sociétaire* of the Salon.

1902

In winter financial difficulties force Matisse and family (Amélie, Marguerite, Jean and Pierre) to return to Bohain. He and friends from the Moreau studio begin to exhibit at Berthe Weill. Exhibits another six paintings at the Salon des Indépendants.

1903

Salon d'Automne founded, at which Matisse and his friends from the Moreau and Carrière studios exhibit and where a Gauguin retrospective is held. Produces his first etchings. Visits exhibition of Islamic art at the Musée des Arts Décoratifs (Pavillon de Marsan, Louvre).

1904

Exhibits at the Salon des Indépendants; besides Matisse and his friends, other exhibitors include Kees van Dongen, Jean Metzinger, Felix Valotton and Louis Valtat. In June, his first exhibition at Ambroise Vollard is held with 45 paintings and one drawing from the years 1897 to 1903. Visits an exhibition of fourteenth to sixteenth-century illuminated French manuscripts in the Louvre. He exhibits thirteen paintings and two sculptures in the Salon d'Automne. Critic Louis Vauxcelles describes Matisse as Moreau's strongest pupil.

1905

Showing of *Luxe, Calme et Volupté* (Luxury, Silence and Lust) at the Salon des Indépendants, where Signac buys the painting. Spends the summer in Collioure with Derain. Works on the first Fauve paintings: small-format, spontaneous oil studies, freely interpreted landscapes painted with lines and rings in contrasting colours on a white background, and sundry interiors. Matisse, Derain, Friesz, Mauguin, Marquet, Puy, Rouault, Valtat and Vlaminck exhibit in the same room at the Salon d'Automne. Critic Vauxcelles invents the term 'Fauves' after this exhibition. Gertrude, Leo, Michael and Sarah Stein begin their Matisse collections by buying *La femme au chapeau* (Woman with Hat).

1906

Signac sees *Le bonheur de vivre* (Joy of Life) in the studio, and criticises it. It is exhibited at the Salon des Indépendants and purchased by Leo Stein. Exhibition at the Galerie Druet, at which 55 paintings, three sculptures, watercolours, drawings, first lithographs and woodcuts are shown. Travels to Algeria (Biskra). Spends the summer in Collioure. He acquires an African

mask. Meets Pablo Picasso at the Steins. Etta Cone begins to collect Matisses. Makes acquaintance with the Russian collector Sergei Ivanovich Shchukin.

1907

Nu bleu: Souvenier de Biskra (Blue Nude: Memory of Biskra) exhibited at the Salon des Indépendants. Picture swap with Picasso: in exchange for the portrait of Marguerite (1906/07), Matisse gets Picasso's still life with jug, key and lemon. At the studio of André Méthey in Asnières Matisse designs a ceramic triptych for the German art collector Karl Ernst Osthaus's Hohenhof house in Hagen. In July he travels with his wife to Padua, Florence, Arezzo and Siena. Paintings by Andrea del Castagno, Duccio, Giotto, Piero della Francesca and Paolo Uccello impress him on the trip. Guillaume Apollinaire's article about Matisse is published in the December edition of the magazine *La Phalange*.

1908

In January, Matisse's admirers—including the German painters Hans Purrmann and Oskar Moll, plus Sarah Stein, Michael Stein's wife—found a school in the rue de Sèvres, where Matisse teaches. In spring Matisse moves into a new atelier at the Hôtel Biron, where Rodin also has his studio (today the Musée Rodin). With Hans Purrmann he visits Germany for the first time. First international exhibition of water-colours, drawings and prints take place at Alfred Stieglitz's gallery and Edward Steichen's Gallery 291 in New York, and in Moscow and Berlin. In Berlin he makes the acquaintance of Max Liebermann and August Gaul. The exhibition in Berlin gets a very hostile reception, notably from Max Beckmann. The *Notes d'un peintre* are published in the *Grande Revue*. Within a year, they are translated into German and Russian. Sergej Shchukin begins to collect works by Matisse, buying thirty-six by 1913, while Morosov buys another six paintings.

Matisse in Nice, 1953

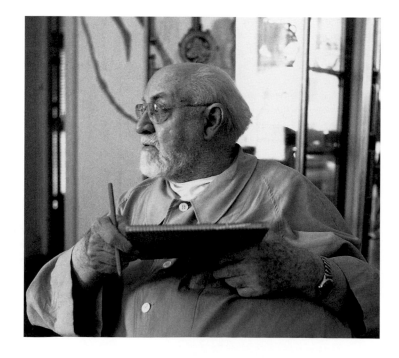

1909

Shchukin commissions two large works to adorn the stairwell of his house in Moscow, *La Danse* and *La Musique*. Matisse signs his first contract with the gallery Bernheim-Jeune. Matisse moves out of his flat at the Quai Saint-Michel, moves to Issy-les-Moulineaux and builds a new atelier there. Makes the sculpture *La Serpentine* (The Serpent) and the first version of the relief *Nu de dos* (Nude from the Rear).

1910

Retrospective at Bernheim-Jeune, where 65 paintings and 25 drawings from the period after 1893 are exhibited. His drawings are shown at the Gallery 291 in New York. Three are presented to the Metropolitan Museum—the first Matisse works in an American public art collection. Three portraits are exhibited at the Salon of the Berlin Secession. *La Danse* and *La Musique* are exhibited at the Salon d'Automne. The simple forms and bright colours cause a sensation. Critics attack the pictures. Initially Shchukin refuses to accept the pictures, but later changes his mind. Only Apollinaire defends Matisse. Travels to Munich with Albert Marquet in October, and visits the exhibition of Islamic art. Takes part in the *Manet and the Post-Impressionists* exhibition put together by Roger Fry.

1911

Matisse paints in Seville, Issy-les-Moulineaux and Collioure. Travels to Moscow to supervise the hanging of the paintings in Shchukin's house. Matisse is impressed by Russian icons. First journeys to Tangiers in late 1911 or early 1912.

1912

In New York, first exhibitions exclusively of drawings and sculptures take place. Participates in the *Sonderbund* exhibition in Cologne and the second Post-Impressionist exhibition in London. Also the *Moderner Bund* exhibition in Zurich along with Jean Arp, Robert Delaunay, Wassily Kandinsky, Paul Klee and Franz Marc—Matisse shows four pictures. Ivan Morosov buys works by Matisse. Visits the exhibition of Persian miniatures at the Musée des Arts Décoratifs in Paris.

1913

Travels to Morocco and Tangiers with Charles Camoin in late 1912 or early 1913. Albert Marquet and the Canadian painter James Wilson Morrice are likewise there. Exhibits paintings and sculptures at Bernheim-Jeune. Takes part in the Armory Show in New York and at the exhibition of the Berlin Secession. Spends summer in Issy-les-Moulineaux, but returns to Paris in the autumn.

1914

Exhibits at the Galerie Gurlitt in Berlin. Works in Paris, then in Issy again. At the outbreak of war, Matisse sends the children to Toulouse and goes with his wife to Collioure. Makes the acquaintance of Juan Gris and his wife.

1915–16

Exhibits in New York. 14 paintings, and around 50 drawings and graphics works and 11 sculptures are shown at the Montross Gallery. Matisse paints in Paris and Issy. An Italian woman, Laurette, begins to work as his model. Visits Arcachon near Bordeaux. Roger Fry and the Mexican painter Diego Rivera visit Matisse in his studio. Matisse paints *Les Marocains*.

1917

Spends the summer in Issy, the autumn in Paris. Spends his first winter in Nice, at the Hôtel Beau-Rivage. Visits Claude Monet in Giverny and Auguste Renoir in Cagnes.

1918

Exhibits with Picasso at the Galerie Paul Guillaume. In the catalogue, Apollinaire devotes a whole page to each artist. Lives in Nice in the Hôtel Beau-Rivage, then in the Villa des Alliés. Summer in Cherbourg and Paris, autumn in Nice again. Visits Pierre Bonnard in Antibes and Renoir in Cagnes again, to show him his works.

1919

Exhibits at Bernheim-Jeune in Paris and the Leicester Gallery in London. In New York, Matisse exhibits at the Marius de Zayas Gallery with works by Courbet, Manet, Degas, Renoir, Cézanne and Seurat. Goes to London with Diaghilev's Ballets Russes. Here he designs stage sets and costumes for *Le Chant du Rossignol* by Diaghilev, to music by Igor Stravinsky and choreography by Léonide Massine. First uses the technique of the cut-out for stage sets.

1920

Travels to London for the premiere of *Le Chant du Rossignol*, spends the summer in Etretat. First monograph on Matisse, by Marcel Sembat, in *Les peintres nouveaux* series published by Roger Allard. It depicts works from 1897 to 1918/19. Galerie Bernheim-Jeune issues the *Cinquante dessins par Henri Matisse* catalogue

1922

The Musée du Luxembourg buys the painting *Odalisque au pantalon rouge* from 1921. Monograph on Henri Matisse by Roland Schacht published in Dresden.

1923

First museum of modern western art founded in Moscow from the Shchukin and Morosov collections. It contains 48 paintings by Matisse.

1924

Exhibits at the Brummer Gallery in New York. The most extensive retrospective to date is put on at the Ny Carlsberg Glyptothek in Copenhagen, and goes on to Oslo and Stockholm. Monograph on Matisse by Adolphe Basler published in Leipzig.

1925

Takes a second trip to Italy. After a ten-year gap, works on a sculpture again, *Grand Nu assis* (Great seated nude), which is not completed until 1929. Exhibition of paintings and drawings takes place at the Quatre Chemins gallery in Paris. On this occasion Waldemar George publishes a

monograph. Interview with Jacques Guenne published in *L'art vivant* magazine, in which Matisse discusses the importance of Cézanne for his own work.

1926–27

Matisse takes part in the *Trente Ans d'art indépendant*, 1884–1914 exhibition at the Grand Palais. Exhibits drawings and lithographs at Bernheim-Jeune. Pierre Matisse organises an exhibition at the Valentine Dudensing Gallery in New York. One of the five pictures shown by Matisse gains an award at the Carnegie International Exhibition in Pittsburgh.

1928

Matisse is represented by 14 paintings, 6 sculptures and 13 drawings and graphic works at the Biennale in Venice. His painting *Nature morte au buffet vert* is exhibited at the Salon d'Automne.

1929

Matisse works mainly on sculptures and drypoint engravings. *Visite à Henri Matisse* by E. Tériade is published in two parts in the *L'Intransigeant*. Matisse discusses in detail the Fauves, the roots of Neo-Impressionism and its culmination in *La Musique* of 1910.

1930

Finishes the last of four versions of the *Nu de dos*. Travels to Tahiti via New York and San Francisco. Several works by Matisse are included in the *Paintings in Paris from American Collections* exhibition at the newly opened Museum of Modern Art in New York. The catalogue notes that five American and eight foreign museums have paintings by Matisse. Exhibition of 265 works takes place at the Galerie Thannhauser in Berlin. Matisse is a member of the jury for the Carnegie Prize, which is awarded to Picasso. Albert Skira commissions illustrations for a book of *Poésies* by Stéphane Mallarmé. In September he is commissioned to decorate the Barnes Foundation in Merion. Tériade interviews Matisse about his trip to Tahiti and his time in the USA. His account is published in

L'Intransigeant on 20 and 27 October. In November, Matisse accepts the commission at the Barnes Foundation in New York. First studies follow.

1931

A sculpture exhibition is put on at the Brummer Gallery in New York. Retrospective takes place at the Galerie George Petit in Paris. Exhibits at the Kunsthalle in Basle and Museum of Modern Art in New York. Preparing the decorations for Albert C. Barnes, Matisse uses *gouaches découpées* and does a series of photos of each stage of the work. Works on the murals for the Barnes Foundation and the Mallarmé illustrations. Pierre Matisse opens his own gallery in New York. Alfred H. Barr Jr. organises a retrospective at The Museum of Modern Art in New York. The reception is unanimously positive. The art historian Meyer Schapiro writes an essay titled *Matisse and Impressionism*.

1932

L'Intransigeant publishes an article called *Édouard Manet vue par Henri-Matisse*, based on an interview with Tériade. The first version of *La Danse* for the Barnes Foundation is the wrong size. A second version follows. Etta Cone buys a group of 250 study drawings for the Mallarmé poems, just recently published. It includes 29 etchings by Matisse. The Mallarmé drawings are published separately. Exhibition of etchings is put on at the Marie Harriman Gallery in New York. The 50 drawings from the book of *Cinquante dessins* (1920) go on show at Pierre Matisse's gallery.

1933

First issue of the Surrealist magazine *Minotaure* is published. Paul Eluard's article *Le Miroir de Baudelaire* relates to a portrait of Baudelaire by Matisse in the volume of Mallarmé's poems. Installation of the second version of *La Danse* at the Barnes Foundation in Merion is finsihed. Alfred H. Barr's book on *The Art of Henri Matisse* published in New York.

1934–35

Exhibits paintings at his son Pierre's New York gallery. Designs for carpets. Creates etchings illustrating James Joyce's *Ulysses*, based on scenes from the *Odyssey*. Corresponds with Joan Miró. While doing preparatory work for *Grand Nu couché / Nu rose*, he uses paper cut-outs for the first time to establish the composition. The stages of development are documented by 25 photos.

1936

Exhibits at the Leicester Gallery, London. Pen drawings of the important series of drawings from 1935/36 are published in a special issue of *Cahiers d'Art* under the title *Dessins de Matisse*, together with an essay by Christian Zervos and a poem for Matisse by Tristan Tzara. Does his first non-figurative cut-out, for the cover of *Cahiers d'Art* magazine. The first version of *La Danse* for the Barnes Foundation is bought by the city of Paris at the instigation of the director of the Petit Palais, Raymond Escholier.

1937

Exhibits drawings at the Galerie Rosengart in Lucerne and new works at Paul Rosenberg's in Paris. Does stage sets and costumes for the Ballets Russes's *Rouge et Noir* ballet in Monte Carlo. The music is taken from Shostakovich's *Symphony No. 1*. The designs follow the second scheme for the Barnes Foundation. Some are done in the *gouaches découpées* technique. *Le Danseur* is the first independent work of art done in the cut-out technique.

1938

Acquires a flat in the Hôtel Régina in Cimiez, which he keeps to the day he dies. *Matisse, Picasso, Braque, Laurens* exhibition is put on at the Kunsternes Hus in Oslo; it travels to Copenhagen and Stockholm. Matisse shows 31 paintings from the period 1896–1937 along with Picasso's *Guernica*. Boston Museum of Modern Art holds the exhibition *Picasso, Henri Matisse*. Solo exhibition takes place at the Galerie Rosenberg in Paris. Exhibition of paintings and draw-

ings is put on at the Pierre Matisse Gallery in New York.

1939

Performance of *Rouge et noir* takes place in Nice in spring. Matisse spends summer in Paris. Goes to the exhibition of Spanish masterpieces from the Prado in Geneva. In October, returns to Nice. A series of charcoal drawings in *Cahiers d'Art* is published. Matisse publishes an article titled 'Notes d'un peintre sur son dessin' in *Le Point* magazine.

1940

In Paris he begins to line up his separation from Amélie. Returns to Nice via Bordeaux, Cibourne, Carcassonne and Marseilles. Corresponds with Picasso and Bonnard. Matisse does little work because of his intestinal illness. Varian Fry, the American head of the *Emergency Rescue Committee*, offers the artist a visa to the USA, but Matisse turns it down.

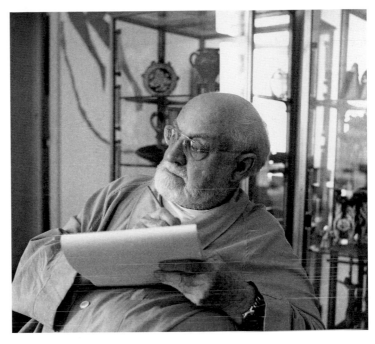

Matisse in Nice, 1953

1941

Pierre Courthion begins a series of ten interviews with the artist. The texts are planned for a Matisse autobiography which Albert Skira intends to publish in Geneva. Exhibits drawings at the gallery Louis Carré in Paris. In May, he returns to Nice. After a serious intestine operation Matisse is forced to work mainly from a wheelchair and bed. The flatness of compositions in this period anticipates the style of the later *gouaches découpées*, which appear in great number in the 1940s and 1950s. Until 1942 Matisse works on the *Thèmes et variations* series. The drawings consist of 17 groups of freely designed pen and pencil variations of compositions and still lifes which all start with a thematic drawing. The series is published in Paris in 1943 by Martin Fabiani under the title *Dessins. Thèmes et variations*. Matisse does illustrations for *Florilège des amours* by Ronsard and *Pasiphaé* by Henry de Motherlant. Makes the acquaintance of Louis Aragon.

1942

Louis Aragon visits him at the Hôtel Régina, and writes the foreword *Matisse-en-France* for the *Thèmes et variations* book. Does illustrations for *Poèmes* by Charles d'Orléans. Swaps pictures with Picasso again. Matisse does two interviews for Vichy Radio. Excerpts from it appear in 1951 in Alfred H. Barr's *Matisse: His Art and Public*.

1943

Matisse settles in Vence, living in the Hôtel Régina. The volume of *Thèmes et variations* comes out. Throughout this and the following year, Matisse works intensively on pieces for *Jazz*, including *La Chute d'Icare*, *Le Clown* and *Le Tobogan*. These indicate that the gouaches découpées have become the core of his work—he entirely abandons painting for the time being.

1944

Matisse draws a series of 35 heads on lithographic paper as illustrations for *Les Fleurs du mal* by Charles Baudelaire. The book does not appear until 1947. Matisse now lives in the villa 'La Rêve' in Vence. Two monographs on Matisse are published in Stockholm: Isaac Grünewald's *Matisse och Expressionismen* and Leo Swane's *Henri Matisse*. His wife is arrested and his daughter deported for working for the Résistance. Amélie Matisse is sentence to six months in prison. In May, Henry de Montherlant's book *Chant de Minos* (*Le Crétois*) with lino cuts by Matisse is finished. The book is not published until 1947.

1945

In summer, he returns to Paris. Exhibits jointly with Picasso at the Victoria & Albert Museum in London, and in Brussels. Retrospective is put on at the Salon d'Automne. Drawings exhibited at the Matisse Gallery in New York and Galerie Maeght in Paris. Special issue of *Verve* magazine called *De la couleur* is devoted to Matisse. The issue contains colour pictures of works from 1941–44. Matisse designs the cover

picture, title page and frontispiece in the summer of 1943, but publication is only possible after the war. The French state buys six paintings from the artist for the collection at the new Musée National d'Art Moderne. In an interview with Léon Degand, published in *Les Lettres françaises*, Matisse defends the decorative qualities of his work.

1946

First visit of Picasso and Françoise Gilot to Matisse. Their stay in Vence is followed by a series of further meetings right through to 1954. François Campeaux works on a documentary film about Matisse (*Matisse – a visit with Matisse*), shot in Paris and Vence. All the *gouaches découpées* for *Jazz* are completed. Despite his illness, Matisse writes the text for *Jazz*, which appears alongside the colour plates in his own handwriting. Zika Ascher commissions

two large screens, for which he does preparatory *gouaches découpées: Océanie, le ciel* and *Océanie, la mer*. This is the first experiment using paper cut-outs on a large scale. Does the cartoons for a two-part tapestry that will be made at the Manufacture de Beauvais. Finishes illustrations for Marianna Alcaforado's *Lettres d'une religieuse portugaise* and Pierre Reverdy's *Visages*.

1947

Tériade publishes *Jazz* in Paris as both a folder edition with twenty colour plates done from the *gouache découpées* and a book edition with handwritten texts by the artist reproduced alongside the plates. It is met by an enthusiastic reception from the public. Important works find their way to the Musée National d'Art Moderne in Paris. First designs for the interiors of the Chapel of the Rosary in Vence are completed.

1948

Ronsard's *Florilège des amours* comes out with illustrations by Matisse. Matisse draws St Dominic for the church of Notre-Dame-de-Toule-Grâce in Alssy. Studies Grünewald's Isenheimer Altar in connection with his work at the Chapel of the Rosary in Vence. Works on the first large gouache cut-outs for the windows in Vence. The series of paintings for the interior is finished. Retrospective of paintings, drawings and sculptures put on in Philadelphia. A special number of *Verve* designed by Matisse called *Les Tableaux peints par Henri Matisse à Vence de 1944 à 1948* focuses on the interior of the Chapel of the Rosary in Vence.

1949

Returns to the Hôtel Régina in Cimiez. Two rooms are knocked together to create the dimensions of the chapel in Vence. This is where the *gouache découpée* for the *L'Arbre de vie* window is made. Exhibits at the Pierre Matisse Gallery in New York. After visiting the exhibition, the influential critic Clement Greenberg calls Matisse the greatest living painter. Retrospective held in Lucerne. The Musée d'Art Moderne exhibits the latest works in honour of the artist's eightieth birthday, including 21 *gouaches découpées* shown in France for the first time.

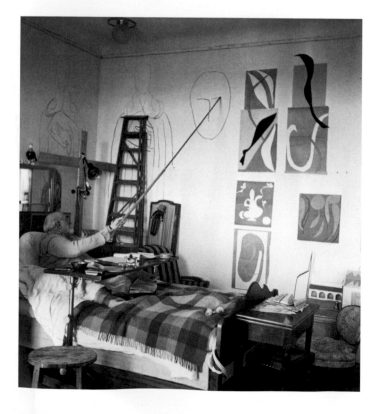

Henri Matisse, Hôtel Régina, 15 April, 1950

1950

Stimulated by his work for the Chapel of the Rosary Matisse works on various narrow, large-scale *gouaches découpées* in the wake of the work for the chapel in Vence, including *Zulma*, *Les Bêtes de la mer* and *Les mille et une Nuits*. The silhouette *Zulma* is presented at the Salon de Mai and bought by the Museum for Kunst in Copenhagen. Exhibits at the Galerie des Ponchettes in Nice. Designs for the Chapel of the Rosary exhibited at the Maison de la Pensée française in Paris. Matisse awarded the Grand Prix at the Venice Biennale together with sculptor Henri Laurens. The stained glass windows are installed in Vence.

1951

During this year, Matisse creates large *gouaches découpées* in the shape of windows but quite independent of them, e.g. *Végétaux*, *La Vis* and *Poissons chinois*. The Chapel of the Rosary is consecrated in Vence on 25 June. Matisse works on his first paintings since 1948, also *gouache découpées* and brush drawings. Retrospective put on at The Museum of Modern Art, New York. Monograph by Alfred Barr Jr. on *Matisse. His Art and his Public* is published in New York. Exhibits at the Galerie Samlaren, Stockholm. Matisse has attacks of asthma and angina. In an interview with Maria Luz, published as *Témoignages: Henri Matisse in XXe siècle* in January 1952, Matisse discusses his works on paper which combine painting and drawing. Retrospective put on at The Museum of Modern Art in New York. The works for the chapel in Vence form a focal point. Aimé Maeght films a documentary about Matisse.

1952

Matisse works on *La Piscine*, his largest paper cut-out. Official opening of the Musée Matisse in Le Cateau-Cambrésis on 8 November. *Life* magazine commissions Matisse to design a glass window. The *gouache decoupée* of *Nuit de Noël* serves as the cartoon for the window. Matisse finishes *Nu bleu I–IV* and other blue compositions.

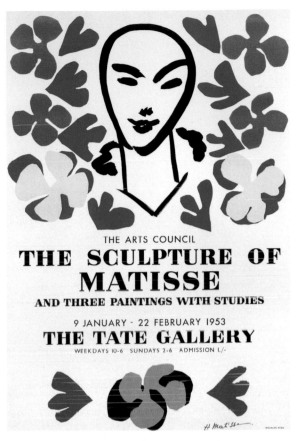

Poster for the exhibition 'The Sculpture of Henri Matisse', Tate Gallery, London, 1952 (cf. cat. 67)

1953

Exhibits 20 sillhouttes under the title *Henri Matisse: Papiers découpés* at the Galerie Berggruen in Paris. For the catalogue Matisse creates the cover picture and the poster. It is the only exhibition showing all the *papier découpés* held during Matisse's lifetime. Sculptures, drawings and paintings shown in the Tate Gallery in London and an exhibition of sculptures put on at the Kurt Valentin Gallery in New York. Matisse designs various wall decorations using *papiers découpés*, which are then executed as ceramic tiles.

1954

Exhibits at Paul Rosenberg in New York. Matisse's last work is a design for the rosette of the Union Church, Pocantico Hills, New York, commissioned by Nelson A. Rockefeller. Henri Matisse dies in Nice on 3 November, and is buried in the cemetery in Cimiez close to his garden.

List of Works Illustrated

1–20 Jazz 1947
Folder with 20 pochoir illustrations (cut-out prints) 20 sheets, each *c.*45 x 67 cm
Städelscher Museums-Verein, Frankfurt am Main/ Kupferstichkabinett der Staatlichen Museen zu Berlin
pp. 34–43

21 Small Dancer on a Red Ground
Petit Danseur sur fond rouge 1937/38
Cut-out from paper coated with gouache, arranged as collage on paper
37 x 19.5 cm
Private collection
p. 54

22 Verve IV (cover design)
Verve IV (maquette de couverture)1943
Cut-out from paper coated with gouache, arranged as collage on paper, on canvas
36.5 x 55.5 cm
Private collection
p. 55

23 The Fall of Icarus
La Chute d'Icare, 1943
Cut-out from paper coated with gouache, arranged as collage on paper, on canvas
35 x 26.5 cm
Private collection
p. 56

24 The Dragon
Le Dragon 1943/44
Cut-out from paper coated with gouache, arranged as collage on paper
42.5 x 65.5 cm
Private collection
p. 57

25 The Fauves (book-cover design)
Les Fauves (maquette de couverture) 1949
Cut-out from paper coated with gouache, arranged as collage on paper
32.3 x 50.8 cm
Private collection, Switzerland
p. 60

26 Cahiers d'Art 3–5 (cover design)
Cahiers d'Art 3–5 (maquette de couverture) 1936
Cut-out from paper coated with gouache, arranged as collage on paper
32.8 x 54 cm
Nationalgalerie, Staatliche Museen zu Berlin Berggruen Collection
p. 61

27 Matisse. His Art and His Public (book-cover design)
Matisse. His Art and His Public (maquette de couverture) 1951
Cut-out from paper coated with gouache, arranged as collage on paper
27 x 42.9 cm
The Museum of Modern Art, New York
p. 62

28 Exhibition H Matisse (book-cover design) Exhibition H Matisse (maquette de couverture) 1951
Cut-out from paper coated with gouache, arranged as collage on paper
27 x 40 cm
The Museum of Modern Art, New York
p. 63

29 Livres Illustrés Estampes Sculptures (book-cover design)
Livres Illustrés Estampes Sculptures (maquette de couverture) 1952
Cut-out from paper coated with gouache, arranged as collage on paper
20.7 x 14.5 cm
Succession Gérald Cramer, Geneva
p. 64

30 Gravures récentes (book-cover design) Gravures récentes (maquette de couverture) 1952
Cut-out from paper coated with gouache, with ink on cardboard
21.6 x 11.6 cm
Private collection
p. 65

31 Theme H Variation 7
Thème H Variation 7 1941
Pen and ink on white hand-made paper with Arche watermark
40.4 x 52.7 cm
Musée de Grenoble
p. 86

32 Theme H Variation 8
Thème H Variation 8 1941
Pen and ink on white hand-made paper with Arche watermark
40.4 x 52.7 cm
Musée de Grenoble
p. 87

33 Study with Lemons
Étude citrons 1945
Pencil on paper
40 x 53 cm
Private collection
p. 88

34 Hibiscus Flowers
Fleurs d'hibiscus *c.*1940
Pencil on paper
24 x 32 cm
Private collection
p. 89

35 Study with Oak Leaves
Études feuilles de chêne 1945 /46
Ink on paper
50 x 33 cm
Private collection
p. 90

36 Study with Oak Leaves
Études feuilles de chêne 1945/46
Ink on paper
38 x 51 cm
Private collection
p. 91

56 Composition with Red Cross

Composition à la croix rouge 1947

Cut-out from paper coated with gouache, arranged as collage on paper

74.1 x 52.4 cm

Private collection, USA, courtesy Nancy Whyte Fine Arts, New York

p. 125

57 Composition (Velvets)

Composition (Les Velours) 1947

Cut-out from paper coated with gouache, arranged as collage on paper

51.5 x 217.5 cm

Kunstmuseum, Öffentliche Kunstsammlung Basel, Basle

pp. 126/27

58 Light blue glass window

Vitrail bleu pâle 1949

Cut-out from paper coated with gouache, arranged as collage on paper, on canvas

509.8 x 252.3 cm

Musée National d'Art Moderne, Centre Georges Pompidou, Paris

p. 132

59 The Tree of Life

L'Arbre de vie, 1949

Cut-out from paper coated with gouache, arranged as collage on paper, on canvas

515 x 252 cm

The Vatican Museum, Vatican City

p. 133

60 The Parakeet and the Mermaid

La Perruche et la sirène 1952

Cut-out from paper coated with gouache

c.337 x 768.5 cm

Stedelijk Museum, Amsterdam, acquired with the support of the Vereniging Rembrandt and the Prins Bernhard Fonds (1967)

pp. 138/39

61 Mimosa

Mimose 1949–51

Cut-out from paper coated with gouache, arranged as collage on paper, on canvas

148 x 98 cm

Ikeda Museum of 20th Century Art, Itoh, Japan

p. 141

62 Blue Nude III

Nu bleu III 1952

Cut-out from paper coated with gouache, arranged as collage on paper, on canvas

112 x 73.5 cm

Musée National d'Art Moderne, Centre Georges Pompidou, Paris

p. 142

63 Blue Nude, Skipping

Nu bleu, sauteuse de corde 1952

Cut-out from paper coated with gouache, arranged as collage on paper, on linen

145 x 98 cm

Nationalgalerie, Staatliche Museen zu Berlin Berggruen Collection

p. 143

64 The Swimming Pool

La Piscine 1952

Ceramics, 2000

230 x 847 cm (left), 230 x 796 cm (right)

Private collection

pp. 144/45

65 The Bell

La Cloche 1951

Cut-out from paper coated with gouache, with watercolour on paper, on canvas

122 x 48.5 cm

Private collection

p. 146

66 The Japanese Mask

Le Masque japonais, early 1950

Cut-out from paper coated with gouache, arranged as collage on paper

79.5 x 49.5 cm

Private collection

p. 147

67 The Sculpture of Henri Matisse (poster design) The Sculpture of Henri Matisse (maquette de poster) 1952

Cut-out from paper coated with gouache, arranged as collage on paper

82 x 57.4 cm

Nationalgalerie, Staatliche Museen zu Berlin Berggruen Collection

p. 148

The Sculpture of Henri Matisse

Tate Gallery poster based on Henri Matisse's original design from 1952, 1953

Offset lithograph

82.5 x 57.5 cm

Nationalgalerie, Staatliche Museen zu Berlin Berggruen Collection

p. 167

68 Nude with Oranges

Nu aux oranges 1953

Cut-out from paper coated with gouache, arranged as collage on paper, on canvas

155 x 108 cm

Musée National d'Art Moderne, Centre Georges Pompidou, Paris

p. 149

Cut sheet with Arabesque Forms

Feuille découpée en arabesque 1944–47

Pen and ink on glossy paper

25.6 x 21 cm

Musée National d'Art Moderne, Centre Georges Pompidou, Paris

Not illustrated

Sheet with Lagoon

Feuille de lagon 1944–47

Pen and ink on paper

27 x 21 cm

Musée National d'Art Moderne, Centre Georges Pompidou, Paris

Not illustrated

Stéphane Mallarmé, Poésies

Albert Skira & cie., Lausanne 1932

Book (etchings)

33.2 x 25 cm

Private collection, Paris

Not illustrated

Henri de Montherlant, Pasiphaé Chant de Minos (Le Crétois)

Martin Fabiani (éditeur), Paris 1944

Book (lino-cuts)

33.7 x 26.2 cm

Private collection, Paris

Not illustrated

Pierre de Ronsard, Florilège des amours

Albert Skira & cie., Paris 1948

Book (colour lithographs)

38.5 x 29.5 cm

Private collection, Paris

Not illustrated

Selected Bibliography

Monographies

Alpatow, Michael W., *Henri Matisse,* (Moskow 1969) Dresden 1973

Anthonioz, Michel, Beaudin, André (Eds.), *Hommage à Tériade,* Exhib. Cat. Bonn, Bottrop, Berlin, Cologne 1978

Anthonioz, Michel, *Verve. The Ultimate Review of Art and Literature (1937–1960),* (Paris 1987) New York 1988

Antliff, Mark, 'The Rhythms of Duration: Bergson and the Art of Matisse', in Mullarkey, John (Ed.), *The New Bergson,* Manchester, New York 1999, pp. 184–208

Aragon, Louis, *Henri Matisse. Roman,* (Paris 1974) Stuttgart 1974

Aragon, Louis, *Les Collages,* Paris 1980

Arthaud, Christian, Girard, Xavier (Eds.), *Henri Matisse. Hommage,* Vence 1990

Barnes, Rachel (Ed.), *Matisse by Matisse,* London 1992

Barr, Alfred H., *Matisse. His Art and His Public,* New York 1951

Baumann, Felix (Ed.), *Henri Matisse,* exhib. cat. Zurich, Düsseldorf 1982

Bell, Tiffany (Ed.), *After Matisse,* exhib. cat. Flushing, Norfolk, Portland, Miami Beach, Washington, Dayton, Worcester, New York 1986

Beltramo Ceppi, Claudia (Ed.), *Matisse e Tériade,* exhib. cat. Florence 1996

Beltramo Ceppi, Claudia, Duthuit, Claude (Ed.), *Matisse 'La Révélation m'est venue de l'Orient',* exhib. cat. Rome 1997

Benjamin, Roger, *Henri Matisse,* New York 1992

Benjamin, Roger, *Matisse's 'Notes of a Painter'. Criticism, Theory, and Context. 1891–1908,* Ann Arbour/Michigan 1987

Billot, Marcel (Ed.), *Henri Matisse, M.-A. Couturier, L.-B. Rayssigier. La Chapelle de Vence. Journal d'une création,* (Paris 1993) Houston 1999

Bock-Weiss, Catherine C., *Henri Matisse. A Guide to Research,* New York, London 1996

Buchholz, Cornelia, *Henri Matisse' 'Papiers Découpés'. Zur Analyse eines Mediums,* Frankfurt, Bern, New York 1985

Carlson, Victor I. (Ed.), *Matisse as a Draughtsman,* exhib. cat. Baltimore, San Francisco, Chicago 1971, New York 1982

Chapelle du rosaire des Dominicains de Vence par Henri Matisse, Vence 1955

Clement, Russel I., *Henri Matisse. A Bio-Bibliography,* Westport, London 1993

Cowart, Jack, Flam, Jack D., Fourcade, Dominique, Hallmark Neff, John (Eds.), *Henri Matisse – Paper Cut-Outs,* New York 1977

Dation, Pierre Matisse, exhib. cat. Paris 1992

Delpont, Eric (Ed.), *Le Maroc de Matisse,* exhib. cat. Paris 1999

Durozoi, Gérard, *Matisse,* Paris 1989

Duthuit, Georges, *Écrits sur Matisse,* Paris 1992

Dvorak, Franz, *Henri Matisse. Zeichnungen,* Vienna 1973

Elderfield, John (Ed.), *Henri Matisse. A Retrospective,* exhib. cat. New York 1992

Elderfield, John (Ed.), *Henri Matisse Masterworks from the Museum of Modern Art,* exhib. cat. New York 1996

Elderfield, John (Ed.), *Matisse in the Collection of the Museum of Modern Art,* collection cat. New York 1978

Elderfield, John, *The Cut-Outs of Henri Matisse,* New York 1978

Elderfield, John, *The Drawings of Henri Matisse,* London 1984

Essers, Volkmar, *Henri Matisse 1869–1954. Meister der Farben,* Cologne 1986

Fage, Gilles (Ed.), *Henri Matisse. Le Chemin de croix,* Paris 2001

Finsen, Hanne / Wivel, Mikael (Eds.), *Matisse. Kapellet i Vence,* exhib. cat. Copenhagen 1993

Flam, Jack (Ed.), *Henri Matisse 1869–1954,* (New York 1988) Cologne 1994

Flam, Jack (Ed.), *Matisse on art,* London 1978

Flam, Jack (Ed.), *Matisse in The Cone Collection. The Poetics of Vision,* collection cat. Baltimore 2001

Fourcade, Dominique, *Matisse au Musée de Grenoble,* collection cat. Grenoble 1975

Girard, Xavier, *Henri Matisse. Les chefs-d'œuvre du Musée Matisse, Nice, Cimiez,* exhib. cat. Dijon 1991

Gowing, Lawrence, *Matisse,* London 1979

Guichard-Meili, Jean, *Die ausgeschnittenen Gouachen von Henri Matisse,* (Paris 1983) Geneva 1984

Guichard-Meili, Jean, *Henri Matisse, son œuvre – son univers,* Paris 1967

Guichard-Meili, Jean, *Matisse,* Paris 1986

Guillaud, Jacqueline, Guillaud, Maurice, *Matisse. Le Rythme et la ligne,* Paris, New York 1987

Güse, Ernst-Gerhard (Ed.), *Henri Matisse – Drawings and Sculpture,* Munich 1991

Hahnloser, Margrit, *Matisse,* Zurich / Wiesbaden 1988

Henri Matisse 1950–1954. Les grandes Gouaches découpées, exhib. cat. Bern 1959

Henri Matisse, exhib. cat. Zurich, Düsseldorf 1982

Henri Matisse. Dessins. Collection du Musée Matisse, exhib. cat. Nantes, Nimes, Saint-Etienne 1989

Henri Matisse. Exposition du Centenaire, exhib. cat. Paris 1970

Henri Matisse. Les grandes Gouaches découpées – de grote uitgheknipte gouaches, exhib. cat. Amsterdam 1960

Henri Matisse. Œuvres récentes 1947–1948, exhib. cat. Paris 1949

Henri Matisse. Zeichnungen und Gouaches découpées, exhib. cat. Stuttgart, Ostfildern 1993

Jacobus, John, *Henri Matisse,* (New York 1983) Cologne 1989

Jedlicka, Gotthard, *Die Matisse-Kapelle in Vence. Rosenkapelle der Dominikanerinnen,* Frankfurt 1955

Jouvet, Jean (Ed.), *Henri Matisse. Der Zeichner. Hundert Zeichnungen und Graphiken,* Zurich 1982

Klein, John (Ed.), *Henri Matisse. Autoportraits,* exhib. cat. Le Cateau-Cambrésis 1988

Klein, John, *Matisse Portraits,* New Haven, London 2001

Labrusse, Rémi, *Matisse. La Condition de l'image,* Paris 1999

Laudon, Paule, *Matisse in Tahiti,* (Paris 1999) Paris 2001

Lavarini, Beatrice, *Henri Matisse: JAZZ (1943–1947). Ein Malerbuch als Selbstbekenntnis,* (Phil. diss. Marburg 1997) Munich 2000

Leymarie, Jean, Lieberman, William S., Read, Herbert, *Henry Matisse,* Berkeley, Los Angeles 1966

Matisse and Picasso, exhib. cat. London, Paris, New York, London 2002

Matisse et Tahiti, exhib. cat. Nizza 1986

Matisse, espiritu y sentido. Obra sobre papel, exhib. cat. Madrid 2001

Matisse, Henri, *Jazz* (Paris 1947), with an introduction by Katrin Wiethege, Munich 2000

Matisse. En retrospektiv udstilling, exhib. cat. Copenhagen 1970

Matisse 1869–1954. A retrospective exhibition at the Hayward Gallery, exhib. cat. London 1968

Monod-Fontaine, Isabelle (Ed.), *Matisse – La Collection du Centre Georges Pompidou, Musée national d'art moderne,* collection cat. Paris 1998

Monod-Fontaine, Isabelle, Baldessari, Anne, Laugie, Claudel (Eds.), *Matisse. Œuvres de Henri Matisse (1869–1954),* collection cat. MNAM/Centre George Pompidou, Paris 1989

Monod-Fontaine, Isabelle, *Matisse: Le Rêve ou de belles endormies,* Paris 1989

Monod-Fontaine, Isabelle, *The Sculpture of Henri Matisse,* London 1984

Néret, Gilles, *Henri Matisse, Scherenschnitte,* Cologne 1994

Noël, Bernard, *Matisse,* Geneva 1987

O'Brian, John, *The American Reception of Matisse,* Chicago, London 1999

Pleynet, Marcelin, *Henri Matisse,* Paris 1988

Russell, John, *Matisse und seine Zeit 1869–1954,* Amsterdam 1973 (The World of Matisse, New York 1969)

Schiebler, Ralf, *Matisse. Scherenschnitte,* Munich 1994

Schneider, Pierre, *Matisse,* Munich 1984

Schütz, Otfried, *Henri Matisse. Die blauen Akte,* Frankfurt, Leipzig 1996

Sommer, Achim, Ronte, Dieter, Schreiner, Christoph (Eds.), *Femmes et fleurs. Matisse. Zeichnungen,* Cologne 1997

Szymusiak, Dominique (Ed.), *Matisee et l'Océanie,* exhib. cat. Le Cateau-Cambrésis 1998

Szymusiak, Dominique (Ed.), *Matisse et Baudelaire,* exhib. cat. Le Cateau-Cambrésis 1992

Szymusiak, Dominique (Ed.), *Matisse. Fleurs, feuillages, dessins,* exhib. cat. Le Cateau-Cambrésis 1989

Ward, Martina, *Tom Wesselmann. Studie zur Matisse-Rezeption in Amerika,* (Phil. diss. Münster 1990) Münster, Hamburg 1992

Watkins, Nicholas, *Matisse,* Oxford 1985

Weisner, Ulrich (Ed.), *Henri Matisse. Das Goldene Zeitalter,* exhib. cat. Bielefeld 1981

Wheeler, Monroe, *The Last Works of Henri Matisse. Large Cut Gouaches,* exhib. cat. New York, Chicago, San Francisco 1961/62

General Literature

Ackermann, Marion, Dank, Claudia, Helmut Friedel (Eds.), *SchattenRisse, Silhouetten und Cut-Outs,* exhib. cat. Munich 2001

Beaumelle, Agnès de la, Pouillon, Nadine (Eds.), *La Collection du Musée national d'art moderne,* Centre Georges Pompidou, Paris 1986

Boehm, Gottfried, Mosch, Ulrich, Schmidt, Katharina (Eds.), *Canto d'Amore. Klassizistische Moderne in Musik und bildender Kunst 1914–1935,* exhib. cat. Basel, New York, Bern 1995

Bois, Yve-Alain, *Matisse and Picasso,* Paris 1998

Brauner, Haidrun, *'Natürlich ist das Dekoration'. Perspektiven in der Kunst des 20. Jahrhunderts ausgehend von Henri Matisse,* Frankfurt am Main 1993

Catalogue of Painting Collection – Museum of Art. Carnegie Institute Pittsburgh, Pittsburgh 1973

Cowling, Elizabeth, *Interpreting Matisse Picasso,* London 2002

Dittmann, Lorenz, 'Arabeske und Farbe als Gestaltungselemente bei Matisse. Der Begriff ›Arabeske‹ in Matisse's schriftlichen Äußerungen', in Berens, Michael, Maas, Claudia, Ronig, Franz (Eds.), *Florilegium Artis. Festschrift für Wolfgang Götz,* Saarbrücken 1984

Fondation Beyeler, collection cat. Munich, New York 1998

Mann, Stephan, *Von Matisse bis Macke. Die Künstlerkapelle im 20. Jahrhundert,* Frankfurt 1996

Ruhrberg, Karl, *Kunst im 20. Jahrhundert. Das Museum Ludwig – Köln,* Cologne 1986

Strauss, Ernst, *Koloritgeschichtliche Untersuchungen zur Malerei seit Giotto und andere Studien,* Munich, Berlin 1983

The Museum of Modern Art, New York. The History and the Collection, New York 1984

Articles

'Dernières Œuvres de Matisse 1950–1954',
in *Verve*, Nos 35/36, Paris 1958

'Matisse's last tile mural', in *Art News,* Vol. 55,
No. 4, Summer 1956, pp. 30/31, 67

,Sammlung Beyeler. Die Werke. Der Bau',
in *du, Die Zeitschrift der Kultur*, Issue
No. 12, Dec. 1997

Aragon, Louis, 'Matisse ou la Peinture
française', in *L'Arts de France*, No. 23–24,
1949, pp. 11–24

Bettini, Sergio, 'Il colore di Matisse', in *La
Biennale di Venezia*, No. 26, Dec. 1955,
pp. 19–24

Bois, Yve Alain, 'Matisse Redrawn', in
Art in America, Sept. 1985, pp. 126–131

Bois, Yve-Alain, 'Légendes de Matisse', in
Critique, No. 324, May 1974, pp. 434–466

Bois, Yve-Alain, 'On Matisse. The Blinding',
in *October*, 68, Spring 1994, pp. 60–121

Bois, Yve-Alain, 'The Matisse System', in
Artforum, Sept. 1992, pp. 90–92

Bouvier, Marguette, 'Henri Matisse chez lui',
in *Labyrinthe*, No. 1, 15 Oct. 1944,
pp. 1–3

Brandi, Cesare, 'Matisse nel nostro tempo',
in *La Biennale di Venezia*, No. 26, Dec.
1955, pp. 25–27

Carmean, E. A., 'Morris Louis and the Modern
Tradition IV: Fauvism; V: Later Matisse', in
Arts Magazine, No. 51, 1976, pp. 122–26

Cassou, Jean, Salles, Georges, 'Matisse
va présenter au public ses Papiers dé-
coupés', in *France Illustration*, No. 383,
1953, pp. 234/35

Courthion, Pierre, 'Le Peintre et son modèle',
in *Labyrinthe*, No. 6, 15 May, 1945,
pp. 6/7

Courthion, Pierre, 'Papiers découpés d'Henri
Matisse', in *XXe siècle*, Nouvelle série –
No. 6, Jan. 1956, pp. 45–47

Cowart, Jack, 'Matisse's Artistic Probe:
The Collage', in *Arts Magazine,* No. 49,
1974, pp. 53–55

Danto, Arthur C., 'Matisse, Art, and Le
Bonheur', in *Artforum*, 1992, p. 89

Degand, Léon, 'Les Papiers découpés de
Matisse', in *Art d'aujourd'hui*, Vol. 4,
No. 2, 1953, p. 28

Duthuit, Georges, 'The material and spiritual
worlds of Henri Matisse', in *Art News,*
Vol. 55, No. 6, Oct. 1956, pp. 22–25, 67

Goldin, Amy, 'Matisse and Decoration. The
Late Cut-Outs', in *Art in America*, Jul./Aug.
1975, pp. 49–59

Hoyal, Susan, 'Henri Matisse – A Celebration
of the Cut-Out', in *Crafts,* No. 65,
Nov./Dec. 1983, p. 51

Kelder, Diane, 'Stuart Davis. All That Jazz',
in *Art News*, Feb. 1992, pp. 80–85

Lassaigne, Jacques, 'La première Exposition
des grandes gouaches découpées de
Matisse', in *Les Lettres Françaises,
Spectacles, Arts*, 6 Aug. 1959

Lebensztejn, Jean-Claude, 'Les Textes du
peintre', in *Critique*, No. 324, May 1974,
pp. 400–33

Leinz, Gottlieb, ' 'Jazz' von Henri Matisse',
in *Pantheon*, Yr. XLIV, 1986, pp. 141–57

Leymarie, Jean, 'Le Jardin du Paradis', in
Les Lettres Francaises, Spectacles, Arts,
6 Aug., 1959

Leymarie, Jean, 'Les grandes Gouaches
découpées de Matisse à la Kunsthalle de
Berne', in *Quadrum*, 1959, pp. 103–14

Marchiori, Giuseppe, 'Papiers Découpés',
in *La Biennale di Venezia*, No. 26, Dec.
1955, pp. 28–30

Marmer, Nancy, 'Matisse and the Stategy
of Decoration', in *Artforum*, Mar. 1966,
pp. 28–33

Martin, Paule, 'Il mio maestro Henri Matisse',
in *La Biennale di Venezia*, No. 26, Dec.
1955, pp. 6–8

Masson, André, 'Conversations avec Henri
Matisse', in *Critique,* No. 324, May 1974,
pp. 393–99

Matisse, Henri, 'La Cappella del Rosario
delle Domenicane di Vence', in *La
Biennale di Venezia*, No. 26, Dec. 1955,
pp. 39–42

Matisse, Pierre, 'Henri Matisse mio padre',
in *La Biennale di Venezia*, No. 26,
Dec. 1955, pp. 4–6

Nochlin, Linda, ' 'Matisse' and Its Other',
in *Art in America*, May 1993, pp. 88–97

Authors' Biographies

Michel Anthonioz

Member of the supervisory board of European cultural channel ARTE. Since 2001, representative of France's delegation to UNESCO. From 1969–79, curator at the Musée de Meudon, subsequently director of the Musée d'Orsay (1980–81). Anthonioz is a freelance writer and has published on subjects relating to the collaboration between Matisse and the publisher Tériade: Hommage à Tériade (Paris 1973), L'Album Verve (Paris 1988) and Matisse/Tériade – Le Livre fleur (Cateau-Cambrésis 2002).

Olivier Berggruen

Art historian, lives in New York. Studied at Brown University, Providence (RI) and the Courtauld Institute in London. Numerous publications on nineteenth and twentieth-century art, including works on Yves Tanguy, Pablo Picasso and Paul Klee. Currently working on a study of the aesthetic writings of the Indian philosopher Abhinavagupta.

Hannes Böhringer

Professor of Philosophy at Brunswick Fine Arts College. Lives in Berlin. Numerous publications on the relationship between philosophy and art, including Orgel und Container (Berlin 1993), Auf dem Rücken Amerikas. Eine Mythologie der neuen Welt (Berlin 1998) and Auf der Suche nach Einfachheit. Eine Poetik (Berlin 2000). Currently working on the renaissance of the Baroque, and is compiling an edition of Wilhelm Worringer's work.

Rémi Labrusse

Professor of Contemporary Art History at the University of Picardy. The focal point of his research is nineteenth and twentieth-century art and its relationship with the art of the Near East. Numerous publications on Henri Matisse, including 'Avec tendresse et précision' (in Matisse et l'Océanie, Le Cateau-Cambrésis 1998), Matisse. La condition de l'image (Paris 1999) and Matisse et la Chine (Taipeh 2002). Curated the exhibition 'Henri Matisse: La révélation m'est venue de l'Orient' (Rome 1997).

Gunda Luyken

Head of the Artist Archive at the Berlinische Galerie, Landesmuseum für Moderne Kunst, Fotografie und Architektur. Curator for temporary exhibitions at the Stiftung Hans Arp/Sophie Taeuber-Arp in Rolandseck. Doctoral thesis on Frederick Kiesler and Marcel Duchamp. Numerous publications on the subject of nineteenth and twentieth-century art (e.g. Eugène Delacroix, Giorgio Morandi, Hans Arp, Kurt Schwitters, Andy Warhol).

Ingrid Pfeiffer

Curator at the Schirn Kunsthalle, Frankfurt. Previously scholarly assistant at the Hessisches Landesmuseum in Wiesbaden. Doctoral thesis on Erich Buchholz and the Bauhaus. Numerous publications on the subject of agriculture, art and twentieth-century/contemporary photography (e.g. Eugène Atget, Johannes Itten, Sonia Delaunay, Eva Hesse, Contemporary Trends in photography and film).

Margret Stuffmann

Former head of the Graphische Sammlung at the Städelsches Kunstinstitut in Frankfurt and honorary professor at the Goethe University in Frankfurt. The principal focus of her scholarly work was nineteenth-century painting. Among her numerous publications are Goya. Zeichnungen und Druckgraphik (Frankfurt 1981), Eugène Delacroix. Themen und Variationen, Arbeiten auf Papier (Frankfurt 1987), Von Linie und Farbe. Französische Zeichnungen des 19. Jahrhunderts (Frankfurt 2001)

Photographic Credits

Full-page photographs

p. 4: Henri Matisse working in his studio in the Hôtel Régina, Nice, 1952
p. 5: Matisse's studio in the Hôtel Régina, Nice, 1952, with *La Négresse* on the wall
pp. 6/7: Large studio in the Hôtel Régina, Nice, c. 1953, with *Grande Décoration aux masques*, *Acrobate* and *Nu aux oranges* on the walls
p. 8: Ceramic tiles from *Apollon*, photographed in the Charles Cox Studios in Juan-les-Pins, c. 1953
p. 9: Henri Matisse in the Hôtel Régina, Nice, c. 1953, with *Apollon* on the wall
pp. 10/11: Matisse's studio in the Hôtel Régina, Nice, 1953, with *Femmes et singes* and *La Piscine* on the wall
p. 12: Matisse's studio in the Hôtel Régina, Nice, c. 1952, with *Grande Décoration aux masques* and *La Cloche* on the wall
p. 13: Henri Matisse sitting in front of a wall with cut-outs, Villa 'La Rêve', Vence, 1948
p. 14: Henri Matisse in his villa 'La Rêve', Vence, c. 1943/44
p. 18: Henri Matisse in his studio, Boulevard du Montparnasse, Paris, 1951, with the first edition of *Matisse. His Art and his Public* on the table
p. 22: cover sheet for *Jazz* (cat. 1–20)
p. 44: Henri Matisse in his villa 'La Rêve', Vence, c. 1948
p. 66: Wall with cut-outs in Matisse's villa 'La Rêve', Vence, c. 1948
p. 102: 'Gouaches découpées' exhibition in the Galerie Berggruen, Paris, 1953
p. 134: The villa 'La Rêve', Vence, c. 1945/46
p. 150: The villa 'La Rêve', Vence, c. 1948
p. 160: Matisse in his villa 'La Rêve', Vence, c. 1943/44

Front cover: Henri Matisse, Composition
on a Blue Ground · *Composition fond vert*
1951 (cat. 54)

Edited by Olivier Berggruen and Max Hollein
Editor: Ingrid Pfeiffer
Assistant: Sybille Schmidt

© 2006 Prestel Verlag,
Munich · Berlin · London · New York
and Schirn Kunsthalle Frankfurt
(first published in hardback in 2003)

© for works illustrated, by the artists, their
heirs or assigns, with the exception of the
following: Henri Matisse by the Succession
H. Matisse / VG Bild-Kunst, Bonn 2006; Joan
Miró by the Successió Miró / VG Bild-Kunst,
Bonn 2006; Hans Arp, Wassily Kandinsky and
Nicolas de Staël by VG Bild-Kunst, Bonn 2006;
Andy Warhol by the Andy Warhol Foundation
for Visual Arts / Artists' Rights Society (ARS),
New York

The Library of Congress Cataloguing-in-
Publication data is available; British Library
Cataloguing-in-Publication Data: a catalogue
record for this book is available from the
British Library; The Deutsche Bibliothek holds
a record of this publication in the Deutsche
Nationalbibliografie; detailed bibliographical
data can be found under:http://dnb.ddb.de

Prestel Verlag
Königinstrasse 9, 80539 Munich
Tel. +49 (89) 38 17 09-0
Fax +49 (89) 38 17 09-35

Prestel Publishing Ltd.
4 Bloomsbury Place, London WC1A 2QA
Tel. +44 (020) 7323-5004
Fax +44 (020) 7636-8004

Prestel Publishing
900 Broadway, Suite 603, New York, NY 10003
Tel. +1 (212) 995-2720
Fax +1 (212) 995-2733

www.prestel.com

Translated from the German by Paul Aston
Editorial direction: Christopher Wynne
Coverdesign: liquid, Augsburg
Design and layout: Meike Weber
Production and redesign: René Güttler
Origination: ReproLine, Munich
Printing and Binding: MKT Print, Ljubljana,
Slovenia

Printed on acid-free paper

ISBN: 3-7913-3473-5
978-3-7913-3473-8